Laura Dowling

A WHITE HOUSE CHRISTMAS

INCLUDING FLORAL DESIGN TUTORIALS

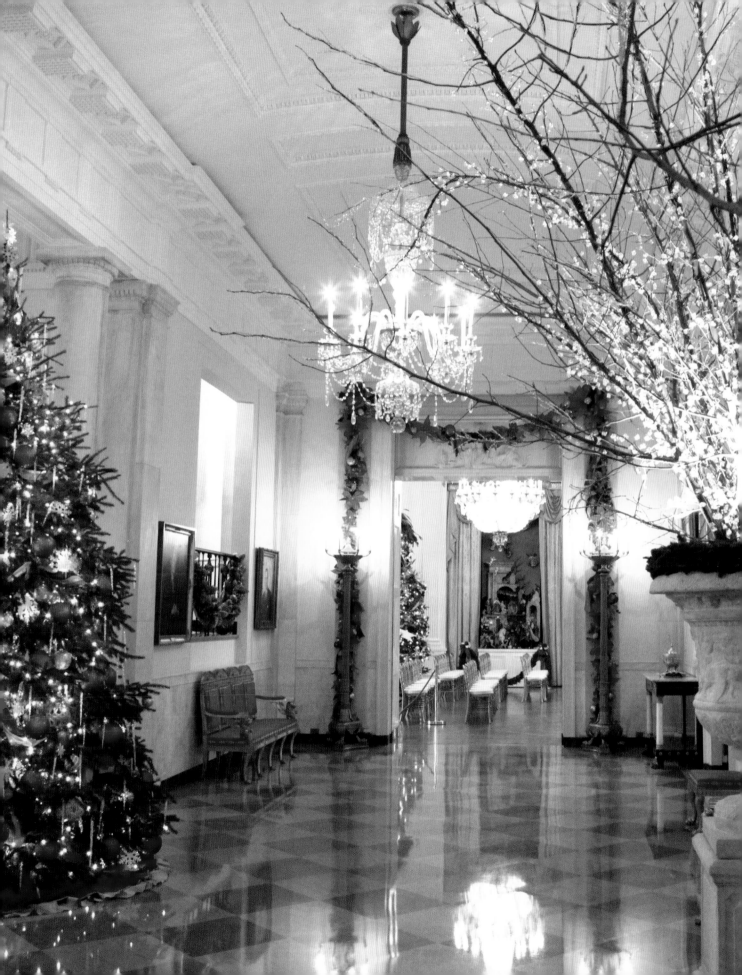

Laura Dowling

A WHITE HOUSE CHRISTMAS

INCLUDING FLORAL DESIGN TUTORIALS

For Heidi,
with inspiration!

all the
best.
Laura

stichting
kunstboek

This book is dedicated in honor of my grandmothers:
GENEVIEVE MAY GARRISON
REGINA MOFFETT DOWLING

And in celebration of the simple gifts
and sweet dreams of Christmas

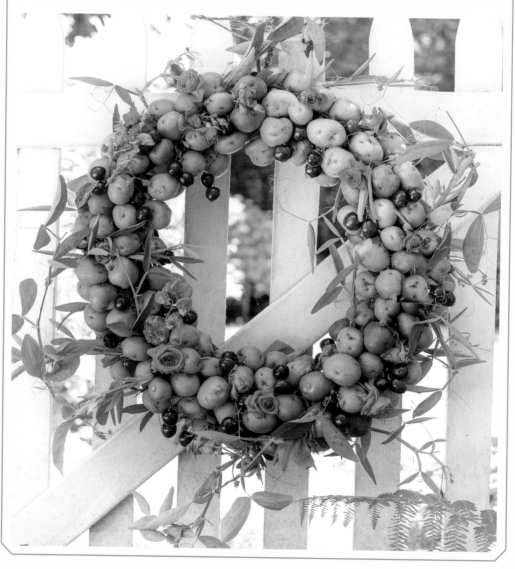

A simple wreath made of purple potatoes, cherries, and fuchsia roses wrapped in wild sweet pea vines adds a festive note during the holiday season – or at any time of the year.

CONTENTS

p.2: To carry out the 2010 Christmas theme of 'Simple Gifts', we decorated the Cross Hall in festive and wintry décor: giant urns of crystal-wrapped branches, snow-flake and icicle-bedecked Christmas trees, and hand-made garlands of 1,000 poinsettias created by volunteers from recycled ribbon.

The Christmas season is by far the largest and most important White House event that occurs each year, the ultimate display of nostalgic traditions and romanticized ideals that are often evoked in literature and film and embedded in our hearts and minds. We can envision an idyllic wintry scene, beautiful decorations, glistening snow and sleigh bells in the moonlight illuminating the metaphorical path home to loved ones who have gathered from near and far. In a spectacular setting of sparkly and sentimental decorations, lavishly wrapped gifts, a cozy gathering around the hearth, decorated tables and endless delectable feasts, we conjure images of Christmas celebrations long past: memories that always shine bright no matter how much time goes by. Christmas is a time for reveling in beloved childhood memories and sentimental family traditions as well as expressing hope for the future. At the White House, the holiday season resonates with all Americans on both a collective and profoundly personal level, full of history, traditions, symbolism and patriotic meaning. At Christmas, the White House is truly America's holiday home, bringing people together from across the country in celebration of our most deeply held values and cherished beliefs.

As Chief Floral Designer at the White House, it was my privilege and honor to create the White House Christmas for six years, working with the First Lady and an extraordinary group of volunteers to create holiday magic. Together, we created Christmas celebrations that surprised and delighted visitors and viewers with inspiring décor projects that carried out the First Lady's vision of highlighting key priorities, showcasing American artists and handcrafted designs, and inviting all Americans to participate in the celebration of the White House Christmas. From architectural details including intricate hydrangea-covered archways, illusion cube-patterned column covers and gilded maple leaf rosette panels to sugar paste floral vases and looped ribbon and robotic versions of the First Family dogs, the décor we created was ambitious and detailed. Our goal was to open doors and opportunities for volunteer collaboration, inviting people from across the country to work behind the scenes on an array of creative projects and original décor. In addition to the artistic endeavors, it was the overarching symbolism, behind-the-scenes stories, heartwarming anecdotes, and creative process that provided the most memorable moments. Working together throughout the years to create imaginative decorations and beautiful décor for the holiday displays forged something larger than the individual tasks and projects to showcase our passion for art and dedication to excellence. Each year we sought to capture the intangible magic of the White House Christmas.

During the holidays the best gifts are often the ones that are personal and meaningful and don't cost anything at all. These simple gifts – the gifts of nature and the winter garden, going home for the holidays, celebrating with friends and family, honoring the people who serve our country, a child's sense of wonder, family traditions, the Christmas feast and the joy of music – represent core holiday ideals that are timeless and universal. At the White House, we celebrated all of these unifying themes with the goal of spreading a spirit of generosity and goodwill towards others. In the Christmas season, the majestic grandeur of the White House is the ultimate expression of holiday splendor, symbolizing iconic American ideals, honoring cherished traditions and creating opportunities for celebration and joy for all.

In 2014, the Red Room glistened in a wintry palette of cream and emerald green with accents of red birds and berries. Bountiful displays of hydrangeas and lilies in hand-made sugar paste urns served as striking focal point displays, while the lush trees and evergreen wreaths created a serene and traditional ambi-

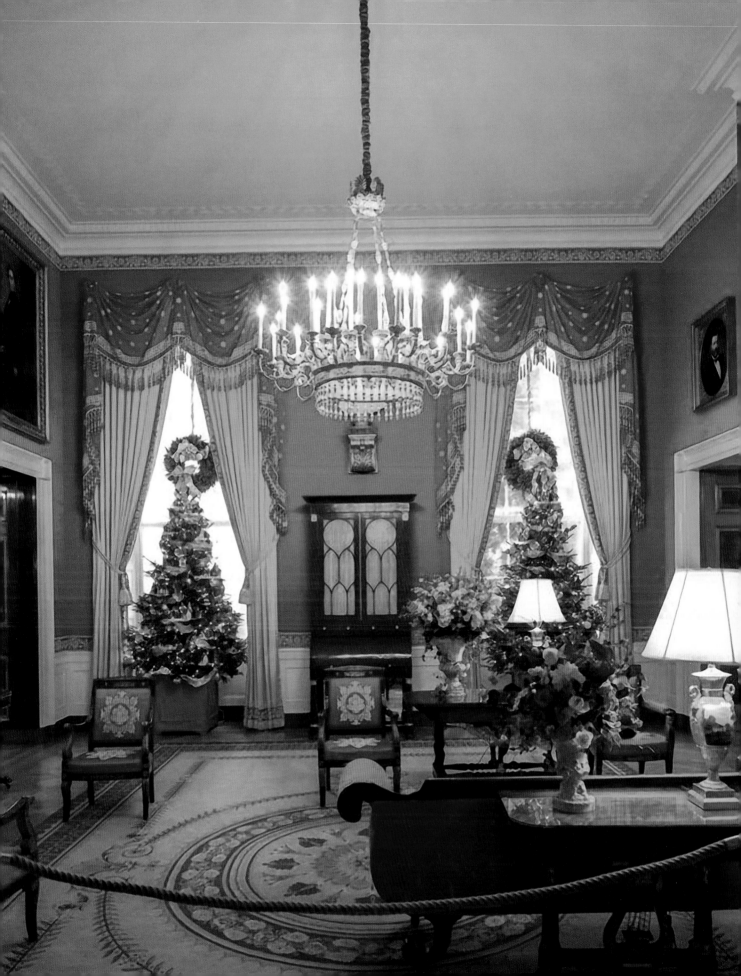

CHRISTMAS IN
THE PACIFIC NORTHWEST

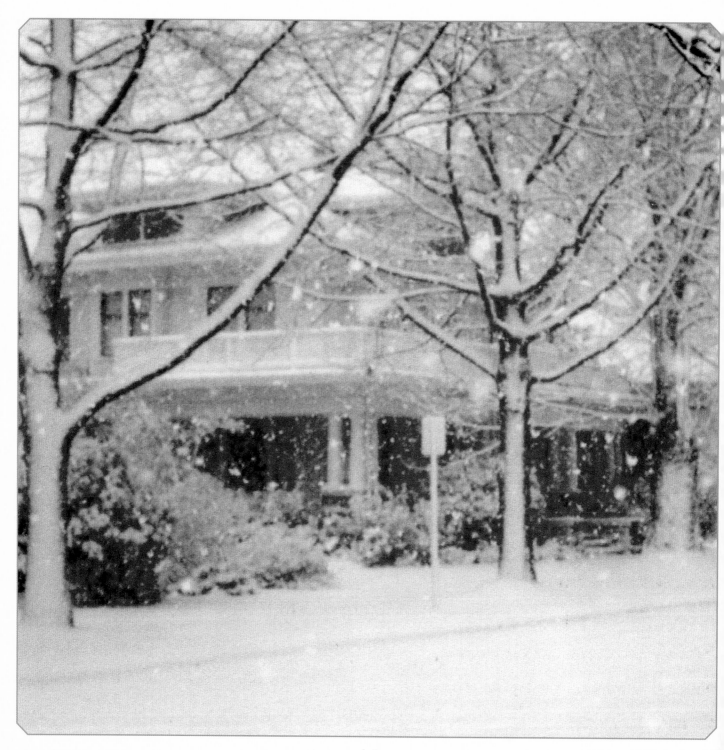

Along the banks of the Skookumchuck River in the verdant lowlands of southwestern Washington State where I grew up, the transition between autumn and winter is barely perceptible, only obvious to those who know the subtle signs. By October, pears and apples have mostly fallen from the trees and the blackberries of summer are beginning to mildew and wither on the vine. The luxurious golden light of Indian summer casts the entire landscape in a vintage postcard sepia tone as warm breezes rustle through the coppery leaves, lulling everyone into an idyllic dream. But one day the signs of change hasten and gentle breezes are replaced by a blustery wind that blows through the valley with just a hint of sharp chill, ushering in dipping nighttime temperatures and dank gray swaths of mist and fog – signaling the arrival of winter.

Holiday preparations started in this cusp of the winter season in my grandmother's kitchen, an expansive, utilitarian space of counters and cabinets, a crackling fireplace, a table in the window, and a built-in heart-pine desk that was stocked with stationery, recipes, colored paper, scissors and Elmer's glue. In this warm and cozy room, Christmas launched with craft and baking projects and continued in full swing. My grandparents' house was a sturdy circa 1900 era foursquare structure in Centralia, Washington, with leaded-glass windows, a wrap-around porch and second floor veranda. Built in the Italian Renaissance revival style, it was large but homey with a rose garden and greenhouse that my grandfather tended with dedication and pride. The kitchen was indeed the heart of the home – a bustling place of cooking and baking throughout the year, but especially during Christmas time. Here, my grandmother baked a vast array of Christmas cookies and confections, notable in both sheer quantity and variety. The annual repertoire included family recipes handed down for generations, specialty cookies from a Norwegian neighbor, and new ideas that my grandmother clipped out of magazines – an ever-evolving assortment of delectable sweet treats. My siblings and I were actively involved in this process, standing on step stools to help pour ingredients into the big mixer, monitoring progress, checking the timer, sampling a

My maternal grandparents' home in Centralia, Washington, was the site of our crafting and baking projects throughout the holiday season. Here, a blanket of winter snow envelopes the Italianate revival-style house and garden, creating a magical Christmas scene.

My grandfather hung the jolly ceramic Santa above the mantelpiece each year, which was always decorated with greenery and pine and cinnamon-scented candles. Here, my sisters and I pose for a picture in front of the fireplace as we eagerly await the arrival of the 'real' Santa Claus.

fresh-baked morsel just out of the oven, always accompanied by 'brown coffee' – a delicious mix of strong percolated black coffee with milk and sugar. After the cookies cooled, we stacked them into storage tins, carefully placing them in a giant walk-in freezer in the basement.

At the same time that the holiday baking extravaganza was underway, we started working on craft projects with my grandmother's guidance – Christmas decorations and hand-made gifts that we proudly presented to relatives on Christmas: ornaments with velvet ribbons and pearl trims, felt-lettered holiday garlands, and winter crafts made from pinecones, mossy branches and berries. It was a lovely process to create heartfelt beauty and holiday cheer, a lesson in the pleasure of the art of giving. In addition, the decorations we made – paper chains and Christmas ornaments covered in satin ribbons – were placed on the tree and became a part of the collection we used every year, interwoven in a colorful tapestry of decorations that created our family traditions.

My Granny Dowling was known for her style and entrepreneurial spirit and Dowling's Antiques; the European antiques business my grandparents started in the 1960s in Chehalis, Washington, was a source of many beautiful things.

By mid-December, the stash of frozen baked goods was brought upstairs, lined up along dozens of containers on the long kitchen countertop. In assembly line fashion, my grandmother created festive Christmas plates with cellophane wrapping, tied with colorful ribbons. These were given away – always to friends and neighbors, and, most notably, to those people who didn't have much, elderly shut-ins and the down and out – those who could use a special dose of holiday cheer most of all. She often took me on these delivery excursions around town – to see the bent lady with the old friendly cat, the elf-like man who wore a paper towel hat, and the sad hermit who lived in a very humble shack. When these people received their plate of holiday cookies, they were often overcome with emotion. It was a powerful lesson in compassion and thoughtfulness, the power of giving, the simple gift of kindness; an instructive example of generosity and remembrance at Christmas time. In those moments, my grandmother was a Christmas angel spreading the true meaning and joy of the holiday season.

This table setting at Ghequiere House in Old Town Alexandria reminds me of the elegant and colorful holiday table settings my grandmother created with her collection of china, silver and cut glass crystal. Our Christmas Eve dinner always involved an etiquette lesson from my Aunt Mary who managed to make this topic interesting with humorous cautionary tales.

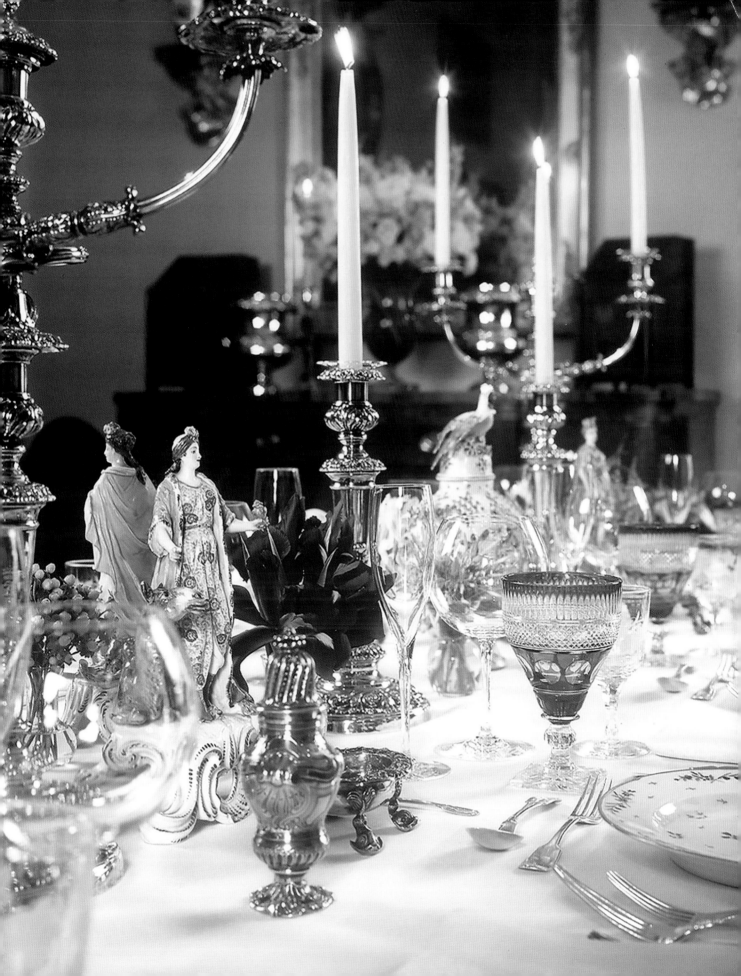

CHRISTMAS EVE. If my maternal grandmother's Christmas was a homespun, traditional affair, Granny Dowling specialized in making Christmas a grand celebration of flamboyant parties full of splendor, sparkle and panache. A native of Baton Rouge, Louisiana and a dancer by training, she had a unique flair for entertaining and decorating in high southern style. In the 1960s, my grandparents founded 'Dowling's Antiques' in Chehalis, Washington – a wholesale antiques business that specialized in European furniture and decorative arts, a highly incongruent but intriguing enterprise in the rustic and casual Pacific Northwest. Our custom was to spend Christmas Eve with this side of the family where we enjoyed a southern style feast of roast turkey, cornbread stuffing and homemade pecan pie, followed by the main attraction: a brief visit from a boisterous Santa who arrived with a large bag of gifts and left with a mysterious brown paper bag in hand. In my grandparents' exquisitely decorated Tudor-style house, the giant Christmas tree decorated with delicate twinkling lights took center stage, followed closely by the holiday table set with English china, French silver, and colorful Czech cut glass goblets, a collection of Granny's beautiful, favorite things. After dinner, we retreated to the large basement room, a cozy, wood-paneled space that resembled an old English library – complete with chintz-covered wing chairs, book-lined walls, and an antique oak bar with a brass railing. Here, we gathered around another tree that glimmered with antique glass ornaments and lights in pastel hues. What I remember most from these annual Christmas Eve fetes were the beautifully wrapped gifts from my grandmother's sister, Aunt Mary Moffett, a professor of art and interior design at Louisiana Tech. These packages enveloped in exquisitely patterned papers and intricate ribbon wraps – loops and accessories – pears, pinecones, or poinsettias – featured personalized gift tags in her inimitable elegant script. They were incredible works of art. The colors were striking: burgundy and chartreuse green, turquoise with plum, emerald green embossed paper with gold ribbon wrap. But it was the idea of the package itself – the thought and care that went into designing beautiful presentations – that created such inspirational and magical pieces of holiday art. While I don't recall the presents inside, I've always remembered this lesson of beauty and detail – a simple gift that transcends time and place; a celebration of the art of presentation and display.

CHRISTMAS DAY. Meanwhile, back in Centralia, the final preparations were underway for Christmas Day. On Christmas Eve, my grandfather ventured into the woods or a local tree farm to procure a large and elegant noble fir tree, which he carefully positioned in a corner of the library, a light-filled room on the first floor. In the German tradition, my grandparents' tree went up on Christmas Eve and was revealed on Christmas Day. Boxes of decorations were brought down from the attic, including the vintage ceramic Santa that my grandfather hung above the fireplace. The tree was decorated with large, old-fashioned colored lights, a mish-mash of special ornaments with sentimental meaning and hand-made pieces – a tree full of personality, personal mementos and familiar favorites that we took delight in seeing year after year. A life-sized wooden Santa and reindeer sleigh were perched on the second story veranda, the reindeer leaping in flight. Intricate paper snowflakes, made by generations of children, went on the windows. Giant candles in shades of red and green sat on the mantel amidst a flowing mass of spun glass 'angel hair'. A lighted Christmas village and nativity scene occupied the entire front bay window. For the relatives who helped decorate the house and anyone else who happened to stop by on Christmas Eve, my grandmother made a big pot of homemade clam chowder that simmered on the stove throughout the evening. To this day, my grandmother's signature clam chowder is a family favorite that we make every year, conjuring memories of clam digs on Puget Sound, gatherings around the roaring kitchen fire, and the excitement of Christmas Eve preparations. The

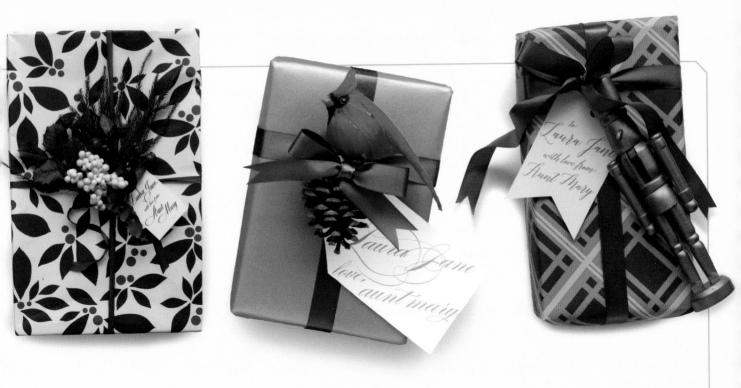

finishing touch was a plate of cookies and carrots carefully laid out by the fireplace for Santa and his reindeer to enjoy.

On Christmas morning, we arrived early to line up outside of the library that my grandfather closed off with the big oak pocket doors to prevent anyone from getting a sneak peek. A big pot of coffee percolated on the stove and we all helped ourselves to fresh cinnamon rolls and mandarin oranges. The youngest children were first in line, everyone else lined up according to age. The anticipation was barely containable. My grandfather presided over the festive scene, and when the suspense became almost unbearable, he pulled open the doors, greeting everyone with a jovial 'Merry Christmas' as we were drawn to the beautiful sight of the majestic noble fir covered in old-fashioned colored lights and gaily wrapped presents spilling out into the room. After all the gifts were opened, my grandmother turned her attention to preparations for the Christmas dinner – a spectacular feast of roast turkey and all of the trimmings, mashed potatoes and gravy, a green bean casserole, cranberry sauce, including both home-made pumpkin and pecan pies for dessert. We helped her set the big dining room table as well as created a centerpiece composed of colorful antique ornaments presented in a cut crystal bowl. My grandmother liked how the candlelight reflected the colors and sparkled on the table. We pulled the family china from the cabinet, brought out the silver from the sideboard, and retrieved the carefully folded and pressed linen napkins from the linen drawer. She believed that all of the decorations should reflect the winter season, so we incorporated holly and berries from the garden in the centerpiece displays. Sometimes there would be large Christmas poinsettias in the light-filled window bay of the dining room. Up to 40 relatives from near and far would attend the feast, a festive and memorable end to a wonderful Christmas Day.

REFLECTIONS. My understanding of the Christmas season is rooted in the lessons I learned in childhood that were passed down through generations, forming an indelible template of an idyllic Christmas dream: the simple joys of surrounding ourselves with loved ones and beautiful mementos, renewing acquaintance with beloved traditions, and reaching out to others in a spirit of kindness and good will. Reflections on the past and expressions of hope for the future – these are the true blessings and universal gifts of Christmas. This early inspiration became the framework for my approach to planning a magical White House Christmas.

Aunt Mary always designed beautiful holiday gift wraps and hand-lettered tags, like the ones shown here, that were inspiring in their artistry and use of color and materials.

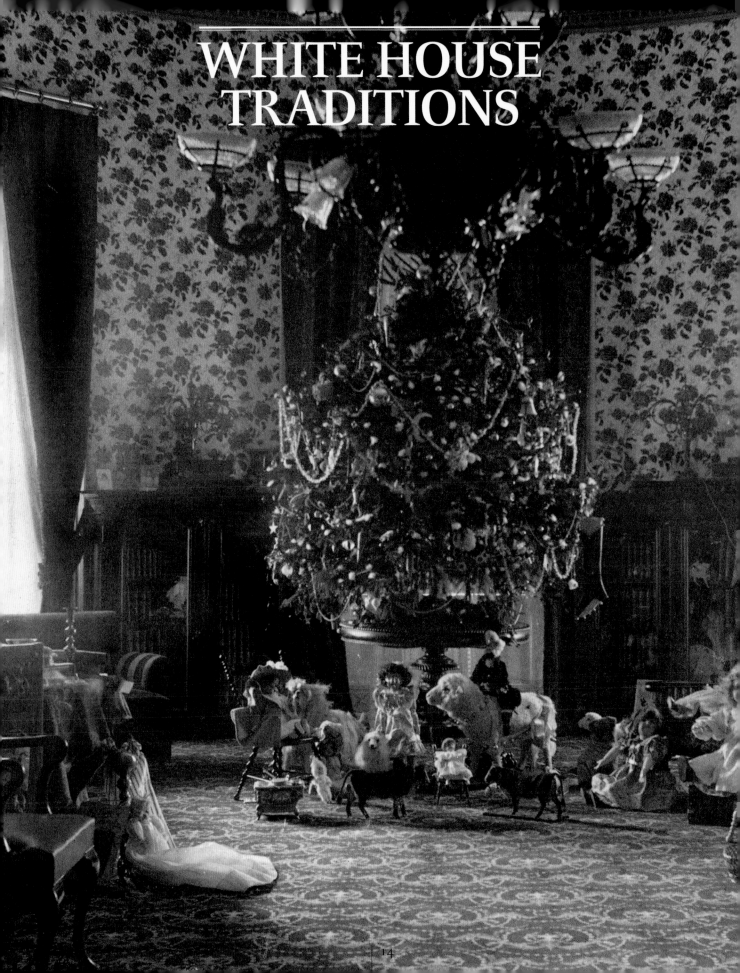

WHITE HOUSE
TRADITIONS

The White House is an iconic symbol of American strength, unity and possibility – a powerful backdrop for supporting American ideals and commemorating key milestones and events. All Presidents understand there is a great opportunity to use the symbolism of White House events and traditions to create an image, underscore policy priorities and leave a lasting impact on American history. Policies and programs take time to implement, but skillfully crafted events and strategic use of White House symbolism resonate with all Americans, allowing Presidents to connect and communicate directly with the American people. At no other time during the year is this symbolism more important than at Christmas, when American tradition, patriotism, and pageantry are on full display.

During the holidays, Presidents take on the role of providing hope and inspiration to all citizens, often during difficult and challenging times. At Christmas, Presidents can leave behind partisan bickering and political score-settling, and divorce themselves from the angry rhetoric that polarizes Washington and the nation. Christmas provides an opportunity for them to rise above the fray to address universal themes of peace, hope, unity and prosperity. It is a time to honor those who protect our liberty, celebrate common ideals, and urge all Americans to reach out to others in a spirit of kindness and cooperation.

PRESIDENTIAL CHRISTMAS SPEECHES.

A longstanding White House tradition is the annual presidential Christmas speech to the nation. These speeches are inspirational and patriotic. If you listen closely to their words, you hear the personal, often profound reflections and see unvarnished glimpses into their core beliefs. All Presidents recognize the balance of the celebration and joy of Christmas with the more somber obligation of silent reflection, delivering a message of hope and redemption tempered with the recognition that many Americans are suffering and many soldiers are far away from home and in harm's way. Many pause to reflect on the need for gratitude of the many blessings Americans enjoy and the duty to reach out to others less fortunate. Their Christmas messages acknowledge our proud history that has stood the test of time.

Beautifully decorated trees are a longstanding holiday tradition at the White House, enlivening both the public and private spaces with Christmas cheer. Here in the second floor Oval Room in 1894, the tree shined brightly with red, white and blue lights – the first time electric Christmas lights were used at the White House.

PRESIDENT ROOSEVELT'S FIRESIDE MESSAGE.

Perhaps the most riveting presidential speech at Christmas was President Franklin Roosevelt's fireside chat on Christmas Eve, December 24, 1944. There, in front of the roaring fire in the Diplomatic Reception Room the president delivered a speech for the ages as families across America gathered around the radio to hear his broadcast. Against a backdrop of the nation at war, Roosevelt began by saying 'It is not easy to say 'Merry Christmas' to you my fellow Americans, in this time of destructive war, nor can I say 'Merry Christmas' lightly tonight to our armed forces at their battle stations all over the world – or to our allies who fight by their side', his voice heavy with the burden of being commander-in-chief. He went on to acknowledge that even though Americans would be celebrating Christmas as usual because of abiding deep spiritual connections and a need to offer hope and continuity to children, there would be deep anxiety about the war and the people serving far from home. He knew that they were risking their lives to protect our liberty and even larger threats to mankind. He spoke eloquently about how the Christmas spirit lives fiercely in these individuals who remain in Americans' thoughts and prayers. He described the fear and anxiety that Americans feel in the face of impending evil and darkness and the challenges that lie ahead. But he used the message of Christmas to communicate an unwavering sense of our collective commitment and determination to conquer the forces of evil to achieve a new state of peace and freedom on earth in the spirit of Christmas. The president knew that it was important to steel the resolve of the American people to the continuing war, to acknowledge their sacrifices and to thank them. Not all speeches are as iconic as Roosevelt's Christmas message, but they are all notable for their inspirational words and heartfelt delivery.

CONCLUSION.

Presidential Christmas speeches – past and present – create the foundation and tone for creating inspirational White House Christmas displays. Through times of triumph and struggle, glory and defeat, a president's words serve as a reminder that American grit – and the spirit of Christmas – are gifts that continue to inspire us, providing a sense of hopefulness and optimism in turbulent times in a complex world. It's a message that resonates – and is perhaps more relevant – now more than ever before.

DECORATING
THE WHITE HOUSE

WHITE HOUSE CHRISTMAS THEMES

If Presidents focus on the challenge and responsibility of communicating a Christmas message that will resonate with all Americans, then First Ladies have traditionally taken on the role of translating Christmas messages into inspiring decorative themes. The tradition of First Ladies' choosing décor for the White House Christmas started in 1961 when First Lady Jacqueline Kennedy selected the 'Nutcracker Suite' (to commemorate the well-known Tchaikovsky ballet) for the White House Christmas tree that she repositioned in the Blue Room from its original East Room location. From a design point of view, it was a brilliant idea. Moving the tree made it the centerpiece of the White House Christmas décor. And ascribing a theme to the tree helped to tell a story and draw the viewer in, creating a charming, cohesive narrative. It provided a framework for everyday Americans to participate and relate to the First Family. The First Lady's theme made a statement that was personal and meaningful; it was both fully representative of her elegant taste and articulated a uniquely American sense of style. Jackie Kennedy's move opened up the door for every First Lady to put her own creative and personal stamp on the iconic White House Christmas.

The challenge of choosing an appropriate theme is more difficult than it sounds. It's always important to settle on the right message, establish a unifying tone, and avoid controversial issues that can cause distractions or be construed as negative in any way. It's possible that each First Lady feels some pressure when choosing a theme since it will be discussed, analyzed and documented in historical record books ad infinitum. Although reporters mostly give First Ladies a pass on holiday themes, foregoing harsh criticism, it's clear that some themes resonate more than others, and some can fall flat. So in brainstorming ideas, we focused on themes that were both inspirational and practical, developing concepts that both capture a sense of the American spirit and translate into ideas that resonate broadly – and can be turned into beautiful décor that tells a cohesive story room by room. The best themes always coordinate well with the classical White House architecture and furnishings, are cognizant of White House traditions, and take into account the context of the current political and cultural environments.

As the centerpiece of the White House Christmas, the Blue Room tree often features its own theme. In 2012, the Blue Room tree honored the nation's military families with a theme inspired by the First Lady's initiative 'Joining Forces'.

In addition to all of these considerations, we wanted to include décor ideas that people could replicate at home, open up new volunteer opportunities for citizen participation, and repurpose materials from previous White House Christmas installations in new and exciting ways. Of course, a key consideration is that the theme needs to capture and embody the spirit of the First Lady and support and carry out her vision for the holidays. The starting point is inspiration. To spark creative thinking and ideas, I walked through the White House tour route to see the space in a fresh way. The White House is an endless source of decorative inspiration with its priceless collection of paintings, furnishings and decorative arts. The architectural features, including patterns and details - the oak leaf and rose garland swag above the North Portico door, carved rosettes in the Grand Foyer, vaulted ceilings in the Lower Cross Hall, fluted sandstone columns in the East Entrance and imposing columns in the Grand Foyer - provided ideas for many of our designs. We made notes about color, design, proportion, mood, placement, themes, concepts, etc. for every room.

To understand the history and context of the White House Christmas, we read accounts and descriptions of how previous First Ladies decorated the White House for Christmas and the various themes they selected over time. It turns out that there are some common threads. Jackie Kennedy's Nutcracker theme has been a popular choice repeated by other First Ladies over the years. Another common Christmas theme emphasizes American historical traditions, including early colonial style and American folk art. Many First Ladies feature their pets in White House holiday décor - always a popular touch. I observed that the use of natural elements and the bounty of nature, including hand-crafted details, led to some of the most beautiful and memorable Christmas displays. In the final analysis, there is always a focus on storytelling – each First Lady crafts a narrative with an inspirational theme, beautiful décor, and an inclusive approach, inviting citizens from all walks of life to participate in creating an inspiring White House Christmas. All of these ideas and influences became the basis for my overall design plan and holiday proposals.

PARIS INSPIRATION. Once I had an understanding of each space and the history and context of White House Christmas design – themes, architectural details, proportion, colors, etc., the next step involved layering on new concepts, color combinations and creative ideas to enhance the presentation and overall design. Paris always factored into our annual holiday planning. Ever since I started travelling to Paris to study flower design in 2000,

Early in the New Year, we began developing concepts, color palettes and design motifs for discussion and presentation to the First Lady. This photo depicts the fuchsia, gold, eggplant and rose colors we used for the East Room design in 2011 to create an elegant, vintage-inspired theme.

I've looked to Parisian art, architecture, fashion and gardens for inspiring ideas that translate into special holiday décor. The annual gift fair in Paris at Maison Objet is the ultimate place to see design trends, colors, flowers, and ornaments on display in an impressive five-day exposition. One year, I was captivated by the fanciful display in the window of Hermès, which featured macaroon topiaries, jeweled animals and pastel colors in a riveting display of artistic mastery. I immediately saw how these concepts could translate into a secret garden and fairy tale scene in the children's area at the White House. I also remember the time I stumbled upon a macaroon shop near the Place Vendôme. The walls were in a textured plaster pattern that gave the impression of being inside an elaborately decorated wedding cake – a magical experience! I wanted to duplicate that feeling in our holiday décor.

PLANNING AND PREPARATION. Planning the White House Christmas is an intense, year-round proposition. The scale and scope of the project are so big that it requires a rigorous and diligent schedule of timelines and milestones to manage the tasks efficiently and effectively throughout the year. In addition to all of the other White House events on the schedule, Christmas looms as the most iconic and complex event that the White House organizes each year; it was always on our minds. A key step involved representing our ideas in notebooks and sketches in an organized way. My architect friend was my right hand person for creating beautifully rendered sketches and drawings that depicted color palettes, design elements, motifs, and specific details for each space and room. Other friends created the digital design boards that displayed and communicated these ideas. We created prototypes and room by room design boards that were designed to depict how the decorated rooms would look when they were decked out with holiday finery.

THE PRESENTATION. All of this work culminated in our presentation to the First Lady, which was typically scheduled in June or July. We transformed her office (or the Diplomatic Reception Room) with a full complement of colorful holiday displays, including small tables that represented each room, color palette and design motif. After a formal presentation of concepts and details, the meeting usually took on a more casual tone. At the conclusion of the 'Simple Gifts' presentation, for example, we continued an informal discussion about the goals of that year's White House Christmas displays. The decorations should be relatable, the First Lady said, and represent each member of the Obama family: the president, the children, the grandmother and even the First Family dog, Bo. As the chefs brought in Christmas cookies to sample and the butlers served a sparkling cranberry drink, we chatted about the upcoming holiday season in a colorful and relaxed atmosphere. Eventually, additional members of the staff came in to join us, toasting the newly selected theme with a glass of champagne, launching a perfect kick-off to the holiday season.

CREATING PROJECTS. Once the First Lady confirmed the theme, we quickly moved into the implementation phase. This involved developing individual project plans, timelines, budgets, and creating a detailed spreadsheet for each of the 65+ individual volunteer projects we worked on each year. Projects included poinsettias made from recycled ribbon, column covers in the East Entrance, the East Colonnade archway, detailed floral containers, the oak leaf rosette

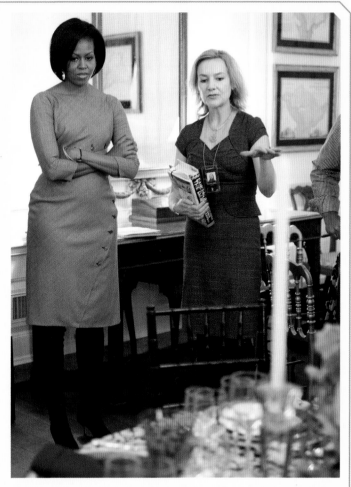

During the holiday entertaining season, table settings often included seasonal displays of red and fuchsia flowers such as roses, amaryllises, gloriosa lilies, etc. For the presentation to the First Lady, we created holiday-themed options for review. Mrs. Obama typically gravitated towards bold and colorful designs like the one pictured here.

column covers, the Bo and Sunny topiary designs, recycled paper trees, custom ribbon trim for trees and vases and a wide variety of other initiatives. Our work began over the summer with the assembly of volunteer teams, the gathering of materials (including many recycled items from the White House collection), and continued in full swing until the installation began the day after Thanksgiving. The process involved a strategic use of time and resources. We broke large projects down into component parts so that we could work on individual elements over the period of several months, integrating Christmas project work into our everyday routines. Colleagues in the East and West Wings often joined me in the flower shop to work on holiday designs. The holiday craft work was a joyful enterprise – a way to include large groups of people from across the country in the process of creating a beautiful White House Christmas.

THE VOLUNTEERS

Each year, 100 volunteers from across the country forego Thanksgiving with their families for the opportunity to travel to Washington to join in the annual White House decorating project. Most have gone through a competitive selection process, sending passionate, compelling – and even heart-wrenching letters to me and a variety of White House officials. Some persistent volunteers apply year after year with the hope of being selected, undeterred by a growing pile of rejection letters, often making the cut through sheer willpower and perseverance. With hundreds of people applying each year, only a relatively small number can become 'official' White House holiday decorators for the 5 days after Thanksgiving. Although there was always a seemingly endless supply of talented and enthusiastic volunteer support – and so much work to do to achieve our creative vision -- only a few people were actually ever lucky enough to be chosen via this official volunteer channel. I saw an opportunity to boost the holiday decorating process – not only to include more people – but to expand our ability to create more detailed and intricate hand-made projects as well, increasing participation and overall capacity. If we made the flower shop more open and accessible to volunteers from across the country – people who wanted to work on holiday projects and contribute their time and talents – we could highlight the White House as open and accessible and create innovative and inspiring holiday décor. That's how the White House Christmas became a year-round activity, divided into three main phases: design and development, creation and implementation, and project installation.

Volunteers are the magic behind the White House Christmas and they took on an even greater role during my tenure, working with me on Christmas projects throughout the year. Early in the New Year, volunteer designers and architects joined me in the flower shop to help brainstorm and sketch ideas for various White House spaces. Their task was to create a supply of drawings that represented each White House interior and exterior space. During the winter months, we developed new ideas – trees and topiaries, wreaths and garlands, motifs and details, using colored pencils to illustrate a range of color possibilities and experimenting with new techniques and materials. We collected these drawings in notebooks that became a reference guide we used throughout the year. By spring, these sketches, architectural renderings and design ideas became fully developed room-by-room concepts, featuring color palettes, specific elements and narrative themes. Volunteers created prototypes and mock-ups of key designs as well as digital inspiration boards, helping me prepare themes and presentations for the First Lady to review. After the overall theme, room-by-room subthemes, ideas and designs were selected and approved, my volunteer teams launched into action.

Among the inspiring and innovative designs we created with volunteers over the years are a ribbon and pipe cleaner archway featuring thousands of pieces of pipe cleaner arranged in a complex latticework motif; the illusion cube column covers made from tens of thousands of berries, folded leaves and individual gold leaf pine cone scales; the doorway frame made of 1,000 gilded oak leaf rosettes; the Red Room sugar-flower vases; oversized wreaths made out of lacquered fruits and vegetables; and the ever-popular replicas of the Presidential dogs Bo and Sunny made out of 40,000 pipe cleaners, miles of looped ribbon, pompoms, licorice and marshmallows, buttons, and even trash bags. All of these projects required detailed plans, budgets and timelines to determine important milestones and calculate the amount of time (volunteer work hours) and resources that each project required.

We made small patterns of motifs – tracking the amount of time required and then multiplying it according to the size of the piece. Each project had its own detailed plan that rolled up into the overall holiday planning process. In any given year, we took ambitious and detailed holiday projects – column covers, hand-made vases, ribbon work details, and custom wreath designs – that we worked on well before the installation period commenced. A highly structured and organized process was key to finishing these projects that eventually merged with the holiday installation process and timeline in late November.

My holiday design process always involved creating patterns and motifs out of simple materials including leaves, berries, pinecones, cinnamon sticks, pipe cleaners and ribbons that volunteers fashioned into column covers, door surrounds, and flower vessels. These geometric designs provided an elegant backdrop to the Christmas decorations.

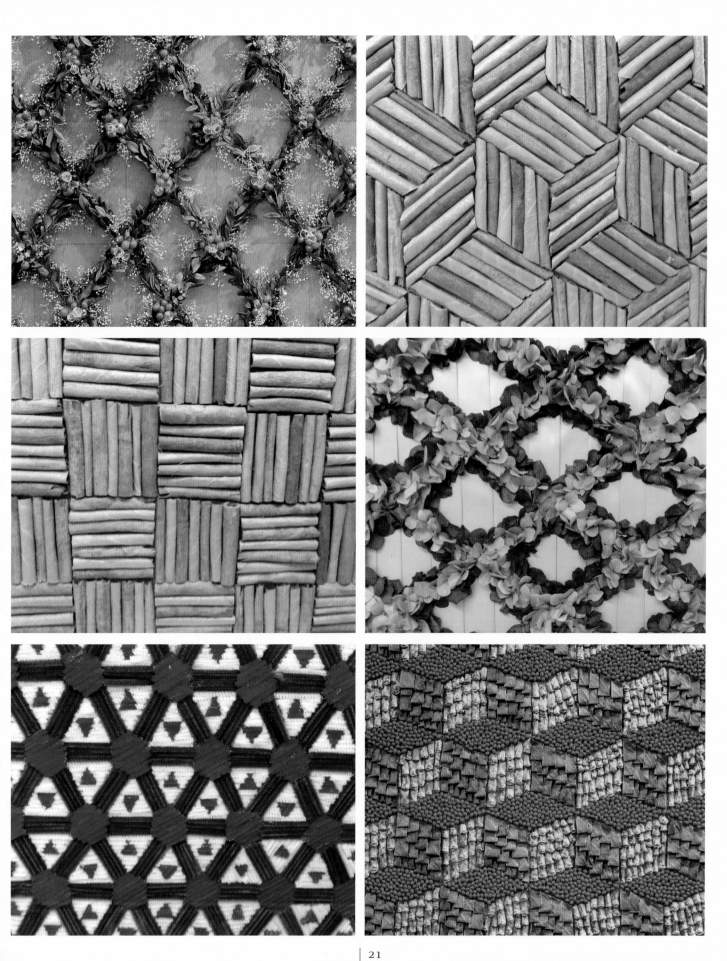

Christmas at the White House comes together over a 5-day period beginning the day after Thanksgiving, starting with two days of preparations – both at the White House and at the warehouse – before the decorating volunteers arrive on day 3 at the White House to hang the thousands of ornaments, fluff miles of ribbon, and install all of the other decorations. The decorating continues over the next couple of days, culminating with a comprehensive clean-up before a final walk-through to ensure that everything is perfect. Then the White House is opened to the public.

The White House is a study in contrasts during the Thanksgiving weekend. While most Americans are enjoying a leisurely day off of leftovers, lounging around and viewing back-to-back endless college football games, the Friday after Thanksgiving at the White House ranks as one of the busiest days of the year. Appearing placid and serene from the outside, inside the White House things are flying, moving in perpetual kinetic motion – it is the day that dozens of trees (including the massive Blue Room tree) are put up, strung with lights, and allowed to settle in place. The scent of fresh evergreen on the State and Ground Floors is overwhelming, permeating the entire White House, even wafting up to the private residence. The day starts early for everyone on the Friday after Thanksgiving, well before dawn, with the arrival of 100 decorating volunteers to a check-in point near the White House grounds. On Pennsylvania Avenue in front of the White House, waiting buses are lined up, their engines idling as each volunteer checks in, signs a non-disclosure form and boards the bus that will drive in a circuitous (and always-changing route) to the undisclosed location of the White House warehouse. After a greeting and welcoming of the volunteers and a quick wave goodbye, they are sent on their way for a full day of work. This first day of White House holiday decorating involves a strategy of dividing and conquering. I typically remained at the flower shop where I could oversee ongoing projects and preparations while other White House staff joined the volunteers and Park Service staff at the warehouse to focus on final preparations, including organizing all of the boxes of decorations for delivery room by room.

At the warehouse, a vast, chilly space that is a giant repository of White House ephemera and history, the volunteers divide into project teams and begin work on a variety of décor projects and organizational tasks. Over the next two days, their goal is to finish up any last minute projects -- hand-made ornaments, painting and gilding, garland-making, etc., while packing and organizing tens of thousands of individual ornaments into hundreds of boxes that will be labeled and delivered to every room at the White House. Some volunteers huddle in the aisles that are set up with tables and craft stations while additional workers begin the arduous process of loading boxes of decorations onto trucks stationed at the loading dock. The place has the appearance of a giant Santa's workshop with an army of elves racing against the clock.

Meanwhile, behind the scenes in the flower shop on Days 1 and 2 of the holiday installation, the work continues as a hub of the creative and administrative endeavor of the White House Christmas, involving multi-tasking on every front. Dozens of additional volunteers, divided into multiple teams worked on special projects – including the detailed column covers, special organic vases, floral decorations, custom ribbon designs, finalizing the designs for installation. The volunteers worked diligently to finish the large-scale architectural pieces that are usually installed before the official volunteers arrive after their 2-day warehouse stint. Other volunteers assisted with the preparation of floral embellishments that will be featured in each room. My administrative tasks included budgeting and planning, creating work plans and project plans, and gearing up for the crushing back-to-back party season that commences the day the White House Christmas opens to the public and continues until Christmas. It was a period of sustained intensity that involved developing plans for china, linen, flowers and staffing for each event. In addition, even before the holiday season officially started, we were already thinking about the 'tear-down' of Christmas, an equally involved logistical process – requiring a fresh set of timelines, plans and 75 additional volunteers.

During the holiday installation, volunteers divided up into teams to work in each space on the State and Ground Floors and throughout the White House complex. The Cross Hall is always one of the key focal point spaces of the White House Christmas. For this installation in 2010, a team decorated the Cross Hall with velvet poinsettia garlands, crystal-wrapped birch branches and four large Christmas trees as part of the 'Simple Gifts' theme.

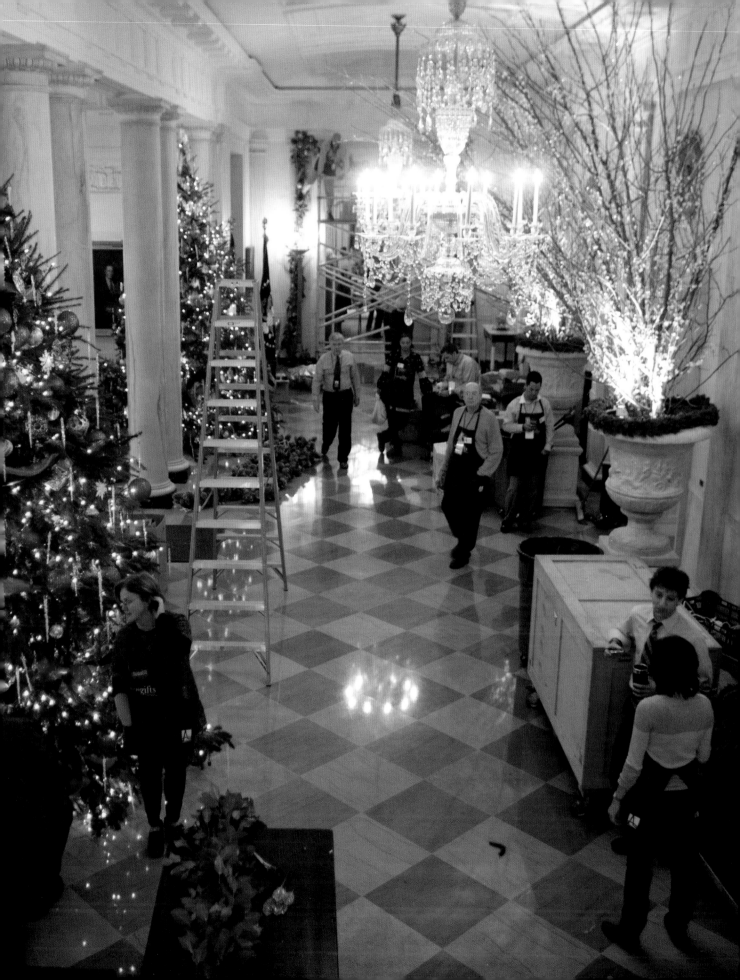

AT THE WHITE HOUSE. On the 3rd day of the holiday installation occurring over the long Thanksgiving weekend, the volunteers finally arrive at the White House around 7 a.m., lining up in the East Entrance, giddy with excitement. Here, they receive a warm welcome, an outline of the agenda of the day, and a quick briefing on rules and guidelines for working in the White House. Volunteers are divided into teams, assigned to specific rooms, and led by a team leader (usually someone with decorating and previous White House experience) who has been briefed on the overall vision and specific design elements in the room. Their first job is to offload the hundreds of boxes of decorations that are beginning to arrive at the North Portico entrance and to move designated boxes to specific rooms. The first day at the White House is consumed with unpacking boxes, getting organized and putting an action plan in place. There are a lot of moving parts and there is a definite feeling of organized chaos. The decorating work continues throughout the day finishing around 4 p.m. After the volunteers leave and the White House is quiet, there is time to take stock of the progress and make notes about what needs to be done in the next two days before the press preview.

Volunteers arrive back at the White House early the next day to continue their work. Day 4 is a key day for implementing the overall design. Volunteers work another full day in their assigned spaces and then are re-assigned as the smaller rooms and list of decorating projects are completed. By the end of the day, the outline of the design becomes apparent and the overall holiday look is taking shape. Day 5 is the day to complete all of the decorations, add the floral touches and begin the clean-up process, which involves sending empty boxes and un-used ornaments back to the warehouse, removing debris and materials (e.g., tarps, ladders, tools, tables, glitter, etc.).

THE REVIEW PROCESS. After all of the decorations went up, the housekeepers descended on the premises for a final buffing and clean-up. Meanwhile, the ushers cleared the State and Ground Floors of staff and volunteers for a walk-through and review of the décor. This high-level review involved a changing cast of characters that could potentially always include the First Lady. Many of the reviewers, especially from the West Wing, were not involved in the planning process leading up to the installation. For them, it was the first time they saw the décor and its component elements. They often looked at décor from a political point of view – was it too

ostentatious? Was the message on point with administration themes? For example, decorations made of candy ran counterpoint to the First Lady's initiative of healthy eating and exercise. These were all issues that were discussed. For the most part, the annual holiday décor passed muster with only a few tweaks or minor changes. But occasionally, there were some dramatic reversals that served as cautionary tales.

One year, the Social Office commissioned a guest designer (whose memorable business card shows him astride a white horse wearing a burgundy velvet and satin smoking jacket and flashing a wide grin) as the team leader in the East Room. They liked his personal story of being an immigrant from South America who went on to achieve the American Dream. He had served as a White House volunteer the year before and was thrilled to come back with this prestigious guest designer responsibility. Months before the actual installation, I remember seeing him at the warehouse as he was selecting materials and elements from the White House collection that would go in his East Room scheme. I asked him about his design and overall strategy for the space. 'It's a big surprise,' he said, smiling broadly, holding his index finger to his lips. 'Shhhh, it's a top secret'. That sounded like a potential red flag since every design element, whether it's a small detail or a grand room design, benefits from discussion and evaluation by all parties in advance. At the White House, secrets are generally never a good idea. Nonetheless, the Social Office expressed confidence in him and his talents. The next time I saw him, right before the installation, he was still mysterious about his East Room plans but he gave me a hint of what was about to come, describing layers of glitz, gold and glitter. I could almost visualize a white horse gliding by as part of the design.

As the installation commenced, the decorator's East Room design started to take shape. Layer upon layer of shiny gold balls, accented with glitter stars and sparkling clear glass ornaments were piled onto the trees, completely covering the evergreen base below. Additional decor, including wide gold fishing nets and gilded starfish, went on top of the trees, ensnaring them in a tangle of deep sea metaphors. Dramatic swoops of garland, heavily laden with dense sprays of gilded gold leaves, cut gleaming swaths across the room. The room took on a distinctive golden hue. A buzz started as people began to take notice. Around 9 p.m. on Day 3 of the installation, long after the volunteers had departed for the day, I saw a grim-faced East Wing official stride

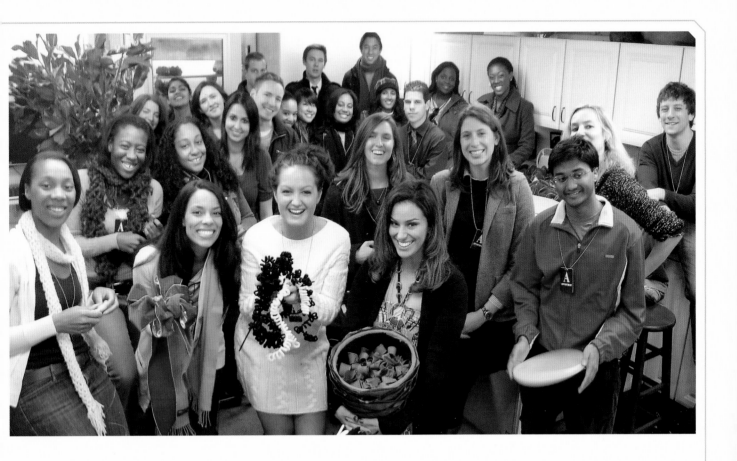

into the East Room to survey the gilded scene and signal her displeasure with two thumbs down. By the next morning, a complete reversal of the décor was in progress and nearly complete. The golden decorations were replaced with traditional burgundy red ornaments; the underwater trees had re-surfaced sans their fishnet cage. The East Room appeared elegant and festive once again, and everyone breathed a sigh of relief. As for the decorator? To his credit, he seemed to shrug off the drama, appearing on Spanish language television shortly after the installation to tout his major holiday decorating role at 'La Casa Blanca,' perhaps with a slight bit of embellishment, still smiling broadly in his burgundy velvet smoking jacket.

SOCIAL MEDIA was another potential pitfall we navigated and there were many lessons learned over the years. Volunteering at the White House used to be a somewhat mysterious, hush-hush, behind-the-scenes venture. No one knew how volunteers were selected; volunteers were content to toil behind the scenes. The only glimpse of the volunteer crew was the annual HGTV White House Christmas special when one could catch furtive glances of them happily decorating trees and hanging garlands. That all changed dramatically in recent years. With the use of cell phones with cameras exploding in popularity, the desire to live publicly (and the incentives and social media platforms that fuel this desire) transformed the volunteer experience. Instead of quietly enjoying the experience as a once in a lifetime opportunity, living in the moment and counting on pleasant memories to commemorate the experience, some volunteers saw the White House decorating experience as a tantalizing marketing opportunity. For them, every moment spent on a ladder, tying ribbons, or tweaking a garland was a chance to promote and amplify their experience on an expansive world stage. And, in a way, who could blame them? It was indeed an exciting experience and they believed they had a right to share it with friends and family, if not the entire internet world.

My volunteer team expanded exponentially during the holiday season with teams working around the clock to complete a variety of craft projects. This image of the White House flower shop in 2010, chock-full of enthusiastic volunteers, shows them proudly displaying their handiwork and festive Christmas spirit.

The problems occurred when professional decorators and event planners crossed the line, hiring publicists and commissioning professional photo shoots at the White House – and, in one case, even turning the state floor into a pop up shop, selling a White House-themed book to a captive audience of fellow holiday volunteers. In the social media age, the challenge of balancing legitimate excitement vs. blatant self-promotion was a question that we tackled, and not always with clear answers. Eventually, volunteers were asked to sign non-disclosure forms in which they agreed not to reveal information or photos about the décor and theme until the First Lady announced them to the press. In the end, it came down to a judgment call; volunteers who erred on the side of restraint and decorum, and did not actively seek to promote and publicize their White House work, always remained in good stead with White House officials and were invited back year after year. These were the people I sought to work with me: the ones who had a singular goal of working together to achieve the common goal of making the White House a beautiful and inspirational holiday home.

CONCLUSION. The volunteers who worked with me in the flower shop represented so much more than helping hands or a means to achieve our project and décor goals. They were an integral part of the White House holiday story and the engine that allowed us to contemplate impossibly ambitious design goals. I was lucky to work with such talented designers at all levels of experience and from all walks of life who joined me in a mission to create beauty and inspiration that resonated with all Americans. Throughout the year and especially during the holiday season, they pushed themselves beyond limits to achieve our goals and carry out the First Lady's vision. Most importantly, they believed in the power and symbolism of beloved White House traditions to communicate the spirit and essence of American style and ideals. I am proud to have worked side by side with them over the years, grateful for their contributions and honored to call them my friends.

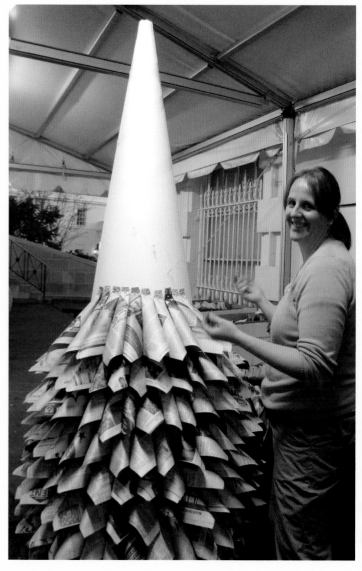

The gilded cone tree in the Green Room was made from hundreds of folded and recycled newspapers that were spray painted gold and glittered. Here, a talented volunteer is shown meticulously measuring and pinning the individual cones onto the Styrofoam base, working outside the Flower Shop in the East Entrance area.

Because of the tall ceilings and expansive proportions of the White House, many volunteers often found themselves high up on ladders or scaffolding in connection with their decorating duty. This photo shows a volunteer decorating the doorway of the Oval Office in 2014, a job that required extra security clearance and enhanced vetting of volunteers.

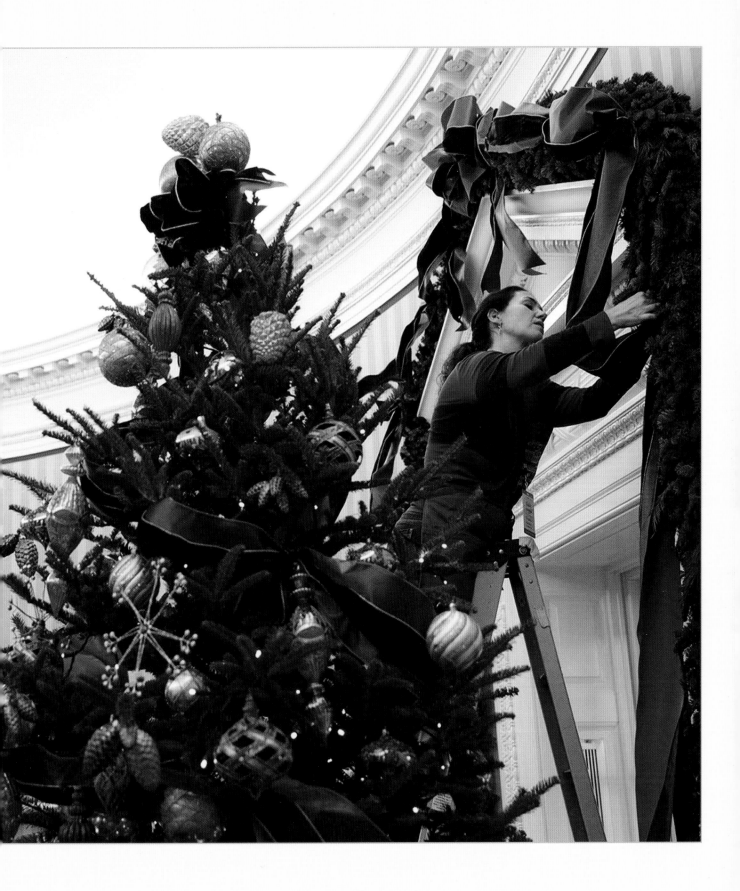

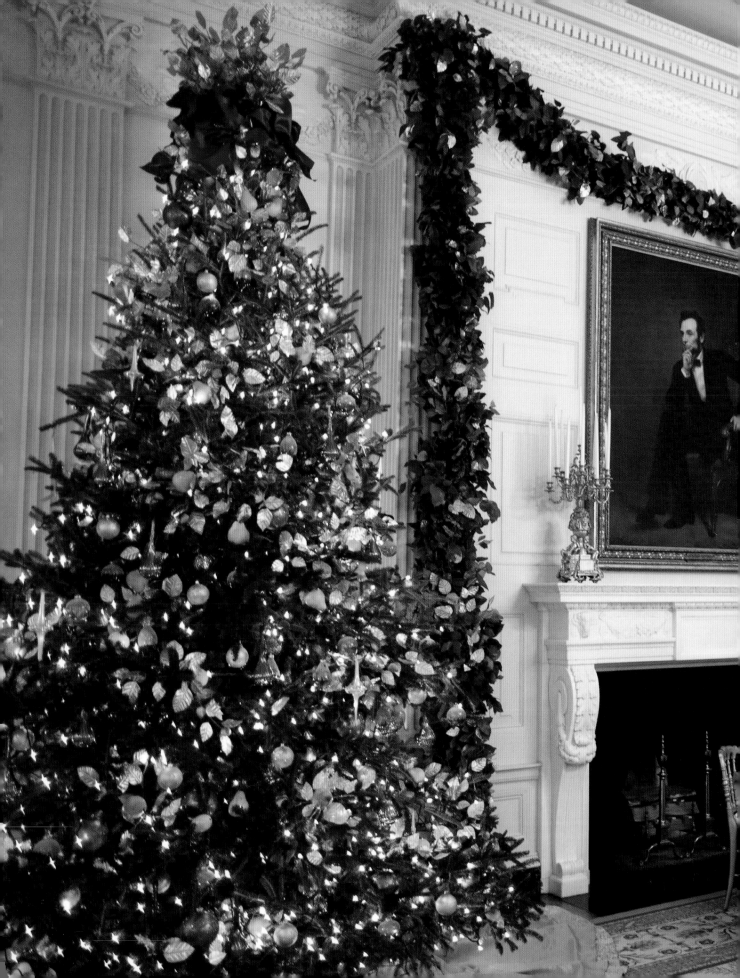

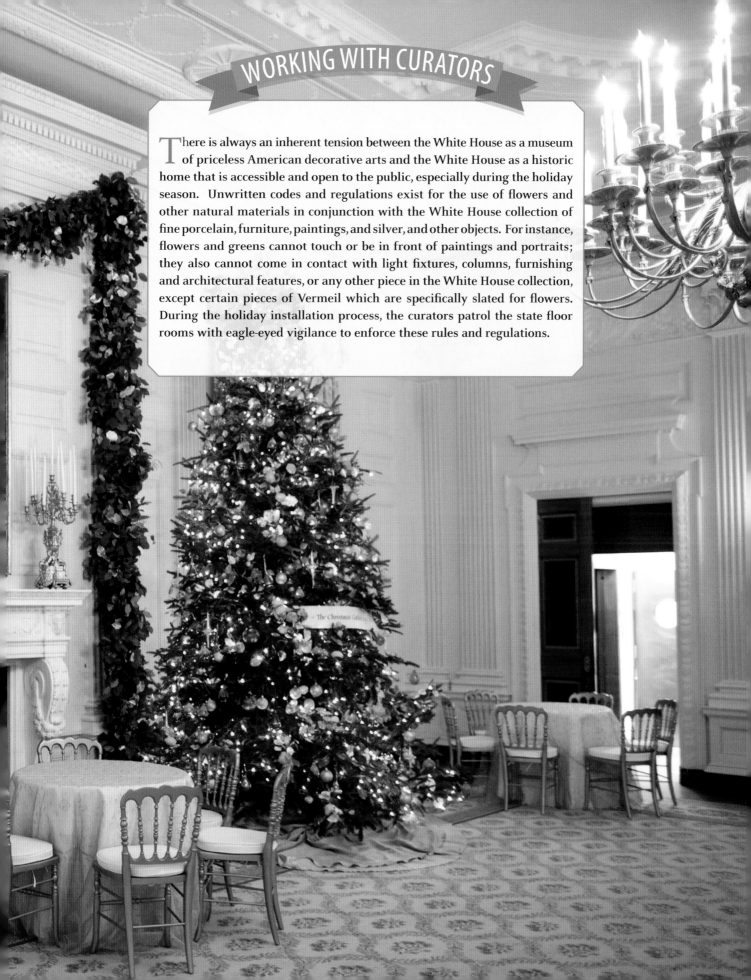

WORKING WITH CURATORS

There is always an inherent tension between the White House as a museum of priceless American decorative arts and the White House as a historic home that is accessible and open to the public, especially during the holiday season. Unwritten codes and regulations exist for the use of flowers and other natural materials in conjunction with the White House collection of fine porcelain, furniture, paintings, and silver, and other objects. For instance, flowers and greens cannot touch or be in front of paintings and portraits; they also cannot come in contact with light fixtures, columns, furnishing and architectural features, or any other piece in the White House collection, except certain pieces of Vermeil which are specifically slated for flowers. During the holiday installation process, the curators patrol the state floor rooms with eagle-eyed vigilance to enforce these rules and regulations.

One year, when a holiday volunteer inadvertently left a glitter-covered cloth on the 18th century crèche that was awaiting installation in the East Room, the curator took immediate corrective action to admonish the decorator and remove the glittery cloth. Another time, carpenters accidentally dropped a nail-studded two-by-four that was designed to hold a large garland above the gilt mirror in the Grand Foyer. Luckily, it missed hitting the volunteers who were standing 19 ft. below, but crashed into a 19th century gilt torchiere, breaking the lights and denting the piece. Within seconds of the mishap, housekeepers swiftly moved in to sweep up the broken glass and electricians brought up replacement bulbs from their underground lair. The beleaguered curators trudged upstairs with cameras and notepads, documenting the damage for repair. Perhaps the greatest curatorial challenge during the holiday season is when thousands of revelers descend on the White House for the endless swirl of holiday parties, eating and drinking – enjoying a lavish buffet menu much of which ends up on the furniture, upholstery, rugs and even the walls. Over the years, the curators have employed a variety of defensive tactics during the high-use holiday season in an effort to protect the collection, including removing the most priceless furnishings and bringing in duplicate sets that can take the wear and tear.

The curators share the responsibility of protecting the White House as a museum with the White House Historical Association while it concurrently functions as an open, vibrant public place – the iconic 'People's House.' Sometimes it seems like the curatorial rules are evolving and in flux. In reality, there is no definitive roadmap for managing changing décor fads and traditions, especially when it comes to holiday designs. Although scented candles are a popular holiday tradition, for example, they pose a challenge for curators. Will the scent permeate the oil paintings and furnishings? Will airborne fragrance damage fabric and paint finishes and perhaps even give visitors the vapors? These issues were all part of the discussion. Early on in my tenure, as I was planning the floral holiday installations, my bouquets came under curatorial scrutiny. My style of using organic containers – vessels covered in leaves, moss, vines and other materials – was new and different as was the size of my arrangements, which were larger than before. The curators became focused on the weight of my bouquets, which they believed were

too heavy to be placed on the furniture, possibly damaging to the collection. It was never clear how much weight was too much weight but that seemed to be an extraneous concern. With the ushers' blessing, they set about to gather empirical evidence to support their theory about the heavy bouquets, weighing my arrangements daily. I would arrive in the morning to see a flower shop staffer and assistant curator dutifully carting the bouquets down to the White House store room where they placed them on scales. My largest bouquets topped out at just under 40 pounds. Other times, I would see ushers and curators standing around my arrangements, clipboards and notepads in hand, speaking in low, hushed tones. No one ever explained to me the ultimate goal of this weighing and documentation exercise which went on for several weeks, ultimately escalating all the way to the Director of the entire White House complex. How did it all end? It was when one of the housekeepers innocently asked 'Why is everyone so worried about the weight of the bouquets when they allow a 500-pound ginger bread house to sit on the pier table in the State Dining Room for a month?' This one simple fact seemed to resonate with the group and I never heard another peep about the 'excess' weight of my bouquets again.

Another issue involved the use of a new kind of natural material in the White House. In 2010, the décor in the State dining room included a long lemon leaf garland that hung above the Lincoln portrait. Lemon leaves are an ideal choice of material for winter wreaths and garlands since they dry over time, yet maintain their shape and color. Mid-way during the holiday season, I received a call from the Chief Usher to come immediately to the State Dining Room. There was a garland 'issue,' he said: the lemon leaf garland was sagging and threatening to touch the Lincoln portrait. I raced upstairs from the flower shop to encounter an unusual scene. A large rolling scaffolding was placed in front of the fireplace. A dozen or more staffers, including the carpenters, curators and ushers were assembled around; there was a palpable sense of anticipation in the air. The dour-faced curator stood with his assistants flanking him, muttering about the threat the garland posed to the priceless portrait. The carpenters stood in a row fidgeting in unison back and forth. The Chief Usher approached me with the group's collective assessment: the garland I had ordered required repair, he said,

p. 28 We used sugared fruit, gilded leaves and citrus-hued ornaments to celebrate the gifts of nature in the State Dining Room in 2010. Here, you can see the lemon leaf garland hanging above the Lincoln portrait right before the curators voiced concern about the 'sagging garland.'

A Christmas 2010 view of the hand-crafted velvet ribbon poinsettia garland flanked by the 19th century French torchieres in the Cross Hall, looking into the State Dining Room.

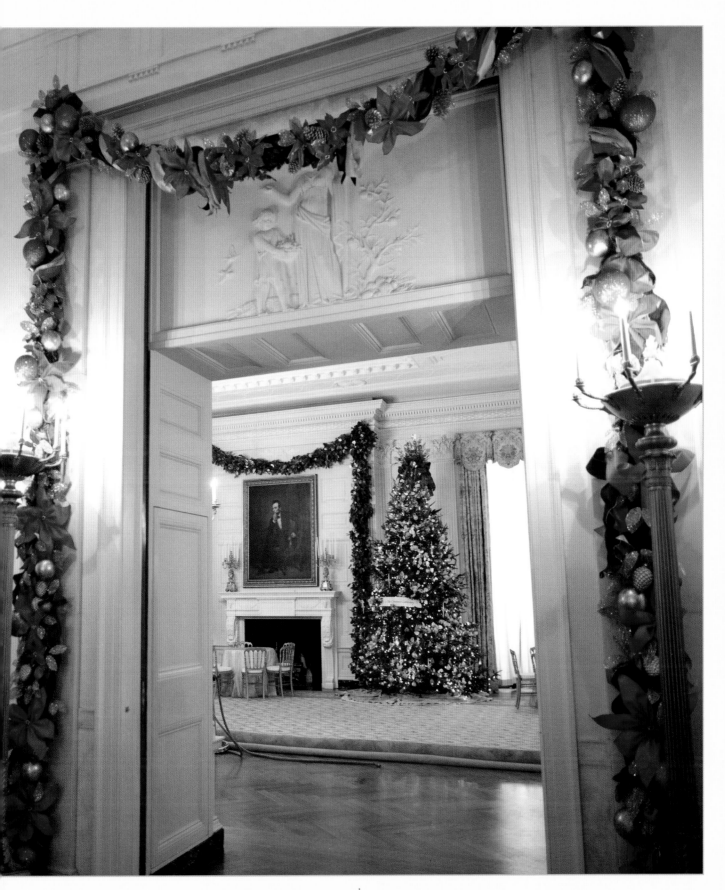

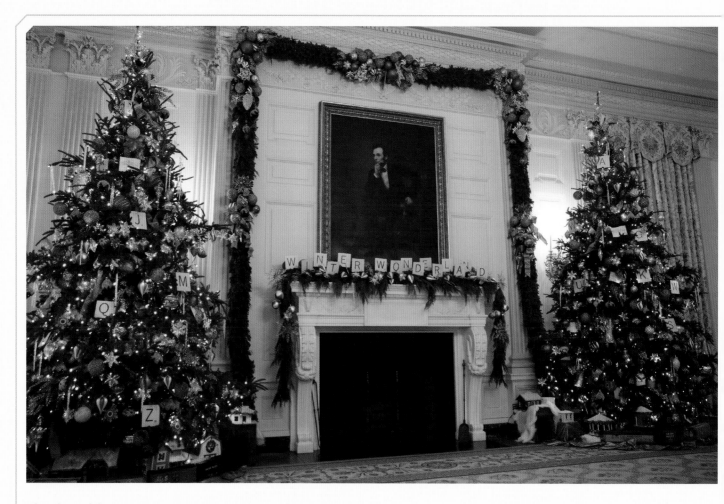

This photo of the State Dining Room in 2014 features the massive garland above the Lincoln portrait before it came crashing down during the first party of the holiday season. The overhead garland was removed – and has not re-appeared since then in any White House holiday decorating scheme.

and needed to be addressed immediately. 'What do you plan to do?' he asked. Looking up at the garland, I noticed that the arc of the lemon leaf swag had indeed dropped to just a few inches above the portrait. As the lemon leaves aged, the commercial garland was slipping from the binding wire, becoming slack, I explained, causing the entire garland to gently sag between the anchor points. 'The solution is easy,' I said, 'we just need to reinforce the horizontal swag with a sturdy cord tied to the garland from behind.' The head carpenter sidled up to me and drawled in his southern Maryland accent: 'Well, ma'am, here at the White House, we have a rule: if you're in charge of putting it up, then you need to be the one to fix it.' He motioned over to the scaffolding, signaling that I would have to climb up, handing me a length of cording and

wire cutters. I was wearing a dress and heels but sensing a challenge, I calmly put down my notebook and pen, turned to the carpenter and said 'let's go.' I climbed up the steel frame of the rolling scaffold until I reached the platform about 14 or 15 feet up in the air, meeting the carpenter at the top, who seemed a bit stunned by my quick response. I noticed that the visitors who were continuing to tour the White House during looked up at us with a mixture of surprise and amusement. Within a few minutes, we reinforced the original garland with the cording and re-hung it to the attachment points on the pilasters flanking the portrait. Our actions averted a curatorial crisis and perhaps dispelled an impression that I would take the easy way out and simply replace a garland that had become a 'thorn in the side.'

The curators were put to the ultimate test in 2014 when the giant 500-pound garland hanging over the Lincoln portrait in the State Dining Room came crashing down in the middle of the first holiday party of the season. While the First Lady spoke in the adjacent Grand Foyer, the massive overhead garland broke free from its attachment points high above the floor, careening down in front of the Lincoln portrait, shattering glass bulbs and ornaments, and whizzing by the unsuspecting partygoers who were standing below. One volunteer described the feeling of the wind created by the careening garland. Another felt that she had just experienced a 'near-death' experience, noting that she almost became a bizarre foot-note in history, remembered as the lady who was hit by garland a White House party. She speculated about what it would be like to become another one of the ghosts that reportedly roam the White House premises.

Remarkably, most people at the party were unaware of the falling garland incident and it was not reported in the press until much later. The catastrophic failure of the anchors took out large sections of the pilasters surrounding the portrait as well, leaving gaping holes and chunks missing from the walls. Within minutes of the occurrence, staff scrambled to clean up the broken glass, remove the garland, and return the State Dining Room scene back to usual serene party scene. I was notified to come up with a repair plan for the garland before the holiday tours resumed the next morning. The most amazing thing? When I came to work the next morning, the walls had been repaired and painted, the overhead garland was removed, as if magical elves had swirled a magic wand and conjured major repairs to ensure that everything appeared totally normal. In photos of the decorations that year, you can see two versions of the State Dining Room decor: one with the massive and beautifully decorated overhead garland and one without, with nary anyone the wiser about the drama that happened in between.

At the end of the day, the true magic of the White House holiday season is how everyone comes together to work in mildly orchestrated chaos to ensure that the White House is both beautiful and inspirational, preserved in perpetuity for future generations to experience and enjoy.

Displaying the 18th century Italian carved wood and terra crèche is a beloved holiday tradition at the White House, where it always holds a place of honor in the East Room.

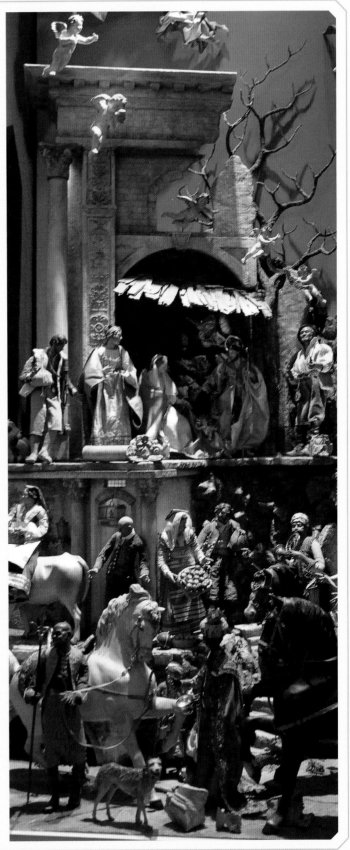

The White House holiday press preview is always a very exciting time. All of our work and preparations throughout the year are geared towards this important moment when the international press, the White House press corps and regional outlets descend on the White House, vying for the first images of that year's theme and holiday décor. It's a combination of tradition and protocol during which the First Lady welcomes reporters to the White House, announces the theme of the White House Christmas, and celebrates with regular citizens, typically military families and children. The press preview is a tradition that has gone on for decades with various iterations and protocols, the kickoff to the White House holiday season.

The day starts with reporters taking a self-guided tour of the décor. Lead volunteers are positioned in key places to answer questions and brief the press on the particular details of each project, adding an authentic account of their on-the-ground experience creating the holiday decor. A Marine pianist plays Christmas carols on the grand piano in the Grand Foyer, creating seasonal sounds that waft throughout the Executive Mansion. Sometimes, a table is set up with White House cookies that the reporters can eat or take home as souvenirs – a scaled back version of the lavish holiday buffets that were a much-anticipated feature of previous years. After about 45 minutes or so, reporters are called into the East Room where the First Lady welcomes the press and military families who have been invited to join in the festivities. It is here where she reveals the theme of the White House décor and talks about the symbolic meaning associated with the décor elements room by room, mentioning highlights, facts and figures regarding each specific element. These details include the number of volunteer decorators and the states they represent, the number of trees and wreaths, miles of garland and ribbon, quantity of ornaments and the weight of the iconic gingerbread house. After completing her opening remarks, the First Lady invites the children in the audience to join her as she leads them to the State Dining Room for a crafting session with florists and chefs.

Mrs. Obama introduced the idea of hosting a craft-making workshop for children of military personnel as her way of putting a unique stamp on the time-honored press preview tradition. The concept calls for three craft-making stations to be set up in the State Dining Room – one that I hosted featuring a floral craft-making project and the other two manned by White House chefs who instructed children on how to make food-re-lated holiday crafts. It was always a fun project that we spent a lot of time thinking about to come up with a craft idea that met two major criteria: an idea that children could enjoy making and one that could be completed within the strict parameters of the event. Kids only have 5 or 10 minutes to make each holiday craft design before they switch to the next station as the entire event with the First Lady occurs in a relatively short amount of time, under 30 minutes. Behind the scenes, we worked to set up fail-safe, risk-free projects that kids could make quickly and take with them. Some of my favorite children's craft projects over the years included the Bo-shaped cookie ornaments with ribbon trim, 'Bo-flake' snowflake ornaments on lucite discs, 'Bo-quet' tissue paper poinsettias, and 'Bo-tale' coloring books featuring First Family dogs Bo and Sunny in cute holiday vignettes.

Over the years, I learned that the old adage of 'never work with children or animals' has a certain ring of wisdom and truth. The White House press preview events were always unpredictable and fraught with the unknown, sometimes leading to amusing results. My first year, I decided to teach kids how to make a gilded magazine tree, similar to what we created for the Green Room. It was a simple concept, taking old magazines, folding the pages and then spraying them with paint and glitter. When the children arrived at my station to create the project, the youngest child there – a little boy about 3 or 4 years old – had a difficult time with the task, loudly proclaiming 'this is hard' in full earshot of the cameras and press. The older kids had more success with the project but I noticed that they could be a little mischievous. One girl took the gold glitter that we had laid out and stuck her tongue in it – proudly displaying it for all to see as cameras clicked away. Then she took a sample glittered tree and shook it upside down, shaking glitter all over the carpet (much to the housekeepers' annoyance). Finally, she took a White House cookie and embellished it with glitter, licking the icing with her gold-glittered tongue, flaunting it to reporters. As she presented this cookie to the First Lady, urging her to take a bite, I was unsure for a moment about whether to intervene. Then I noticed that the First Lady graciously accepted the glitter gift and immediately, surreptitiously handed it off to an aide standing nearby.

Each year at the holiday press preview, we taught children of military families how to create special, hand-made projects, including trees made of folded and glittered magazines, tissue paper poinsettias and the always popular Bo-themed ornaments pictured here.

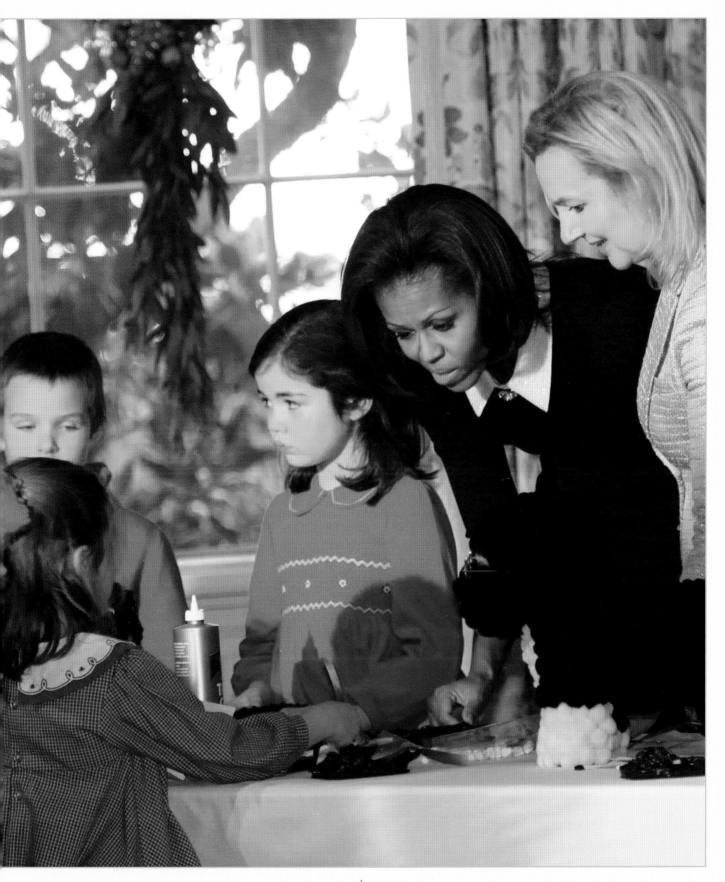

Another time, we were crafting coloring books featuring the First Family dogs Bo and Sunny. A rambunctious little boy came up to our table. 'I really feel like knocking over that tree,' he said, pointing to the 16 foot tree standing behind us in the State Dining Room – as my eyes widened in horror at the mere thought of this delinquent activity playing out in public at the Christmas preview. Luckily, my friend Captain Rosie, a U.S. Army psychologist and flower shop volunteer, intervened to de-escalate the situation. She grabbed his hand and whispered 'I'm your new best friend,' staying with him during the duration of the activity and averting a potentially serious addendum in the annals of White House Christmas debuts.

Everyone remembers the year that the little girl with blonde ringlets was standing in front of one of the craft tables as Mrs. Obama appeared with First Dogs Sunny and Bo. At that time, Sunny was new to the household and not schooled in White House ways of protocol and decorum. When the little girl went to pet her, Sunny seized the opportunity to jump up, knocking her to the ground. The next moments unfolded in slow motion as the entire room stopped and gasped – but the little girl bounced up and was immediately enveloped in the First Lady's arms. Sunny stayed on a short leash for the remainder of the event.

In recent years, social media has become an increasingly integral part of everyday life. It wasn't surprising, therefore, to see cell phones show up with children at press preview craft events. Early on in my tenure, I was not too familiar with iPhone features and cameras and did not even know how to use one. So when a little girl handed me her phone to take a picture of her with the First Lady, I stood frozen for a moment like a deer in the headlights. Somehow I figured out which button to press and handed the little girl her phone as the First Lady smiled knowingly and moved on to greet her next little fan.

Upon the conclusion of the crafting session, the reporters finish up taking photos and video footage, and are herded out the door by the press team. The White House holiday season has officially launched!

At the press preview in 2012, the First Lady displayed an image of Bo crafted into a snow-flake ornament, a series of Bo-related snowflake designs, called 'Bo-flakes', designed by my niece who was 16 at the time. A darling little boy proudly showed off his finished craft project in 2011.

Over the years, technological innovations such as IPhones and social media transformed the way people experienced the White House Christmas, leading us to establish new guidelines. Visitors can now take photographs of White House rooms, for example, and are encouraged to post their experiences on White House social media sites. Here I am at the press preview in 2013, taking my first IPhone photo – a snapshot of the First Lady and an enthusiastic young guest.

A WHITE HOUSE CHRISTMAS TOUR

Ground Floor

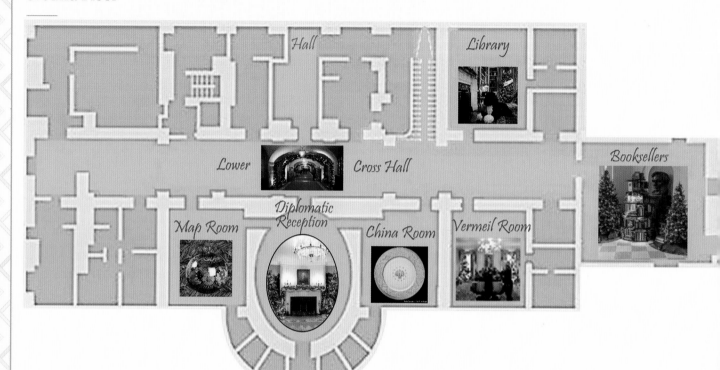

Hall

Library

Lower Cross Hall

Booksellers

Diplomatic Reception

Map Room China Room Vermeil Room

State Floor

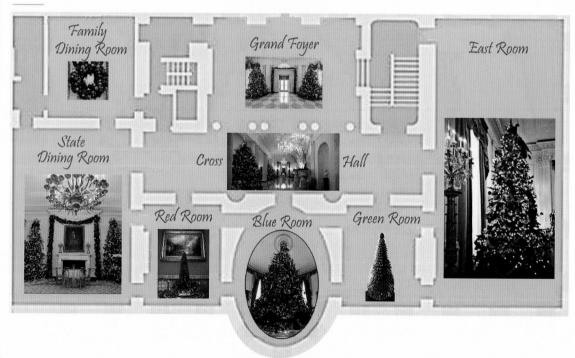

Family Dining Room

Grand Foyer

East Room

State Dining Room

Cross Hall

Red Room Blue Room Green Room

Overview

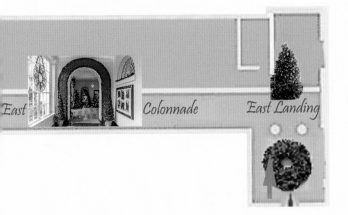

Holiday Tour

Welcome to the White House

An invitation to the White House Christmas is a coveted experience that almost 100,000 lucky visitors enjoy each year. Whether they go through formal channels and obtain tickets through their congressional offices or tap into personal White House connections to secure access, every visitor is amazed by the beauty and grandeur of the White House Christmas displays. From the moment they enter the East Entrance on the self-guided tour, the goal is to surprise and delight visitors at every turn with innovative, hand-made projects and details, many of which can be duplicated at home. And as they make their way from historic room to historic room on both the State and Ground Floors, visitors are amazed by the period furnishings and paintings that depict over 200 years of American history embellished in festive holiday finery. It truly is the most wonderful and inspirational time of the year! Please join me on a behind-the-scenes tour of an inspiring White House Christmas.

Please
Watch Your Step

A First Impression

EAST ENTRANCE

The East Entrance of the White House sets the tone for the entire holiday tour, making a grand visual statement and a revealing first glimpse of the décor and elements within. The exterior décor typically highlights the beauty of nature, including a festive display of Christmas trees, evergreen wreaths, and ribbon bedecked garlands and swags. The colorful decorations and natural greens stand out in sharp relief against the bright white background of the entrance portico. The current design of the East Entrance, constructed in 1942, features a formal covered entrance and a symmetrical alignment of double columns along the front facade. It conveys a formal feeling, calling for designs that emphasize classical motifs. Our goals for the East Entrance focused on creating festive, natural designs that incorporated principles of scale, repetition, and balance punctuated with bold Christmas colors.

Early in the year, we worked on rough sketches and drawings for this space, using the architectural façade as the backdrop for adding in all of the various design elements. For inspiration, I looked to a unifying symbol, color or motif that tied the presentation together. One year, dreams of a snowy White House Christmas translated into a palette of snowflake white, icicle silver, pale winter morning blue and mistletoe green with snow-covered trees, lighted snowflake wreaths, silver ornaments and vintage mercury glass. The colors and elements evoked a winter landscape of frosted trees and glistening frozen ponds. This tied in with the overall 'Winter Wonderland' theme. Another year we focused on creating a winter garden theme with emerald green topiaries, icy sage and eucalyptus wreaths, silvery branches, crystal icicles, and a garden trellis. The diamond trellis motif suggested a garden gate and carried out a garden-inspired theme that was repeated in several rooms. A favorite East Entrance design featured the simple gifts of nature in the winter season: cedar wreaths and garlands, pinecone topiaries, and red winter berries in a palette of evergreen and cardinal red – a perfect introduction to the 'Simple Gifts' theme. Special projects included large ruched ribbon wreaths made from recycled ribbon, boxwood wreaths made to resemble snowflake designs, topiary containers crafted from folded and gilded magnolia leaves and decorative door surrounds made from various materials in a range of patterns and motifs.

BOXWOOD TRELLIS DESIGNS. The White House is a compilation of geometric patterns and motifs – rectangles and ovals, and interlocking circles – and I often incorporated these patterns into White House holiday décor. The geometric motifs work well against the classical façade of the White House, adding a timeless and elegant touch. In 2014, we created two large boxwood trellis column covers to flank the doors on the East entrance – large-scale designs that provided the focal point décor for the winter garden theme. The design specifications were extensive: the underlying frames were made out of plywood boxes built by the carpenters – 16 feet tall and 5 feet wide – crafted as 3-sided covers that would be installed on each side of the entrance doors. Once the carpenters completed the frames, the painters finished them in the same shade of white as the East Entrance. Next, we marked off the trellis design on

the frames to form a classic diamond pattern motif. These were covered in boxwood, creating an intertwining trellis effect. Because the designs needed to last over a month outside in the elements, we chose preserved boxwood so that it would maintain its color and the appearance of freshness. Volunteers wired the boxwood into thousands of small bundles that were then glued following the lines of the diamond pattern on the forms. The detailed wiring, bundling and application of boxwood was a time-consuming process that took about 4 months to complete, including a brief hiatus we took to address a situation.

As we were in the final stages of completing the two large boxwood trellis column covers, we received word to halt production immediately. Someone raised an issue about the use of preserved boxwood materials in the design. There was concern over the possibility that the preserved material could infect the boxwood on the White House grounds with a rare form of blight, which launched a series of meetings and discussions on the topic. At the White House, every issue – real or imagined – must be evaluated for veracity and potential impact. All projects go through an extensive design and review process where sketches and prototypes, budgets, materials, project and staffing plans and timelines are discussed and vetted. It is important to discuss every detail from every perspective and I always found these extremely useful for tweaking styles and approaches. Luckily, in the case of the exterior boxwood trellis designs, we could confirm the details of the material with the boxwood provider: where it was from, how it was made, the preservation process (similar to embalming), that assuaged the fears of White House officials and allowed us to proceed with the project. In planning and executing complex projects such as the White House Christmas, unexpected concerns like this could crop up at any moment at any time. So we always factored this into our timelines.

GOLDEN BRANCHES. Not every décor element makes it to the final day. One year, a small, but insistent buzz began to grow over an installation in the East Entrance. It was a concept of gilded branches and hanging crystals that sounded good on paper but went awry during the execution. Over the course of the three day installation, the design progressed – gold manzanita branches strung with dangling crystal garlands in giant faux stone urns – creating what some people thought was a gloomy effect. At the final walk-through of the décor that began at 9 p.m. the evening before the press preview and the official opening of the White House décor, a group of reviewers (that al-

p. 40 Dramatic displays of golden branches with leaves and birds arranged in faux stone urns greet visitors at the East Entrance in 2013. This photo shows the final result after reviewers voted to revise the design at the last minute, opting for a more understated display.

ways potentially included the First Lady) decreed that the front entrance decorations needed drastic overhauling, an 80% reduction in the existing amount of décor. After the verdict, staff made a series of phone calls to a core group of colleagues, including Park Service personnel and a few decorator contractors and volunteers, asking them to convene before 7 a.m. the next morning to entirely re-do the front entrance. The revisions had to be completed before the press preview officially scheduled for 11 a.m. Most of the official decorating volunteers were unavailable because their official decorating duties were over. They were snug in their hotel beds dreaming of the sugarplums and champagne they would feast on when they returned later that day for the volunteer party.

When I arrived at work the next morning, the revisions were already well underway. Behind the large boxwood hedges that shield the front entrance, I could catch a glimpse of flying garlands and ornaments, and occasionally a worker's head popped out of the fray and then quickly disappeared. Just as newspaper outlets and preliminary press, including HGTV, were arriving to document the décor, the last of the dangling ornaments and gilded branches were being tossed onto the backs of waiting trucks, which would return the excess material to the warehouse. The entire revision was completed in just a couple of hours. After the dust settled, the final result emerged as a more understated and demure version of the original design. For most visitors, this is the only version they would see. This was yet just another example of how the magic of the White House Christmas unfolds, not always in an easy or straight line, but always ending up where it needs to be.

During the holiday season, the East Entrance is both the first stop on the holiday tour and the last place visitors see as they depart a White House party, making both a first and lasting impression. In the twinkling glow of festive holiday lights, accented by candle-lit lanterns, the East Entrance décor takes on a special character at night. As guests walk down the boxwood-lined steps leading them out the gate, they are invariably drawn to turn around to see the extraordinary view: the White House illuminated in a display of glowing lights and festive décor – a classic Christmas scene with timeless appeal.

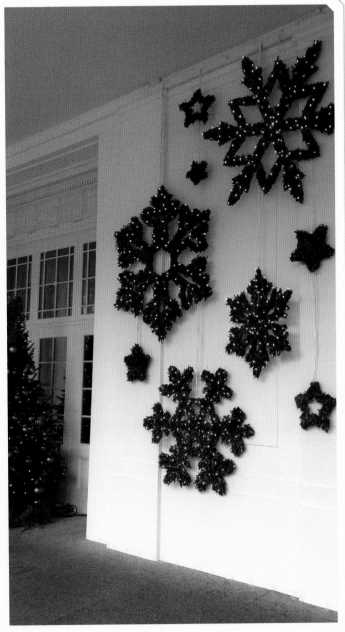

Over the years, we created several intricately-patterned column covers for the East Entrance exterior and interior displays as well as snowflake-shaped wreaths that were decorated with boxwood and lights. These projects often took months to make and involved dozens of volunteers. Here, large boxwood wreaths in the shape of stars and snowflakes appear to float across the East Entrance which is decorated with trees and topiaries.

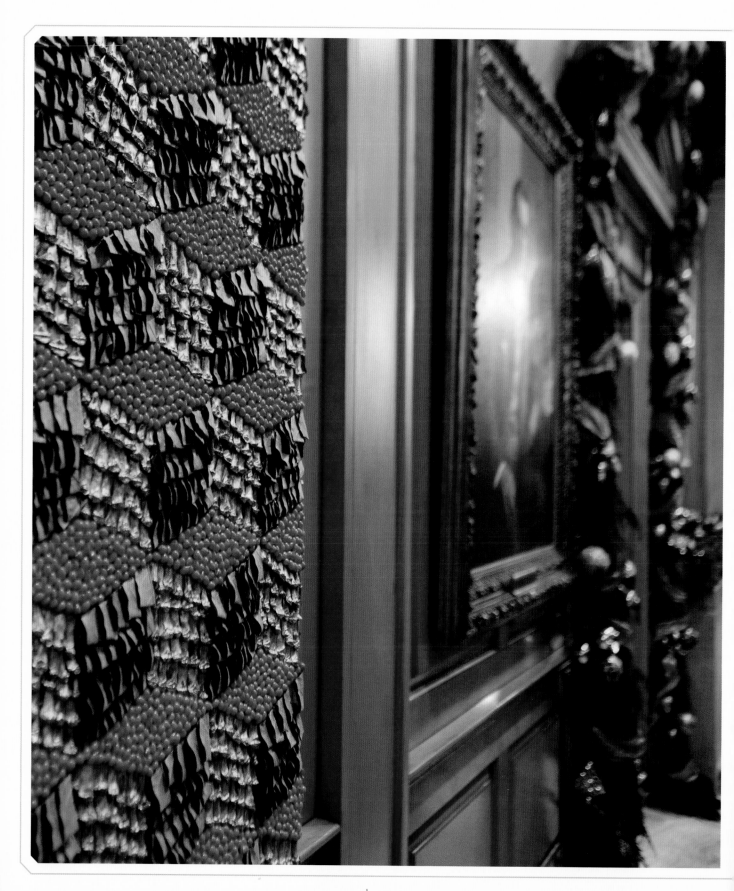

EAST ENTRANCE INTERIOR

The doors of the East Entrance open up to the East Entrance foyer, the starting point of the White House Christmas tour. With its wood-paneled walls and gallery of portraits and photographs, including the iconic portrait of Nancy Reagan in the red column dress, the foyer conveys a feeling of warmth and tradition, of coming home for the holidays. This was my inspiration for creating holiday décor that celebrates the beautiful traditions and compelling message of Christmas. The color palettes we used were often traditional, carried out in warm and cozy shades of red, green, copper and gold. Occasionally, it was possible to introduce a modern touch by using a contemporary palette of sage green and white accented with touches of silver and gold. Another unusual color palette we used to convey a winter wonderland effect was ice blue and red with touches of evergreen and silver glitter. The design considerations focused on creating beauty and impact throughout the space, using architectural features (including the doors and fluted columns) as a backdrop for the decorations. The key decorative element was always the architectural door surrounds – fitted plywood boxes decorated with natural details in a variety of colors, patterns and motifs. Over the years, we fashioned oak leaf rosette garlands over a magnolia leaf vase; illusion cube column covers made from berries, leaves and pinecones; and ribbon-covered column covers with an overlay of boxwood, winterberries and crystal trim. Evergreen garland swags and kissing ball tied to the brass chandeliers completed the festive displays.

OAK LEAF ROSETTE GARLANDS. The gold oak leaf rosette and magnolia garlands that flanked the East Entrance foyer were among my all-time favorite projects. The concept involved creating a special artistic detail to add interest in the space. The emerald green and velvety bronze magnolia leaves coordinated with the wood paneling; the gilded oak leaf rosettes added a natural, sparkly touch. Because the materials were simple and easily available, the oak leaf garlands could inspire visitors to try new techniques at home – a nice interactive touch. Finally, it involved a large community of volunteers working together on a special holiday initiative. My goal was to create an inspiring focal point design at the beginning of the White House tour.

The illusion cube column cover design involved some of our most labor-intensive work and was among my all-time favorite volunteer projects. We used these column covers two years in a row – in 2012 and 2013 – to flank the East Entrance corridor where guests start the White House holiday tour.

I came up with the idea on my way to work one morning. As I sat at an intersection of Cameron and King Streets in Old Town, Alexandria, waiting for the traffic light to turn, I stopped in front of the Delaney House, an Italianate design circa 1820. I've always loved this house. Years ago, in the 1990s, I thought about renting a studio apartment there after seeing a 'For Rent' sign in the window. When I went to look at the apartment I found that it was basically the front parlor room that overlooked the main thoroughfare in Old Town.

It was a one-room studio with a closet that had been converted into a kitchenette and a separate bathroom. I had a decidedly mixed reaction. The proportions and architecture of this room were inspiring, along with the ceilings soaring to at least 16 ft. high and wide heart pine floors. It was a spectacular building, but the condition of the place was troubling; it was hard to get past the toilet positioned in the middle of the main floor room. 'Don't worry about that,' the little old landlord ladies (with a tinge of blue in their hair) said reassuringly, noting that it would be re-installed in its correct place soon. I wasn't an avid cook, but even I was a little skeptical about a stove and refrigerator – positioned in a closet without venting – that would probably violate minimum safety code standards. I took a pass on the apartment, forgoing my security deposit, but always remained impressed by the architecture and ambiance of this historic Old Town house. So, years later, as I sat there at the stoplight on my way to work, I noticed the architectural detail of the window with renewed interest – especially the carved frame. I thought this detail would be perfect to incorporate in White House holiday designs. My idea was to re-create this shape as door surrounds in the East Entrance: the doors that flank either side of the foyer leading to East Wing offices are a primary architectural feature.

An architect friend helped me re-configure the motif as a doorway decoration. She drew it to scale, enlarging the width in proportion to fit the White House doorways, providing precise details and measurements. We took the sketches to the White House carpenters and came up with a game plan for creating a 3-sided plywood structure to surround each door. For materials, I chose magnolia leaves, pine cones and oak leaves – all seasonal materials that are readily available. The design featured an oak leaf rosette trellis garland over a magnolia and pinecone base. Fallen oak leaves were fashioned into rosettes that were then glued over the top of the magnolia base, with a pinecone base covered in individual pine cone scales, glued onto the surface in a scallop motif. It was an ambitious, labor-intensive project that required a significant amount of volunteer work and organization. Calculations showed that we would need at least 1,000 oak leaf rosettes, 2,000 individual pinecone scales, and hundreds of magnolia leaves for the project. So we went to work. Volunteers fanned out in neighborhoods across the Washington, D.C. region to gather enough leaves for the project. The volunteers were a loose-knit and evolving group who worked over a period of several months to bring the concept to fruition. At the start of the fall, the oak leaves were plentiful in backyards and gardens all over town. As time went on during the fall season, however, city groundskeepers became adversaries, efficiently collecting the leaves before we could gather them. It became a race against time – with volunteers deployed all over Old Town, jumping over gardens and brambles and nettles, running across busy streets against the light to chase down leaf blowers and grab the last lingering bunch of uncollected leaves – all in the quest for the perfect oak leaves that we could use to make the 1,000 rosettes.

Back at the White House, we fashioned these leaves into stylized roses, using approximately 24 leaves for each individual rosette. Once we made the oak leaf roses, we sprayed them with gold paint, dipping the edges in gold glitter, storing them in large bags until we reached our goal. The design process involved gluing the base layer of magnolia leaves with the velvety brown side showing to the plywood base. We measured off the diamond trellis design that created the pattern for the oak leaf rosettes. The pattern application process was also labor intensive, involving detailed gluing of the 1,000 rosettes and hundreds of individual pine cone scales. The architect worked on the project in the carpenters' shop where she had to partake in their ritual of eating homemade beef jerky, a specialty of the head carpenter, in order to qualify to enter their space. The entire project took several months to complete – and a lot of beef jerky.

All of the volunteers were excited when the panels finally went up in the East Entrance – the project represented the culmination of several months' work and long hours crafting and gluing. This was always one of my favorite projects because it was the first time we used architectural features as a backdrop for the décor. The velvety brown magnolia leaves complemented the wood paneling; the gilded oak leaf rosettes glittered under the gold chandeliers. The boxwood kissing balls hanging from the three brass chandeliers added an element of fresh greenery to the space. The overall presentation was completed with large pine cone topiaries, under-planted with scented paper-whites, in planter boxes covered in magnolia. It set us up to create even more ambitious projects in the ensuing years.

ILLUSION CUBE COLUMN COVERS. Perhaps my favorite project – in terms of scope, design and volunteer work – was the illusion cube column covers we made in 2012. Inspired by the use of geometric motifs in the architecture and design of the White House – as well as stories of President Andrew Johnson's daughter who re-decorated the White House in strong colors and bold geometric designs after the Lincoln years – we wanted to weave geometric motifs into our holiday work. The concept involved designing three-sided plywood covers – 14 feet high, 4 feet wide and about 8 inches deep to fit over the four sandstone columns on either side of the East Entrance foyer. These forms were covered in a pattern of 3D cubes made out of red berries, folded lemon leaves and individual gilded pine cone scales. Only later did we realize that the same illusion cube motif appears elsewhere in the White House – on the early 19th century marble-topped table in the Red Room designed by French-American cabinetmaker Charles-Honoré Lannuier, one of the most exquisite pieces in the White House collection. It was an ambitious project requiring a wide range of artistic talent (precision drawing and pattern-making); skilled application and focused detail work (gluing 60,000 berries, 10,000 folded lemon leaves and 10,000 individual pine cone scales); and an army of volunteers to provide logistical support.

From start to finish, the project took about 6 months to make. The carpenters built the plywood boxes, carefully measuring and custom-fitting each one to fit in its designated space in the foyer, numbering them on the back. We started by measuring the pattern onto the plywood frame – a series of straight lines and connecting diagonal pieces that formed the illusion cube pattern. To calculate the amount of materials we needed, we created a sample patch to scale multiplied by the square footage space

we needed to cover. The next step was to gather all of the materials and create a volunteer plan for preparing them for the design. This work involved clipping faux berries from stems, folding and stapling small pieces of lemon leaves and clipping individual pine cone scales from pinecones. It was another labor-intensive project that we worked on in spurts over time. Groups of volunteers sat together at the counter, visiting, laughing and talking – enjoying each other's company as they worked toward this common goal. Meanwhile, we set the plywood column covers up outside of the flower shop on long tables and carts. This is where the application team, led by my friend Margaret – the team leader – who worked tirelessly on this project, was joined by other volunteers along the way. The individual pieces were applied with a silicone gun to ensure that the materials adhered securely. Day in and day out, the application team worked with meticulous precision to follow the lines of the pattern. It was exciting to see the textured wall and three dimensional effect take shape.

While we were working in the flower shop, we heard that the column covers were going up in the East Entrance. Several of us went to watch the installation, eager to see how they would look in place. Although the pieces were numbered to identify their proper placement, there was no indicator to tell which side was up. So when the carpenters installed the first two pieces upside down, they inadvertently cut out sections of the finished illusion cube pattern to fit around the floor moldings. When they realized the mistake, they halted work but not before cutting out hours and hours of our painstaking work. After making a bit of a joke about being able to tell which end is up, we went back to the flower shop to resume work on the column covers, repairing the missing chunks. Eventually the column covers were installed in the East Entrance, creating a special and inspiring design.

I believe that all of this hard work created a memorable experience for visitors as they entered the East Entrance and walked into the White House to begin their tour. Through our collective efforts on these detailed designs we helped to convey the spirit of innovation and collaboration that characterized our best work.

Carpenters installed the illusion cube column covers in 2012 by pressure-fitting the decorated plywood frames around the sandstone columns, a technique that does not require nails or screws.

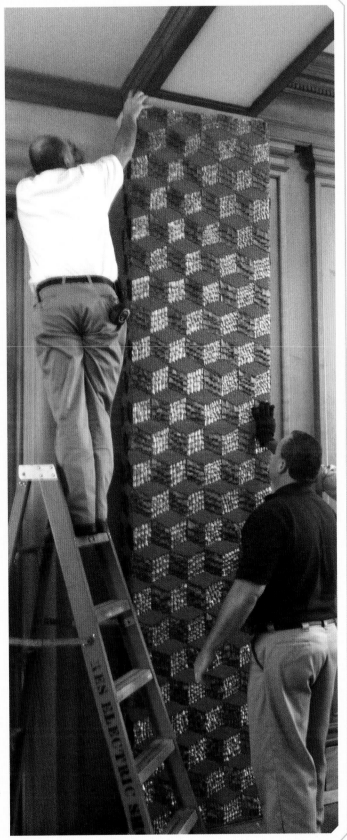

RUCHED RIBBON WREATHS

One of the great hallmarks of White House holiday design is the concerted use of recycled and repurposed material to create something new and inspirational. A great pleasure of serving as Chief Floral Designer was the ability to gain access to the vast collection of elements and décor, the beautiful cache of vintage and historical materials from White House Christmases past. My favorite hunting grounds were the giant rolling bins in the back of the warehouse where a colorful collection of holiday ribbons in every hue were stored away, waiting to be rediscovered. Here is an idea for using extra rolls of ribbon to create festive holiday wreath designs with texture and impact. You can add touches of sparkle and natural greens to complete the display.

WHAT YOU'LL NEED

- A 16 – 18 inch grapevine wreath form
- Thin paddle or wrapping wire
- 4 inch wired wood picks
- 5 – 6 rolls of 3 inch wire edge ribbon
- 1 roll of accent ribbon
- 1 box of small shiny ornaments
- Green trailing ivy

STEP-BY-STEP TECHNIQUES

1 Create a single-sided looped ribbon garland using thin paddle wire to make 1 inch loops that are even and close together.

2 Working side to side across the front of the wreath frame, apply the ruched ribbon garland to the frame, tying the ribbon on each side with the wire.

3 Once the wreath is completely covered with the ribbon, add small shiny ornaments to the design, wiring them to the wood picks and inserting them in a balanced pattern on the wreath.

4 Add trailing ivy on the inner and outer surfaces of the wreath to create definition.

5 Finish the bouquet with a jaunty coordinating bow.

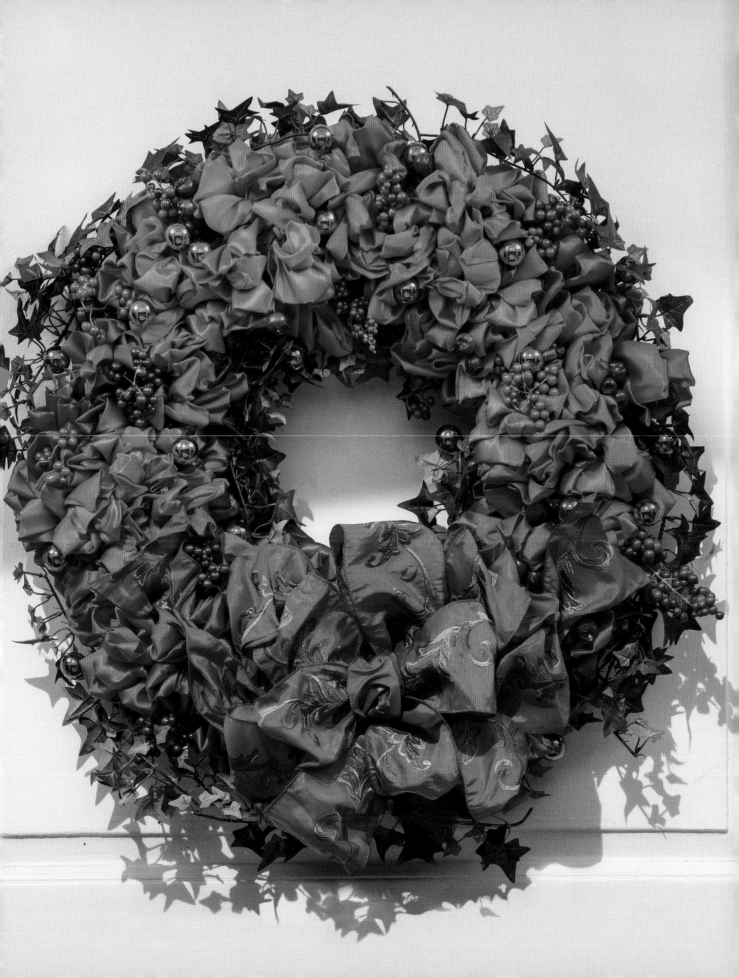

OAK LEAF ROSETTE WREATH

In the autumn season, falling leaves abound, providing the perfect element for natural-style holiday wreaths and crafts. Autumn leaves can be crafted into gilded winter garlands, wreaths, and floral vessels; they were the focal point of one of our most creative White House projects. In 2010, we used over 24,000 fallen oak leaves in our door surround design in the East Entrance. Volunteers crafted individual rosettes from leaves that they gathered from gardens throughout the region over a period of several months; the rosettes were glued onto a magnolia-covered Italianate-style frame. Here is an idea for adapting the technique at home: an oak leaf rosette wreath accented with crabapples, berries and variegated holly.

WHAT YOU'LL NEED

- A 16 inch to 18 inch straw wreath frame
- A large bag of oak leaves (approximately 850)
- 2 bunches of variegated holly
- 2 pints of cherry tomatoes
- 1 bunch of nandina foliage (with red berries)
- 1 pint of crab apples
- 6 inch wired wood picks (for attaching tomatoes and crabapples)
- 1 can of 24 karat gold floral craft spray paint
- Thin paddle wire
- Thick bark wire (for hanging)
- Medium gauge paddle wire
- Clippers

STEP-BY-STEP TECHNIQUES

1. Wrap the bark wire around the straw wreath form, leaving a loop for hanging the wreath.

2. Craft 35 oak leaf rosettes using approximately 25 leaves for each rosette.

3. Make an oak leaf rosette wreath by folding the first oak leaf in half and rolling it into a tight cylinder to become the bud of the rosette.

4. Holding the bud, fold the next leaf in and wrap it around the bud, adding additional leaves in this fashion until the rosette is full and natural looking.

5. Tie off the base of the rosette with the thin paddle wire, ensuring that all the leaves are tightly bound.

6. Using the gold spray paint, gild all of the rosettes.

7. Cover the straw form with small bundles of variegated holly, using the medium gauge wrapping wire, to form the base layer of the wreath.

8. Wire the rosettes onto the frame, positioning them evenly around the vase, changing the facing of the rosette to create interest and depth.

9. Using the wood picks, add sprigs of nandina foliage and berries to fill in the design.

10. As a finishing touch, add the crab apples and cherry tomatoes in and around the wreath using the wood picks.

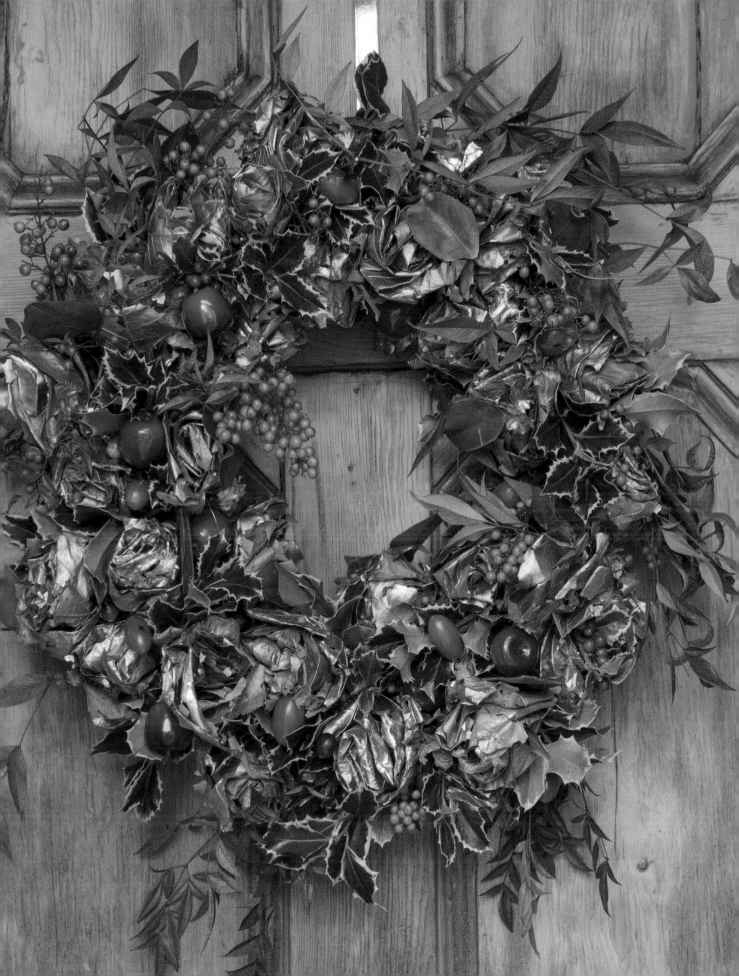

EAST LANDING

The East Landing is a light-filled corner space that joins the East Entrance and the East Colonnade, connecting to the Executive Mansion. With exterior doors and windows facing out to the South Lawn and the Jacqueline Kennedy East Garden, the space creates a natural point for pause and reflection. Over the last several years, the East Landing has been dedicated to military appreciation with decorations and interactive displays that are designed to honor military personnel and their families. The goal is to create an inspirational display that pays tribute to the nation's service members, honoring their exceptional duty, service, and sacrifice. The focal point piece was the majestic military tree, decorated with ornaments representing the five branches of military service, layered with colorful patches that highlight military divisions, badges and ribbons. The tree was always decorated in a patriotic palette of red, white and blue with accents of silver and gold. Wreaths and garlands festooned with red, white and blue ribbons and silver stars carry out the patriotic theme. I remember a special collaboration with a floral artist from the mid-west who with natural materials fashioned a dove of peace that perched on the top of the military tree. That year, the tree was especially beautiful with swags of ribbon cascading around the tree, highlighting the special ornaments.

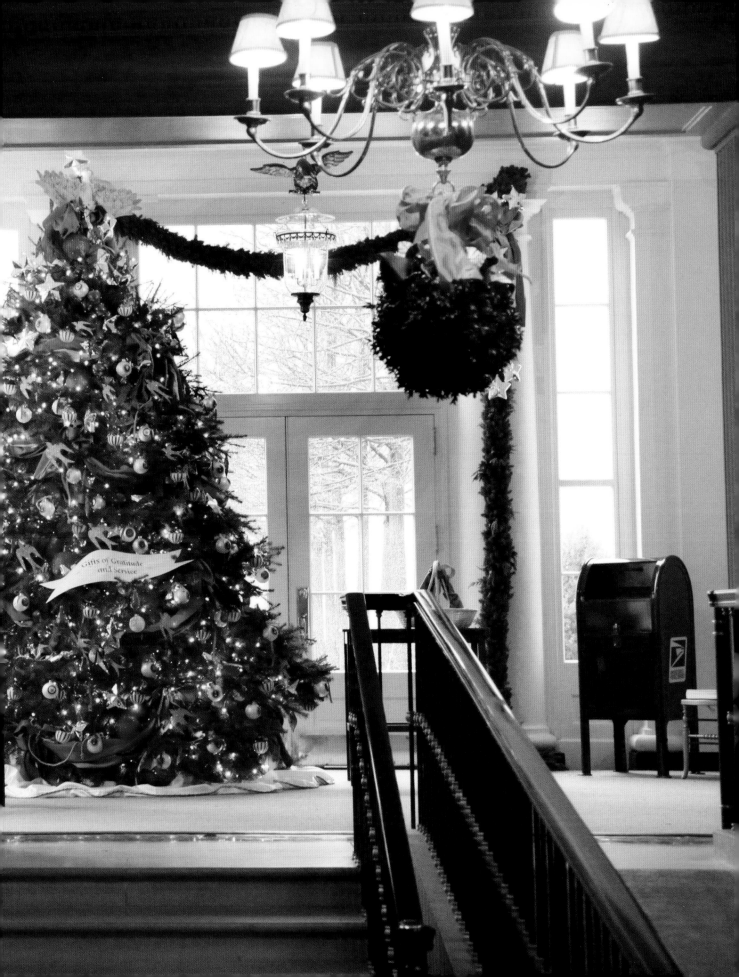

From the beginning, we incorporated an interactive component to the display that allowed visitors to send holiday greetings to military personnel around the world. Initially, this involved hand-written notes that were sent by traditional mail. After selecting a post card and writing out a note, visitors could drop their Christmas wishes into an old-fashioned mailbox that was a receptacle for thousands of cards that were collected and mailed to service members. Over the years, we increasingly used digital technology to communicate holiday greetings from the White House, including posting messages on special websites and social media platforms.

Several times over the years, the military tree was specifically designed to honor Gold Star families (those who have lost a loved one in service to our country) with special gold star ornaments, tributes, and personal details. The decorating team for this space included Gold Star family members. For them, it was both comforting and inspiring to participate in this annual White House ritual – and a memorable experience to place an ornament with the name of their fallen loved one on this symbolic tree. One year, we set up a flat screen television in the space to depict the faces and tell the stories of those men and women who made the ultimate sacrifice for our country, providing a touching tribute. Overall, the Gold Star tree was an opportunity to display a nation's gratitude and served as a solemn reminder of the sacrifices made by military service members to preserve our freedoms.

At the end of the season, another set of volunteers always arrived to carefully and respectfully take down the symbolic ornaments that are full of personal inscriptions that represent the meaning of service and sacrifice. One year, when almost all of the decorations had been taken down, packed away and carted off to storage, a volunteer approached me with a special request. Her friend was a Gold Star mother, she explained, whose son lost his life in battle in Afghanistan the year before. She knew that his name was represented on a White House Gold Star ornament in tribute to her son. Would it be possible to retrieve it for her? We went to the tree, which was still covered in these Gold Star ornaments, but had trouble locating the specific one. We combed the tree, searching for the memento that would be so meaningful for this Gold Star mother. Just as we were about to give up, we spotted his name on the simple Gold Star that was tucked in among the other ornaments and branches. After retrieving it and placing it in a special ribbon-wrapped box, the volunteer presented the symbolic gold star to the mother whose brave son died in service and who was honored at the White House for his heroism and sacrifice. In that moment, the ornament that depicted the soldier's name, rank and date of death became a simple, yet powerful gift for the family to treasure.

CONCLUSION. In the East Landing, every aspect of the decorations – from the choice of colors and selection of ornaments and ribbons to the volunteers and visitors who sent holiday greetings was meaningful and symbolic. It went well beyond design to encompass a much broader meaning of tribute and honor – an expression of gratitude from an appreciative nation. Over the years, the East Landing became a special place for visitors to not only rejoice and count their blessings, but to celebrate and honor the courageous individuals who contribute and sacrificed so much in their efforts to protect liberty and freedom for all Americans.

p. 52 As guests moved through the East Entrance towards the East Landing in 2010, they caught a glimpse of the red, white and blue Military Appreciation tree at the top of the stairs. Presidential portraits and lush magnolia garlands frame the view of the patriotic tree that highlights the 'gift of service' – topped by a hand-made dove of peace.

In the East Landing, gold ornaments and gold ribbons – along with ceramic stars that displayed fallen service members names – decorated the symbolic Gold Star Family tree. Here, a gold ribbon wreath ringed with ivy carries out the theme of remembrance and gratitude that was always part of our White House Christmas décor.

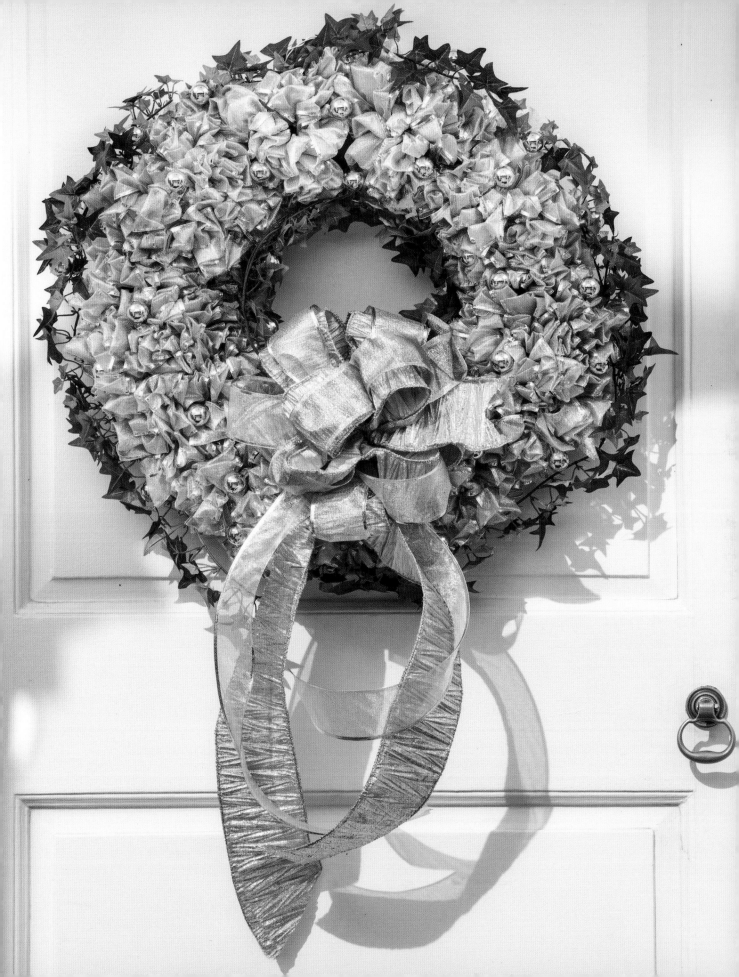

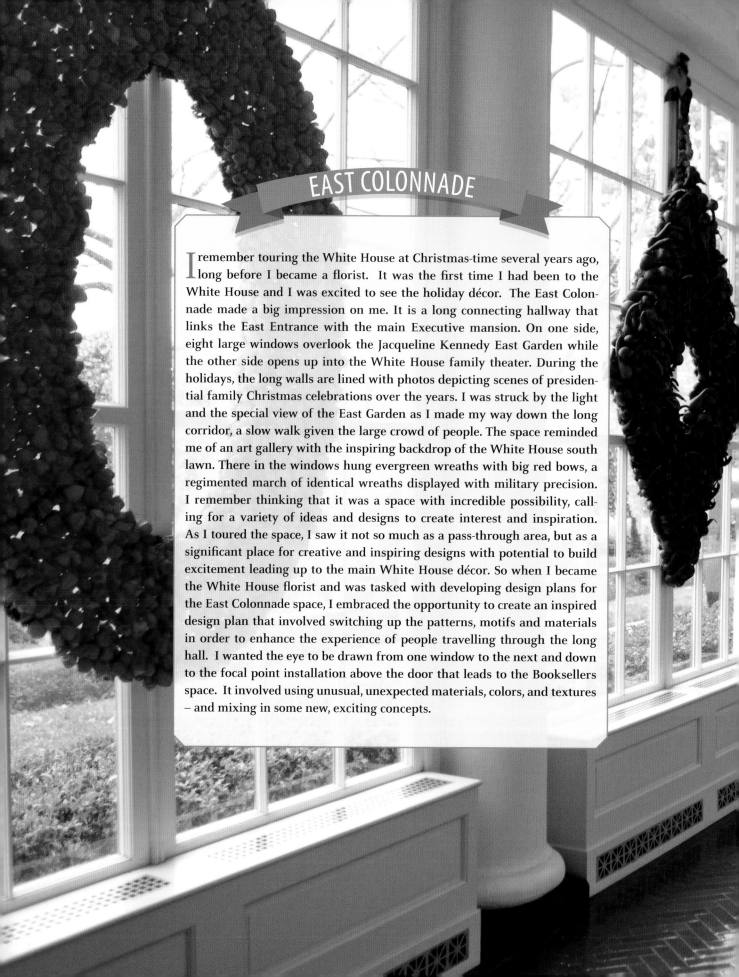

EAST COLONNADE

I remember touring the White House at Christmas-time several years ago, long before I became a florist. It was the first time I had been to the White House and I was excited to see the holiday décor. The East Colonnade made a big impression on me. It is a long connecting hallway that links the East Entrance with the main Executive mansion. On one side, eight large windows overlook the Jacqueline Kennedy East Garden while the other side opens up into the White House family theater. During the holidays, the long walls are lined with photos depicting scenes of presidential family Christmas celebrations over the years. I was struck by the light and the special view of the East Garden as I made my way down the long corridor, a slow walk given the large crowd of people. The space reminded me of an art gallery with the inspiring backdrop of the White House south lawn. There in the windows hung evergreen wreaths with big red bows, a regimented march of identical wreaths displayed with military precision. I remember thinking that it was a space with incredible possibility, calling for a variety of ideas and designs to create interest and inspiration. As I toured the space, I saw it not so much as a pass-through area, but as a significant place for creative and inspiring designs with potential to build excitement leading up to the main White House décor. So when I became the White House florist and was tasked with developing design plans for the East Colonnade space, I embraced the opportunity to create an inspired design plan that involved switching up the patterns, motifs and materials in order to enhance the experience of people travelling through the long hall. I wanted the eye to be drawn from one window to the next and down to the focal point installation above the door that leads to the Booksellers space. It involved using unusual, unexpected materials, colors, and textures – and mixing in some new, exciting concepts.

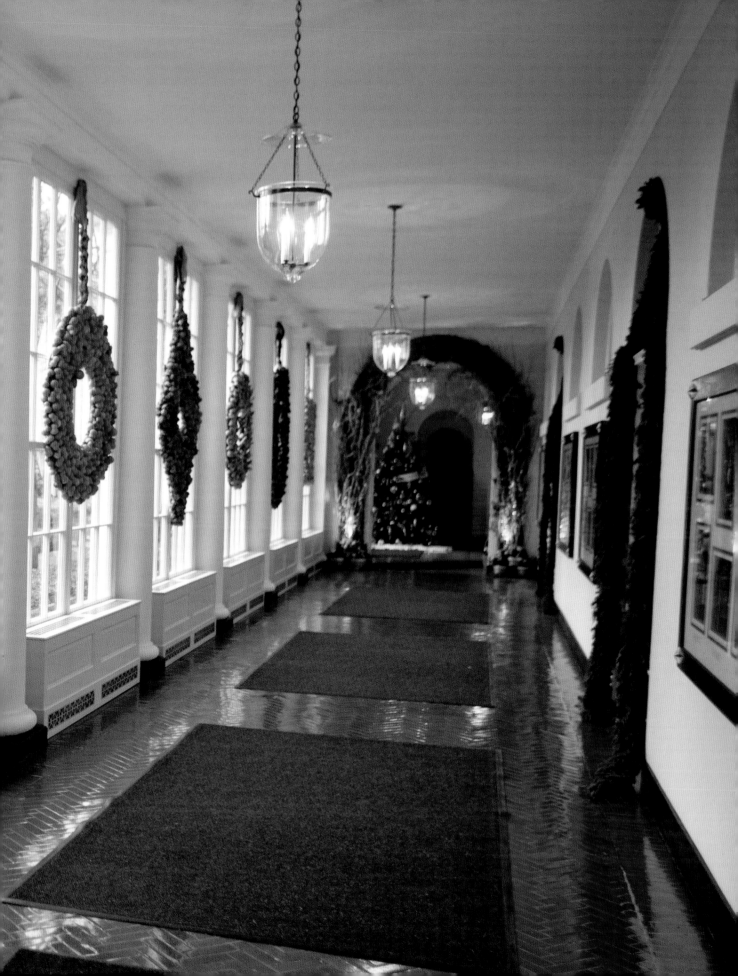

FRUIT AND VEGETABLE WREATHS.

In 2010, my inspiration was the First Lady's vegetable garden which was already producing a wide variety of vegetables and herbs. The goal was to showcase the power of design to communicate key messages by connecting the holiday design with the First Lady's 'Let's Move' healthy eating and exercise initiative, a key priority. My concept was a collection of eight fruit and vegetable wreaths in various geometric forms: squares, rounds, diamonds and oval shapes. The oversized wreath frames were covered in dried vegetables, fruits and flowers in vibrant hues. Because the designs would be in place for over a month, the materials needed to last the duration of the season. Dried materials, including gourds in various colors (purple, green, gold), were a good option, as was a wreath made entirely of orange lanterns, a seasonal orange plant with a red fruit inside. We collected all of the materials, sourcing them from a supplier that specializes in dried materials. The large four-foot wreath frames were reinforced with wood and chicken wire in order to support the weight of the fruit.

We covered the forms with a first layer of bubble wrap to provide an even surface on which the decorative materials could be applied. Teams of volunteers methodically wired the fruit to the frame. Another helpful tip is to use straight wire to string together three or more pieces of the fruit or vegetables. Then these pieces can be stretched across the frame and tied on the back of the frame. The volunteers worked on these pieces over a period of several months. During the installation period, the carpenters helped us hang the heavy pieces with strong cable cording in the East Colonnade windows. In the south-facing space, the light shone through the dried materials, illuminating them like stained glass windows. We created French braided cording in coordinating colors using a technique my grandfather taught me long ago to cover the cable. The shapes were hung in a series, with alternating shapes drawing the eye throughout the space. To carry out the natural theme, we created an archway made of crystal covered branches growing out of a base of winter vegetables and gourds. This provided the focal point piece at the end of the hallway.

p. 56 The East Colonnade was decorated with a collection of oversized fruit and vegetable wreaths made from a variety of dried materials in a mix of geometric shapes in 2010 – oval, diamond, round and square. The use of fruits and vegetables supported the First Lady's 'Let's Move' initiative that promoted healthy eating and exercise.

DECORATIVE DOOR SURROUNDS.

Over the years, the East Colonnade became a key space to decorate – featuring creative wreath designs, topiaries and always a dramatic doorway surround crafted from simple and/or natural materials. The starting point was a vintage iron frame custom-made for the space that we could re-use year after year. We started with sketches and color proposals, mapping out a pattern and motif. When creating detailed pattern work for door surrounds and column covers, we always started in the middle of the piece to lay out the pattern and then work towards the outer edges. This ensured that the pattern was centered and precise on the frame. One design featured an intricate trellis pattern that we made from a red ribbon-covered base with a green pipe cleaner overlay. We drew this pattern directly onto the frame, using tracing paper and a carpenter's measuring tool with a right angle. It was a detailed and time-consuming process to ensure that the pattern was perfectly laid out. We made a small section of the design to calculate the time and materials it would take to complete the entire piece. This analysis allowed us to develop specific plans for each project, creating the context and timelines for how they fit into the overall project plan.

The process for creating the pipe cleaner trellis required a systematic approach. Four volunteers who work together as part of a local event planning firm were my core team. We broke the project down into its component parts. After the design was carefully measured and traced onto the frame, the volunteers swung into action. They started by cutting hundreds, maybe thousands, of small pieces of green pipe cleaner, using wooden templates that the carpenters made to ensure that the pieces were uniform in size and shape. The volunteers wrapped the piece of pipe cleaner around the wood block, gathering the four shapes (labeled A, B, C, and D) in separate baskets. They sat at a long table, working in an assembly line fashion. When they left, other volunteers could come in and pick up where they left off, using the template wood blocks as patterns to maintain consistency and uniformity. The application process involved hot-gluing the pipe cleaner pieces to the red ribbon frame, taking care to follow the pattern, making it even and precise. It got tricky towards the top of the archway as it curved around the opening.

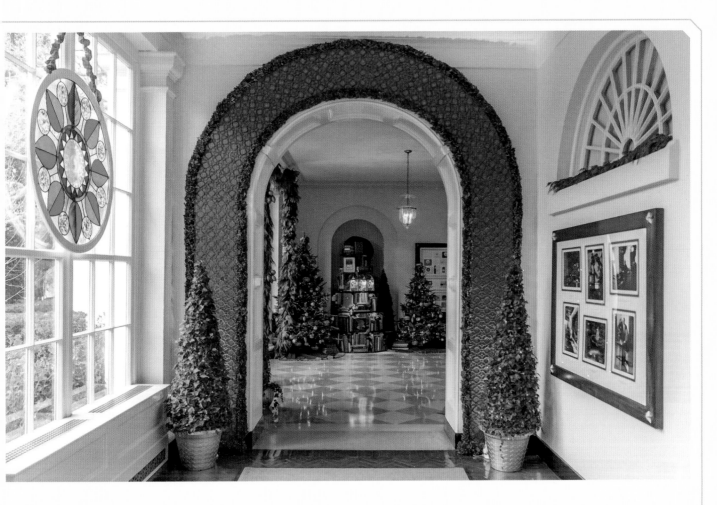

Here, the volunteers had to create some 'bridge' pieces to link the curved part of the geometric trellis design together with the straight sides. It was a very time-consuming project. But when it was done and we could see the finished design (the texture, color, pattern, motif), we all agreed it was worth the effort. The carpenters installed the piece over the doorway at the end of the East Colonnade where it became a striking and festive architectural feature throughout the season. My favorite comment I overheard as guests walked by was when people said that they were excited to try this at home – using simple ribbon and pipe cleaners – to get the same effect. Little did they know how much time and effort it took to complete the project. But if it looked effortless and inspired visitors to create a similar design at home, we felt we had achieved our goal.

Another time, we created a variation of the archway using preserved hydrangea that was applied in a chevron motif in alternating stripes of burgundy and green. Similarly, this project required expert measuring and calculations to achieve the correct pattern. The hydrangea was both a seasonal choice using traditional holiday colors and a practical one since the preserved material would last the duration of the season. We measured and then glued the hydrangea on in small clusters of petals to build up texture. When the piece was installed, we lined the edges with narrow pine garlands to accentuate the classic Christmas effect.

Green pipe cleaners, red ribbon and boxwood were fashioned into an intricate garden trellis design in 2013 to decorate the East Colonnade archway. Teams of volunteers worked for several months to create this festive focal-point design.

p. 60 In the East Colonnade, a dramatic arch made of burgundy and green hydrangea applied in a chevron motif adds a contemporary dimension to the 2014 holiday décor.

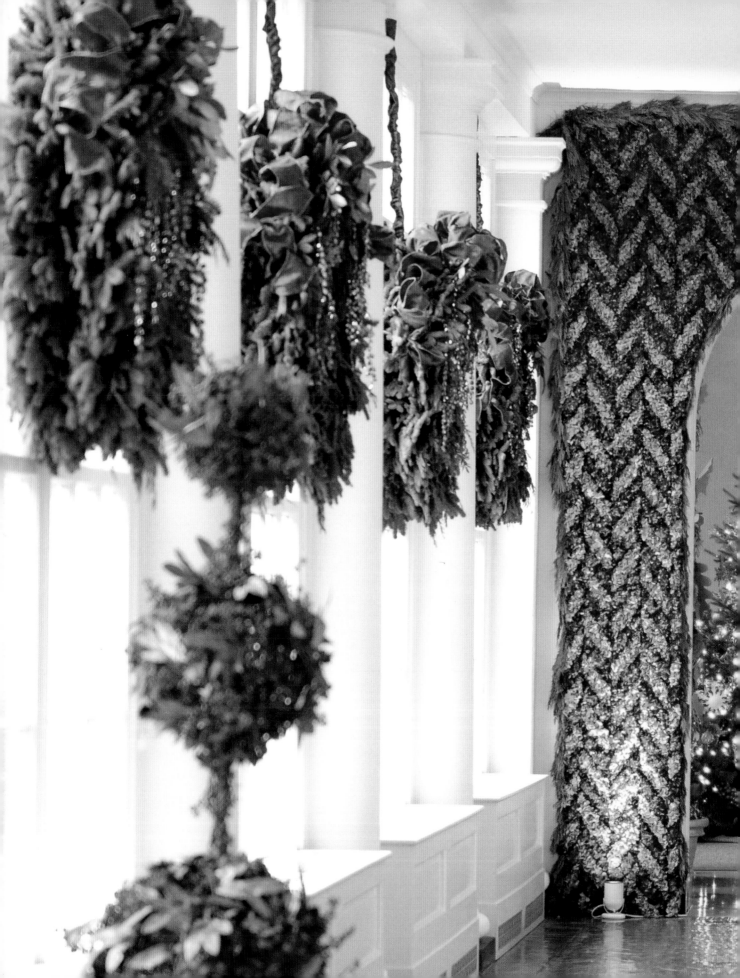

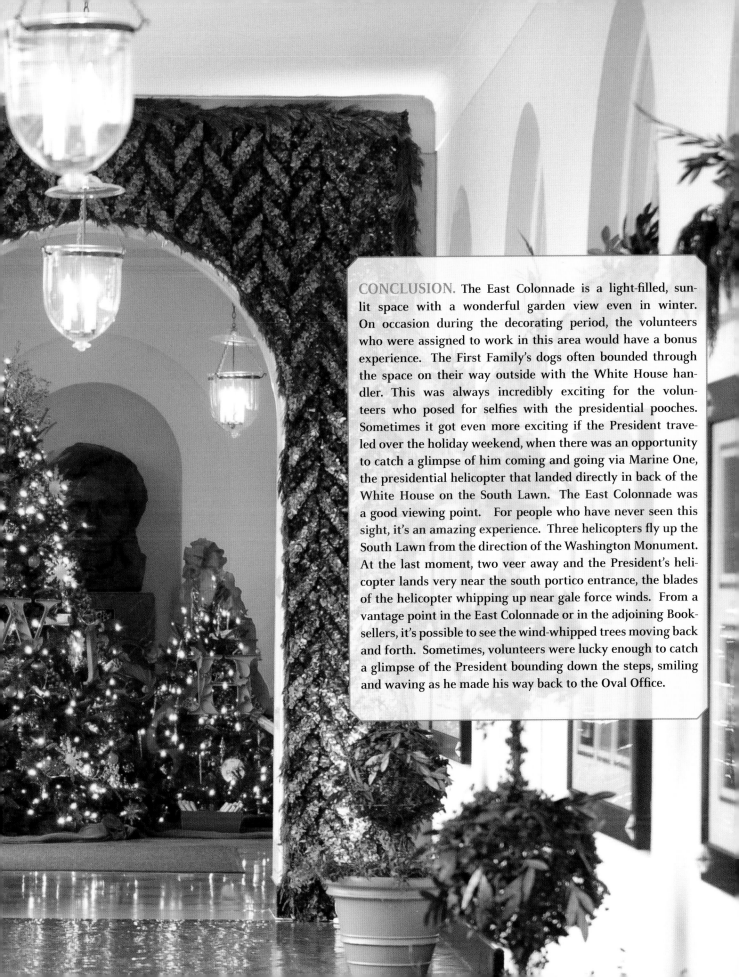

CONCLUSION. The East Colonnade is a light-filled, sun-lit space with a wonderful garden view even in winter. On occasion during the decorating period, the volunteers who were assigned to work in this area would have a bonus experience. The First Family's dogs often bounded through the space on their way outside with the White House handler. This was always incredibly exciting for the volunteers who posed for selfies with the presidential pooches. Sometimes it got even more exciting if the President traveled over the holiday weekend, when there was an opportunity to catch a glimpse of him coming and going via Marine One, the presidential helicopter that landed directly in back of the White House on the South Lawn. The East Colonnade was a good viewing point. For people who have never seen this sight, it's an amazing experience. Three helicopters fly up the South Lawn from the direction of the Washington Monument. At the last moment, two veer away and the President's helicopter lands very near the south portico entrance, the blades of the helicopter whipping up near gale force winds. From a vantage point in the East Colonnade or in the adjoining Booksellers, it's possible to see the wind-whipped trees moving back and forth. Sometimes, volunteers were lucky enough to catch a glimpse of the President bounding down the steps, smiling and waving as he made his way back to the Oval Office.

HOLIDAY VEGETABLE OR FRUIT WREATHS

Inspired by the holiday crafting projects I made with my grand-mother as a child and the natural decorations of Early American colonial style, I've always enjoyed creating wreaths made from seasonal materials, especially vegetables, fruit and flowers. In recent years, I've experimented using a wide variety of resources, including unusual combinations of vegetables and foliage that are in keeping with the spirit of colonial style, but feature bold colors and unusual combinations to create a more modern aesthetic. At the White House, these colorful, natural-style wreaths hung in the windows in the East Colonnade overlooking the Jacqueline Kennedy East Garden. Although I used dried and faux fruits in my White House designs (for longevity and to comply with curatorial rules), I prefer working with real materials for the best effect. Here are some tips and techniques for making some of my favorite fruit and vegetable designs:

Tip: As a starting point, choose a sturdy frame and add a strong bark wire loop for hanging. The key to getting a dense, but light look is to work in layers beginning with a foundation layer of ribbon or foliage followed by layers of fruit and vegetables in various shapes and textures. Another tip is to work in regimented rows around the wreath to achieve the most professional finish. Create depth by wiring smaller fruits and berries in a delicate garland that can be woven in and around the design. As a reality check, it is important to note that wreaths made of fresh fruits and vegetables are not meant to last the entire holiday season, so be sure to create a replacement plan for when the wreath fades.

WHAT YOU'LL NEED

- A sturdy wreath form (straw or grapevine wreath) 18 – 22 inches
- Sturdy bark wire for hanging
- Wrapping wire
- Coordinating 3 inch ribbon (to make the base layer)
- Thin paddle wire (to make the ribbon garland)
- 18 inch straight wire (for wiring the fruit)
- A box of medium-sized fruit (e.g., apples, oranges, lemons, limes, etc.) to cover the entire front of the wreath (amount will vary depending upon size of fruit)
- Smaller accent fruit (e.g., crab apples, kumquats, etc.) – approximately 2 pounds
- 6 inch wired wood picks (for attaching the smaller fruit)
- Winter foliage and berries (e.g., ivy, holly, juniper, etc.) (for accents and finishing touches)
 Optional: winter flowers (e.g., orchids, hellebores, etc.) 4 inch water picks (for attaching the flowers)

STEP-BY-STEP TECHNIQUES

1 Prepare the frame for hanging by adding the bark wire to the wreath, doubling the wire and wrapping it securely to create a 3 or 4 inch loop.

2 Create a ruched ribbon garland under layer for the fruit using the techniques described on page 48.

3 Start wiring the fruit by piercing the straight wire through the center of the fruit, wiring 3 pieces of fruit together on this wire in the same fashion.

4 Place the string of wired fruit across the top of the wreath, tying the wire securely on the back.

5 Add rows of fruit around the wreath so that the entire front is covered.

6 Incorporate the accent fruit in a random (but balanced) pattern by inserting one end of the wired wood pick into the fruit and the other into the wreath, weaving the wood pick securely into the frame and continuing to add fruit around the wreath.

7 Wire small bunches of 3 inch sprigs of winter greenery to the wood picks and insert them into the wreath, taking care to fill any holes, creating a natural finish.

8 As a finishing touch, create a delicate garland of winter berries by stringing them on thin wrapping wire, weaving them into the design at different heights and depths to add interest.

Optional: Add festive floral touches by inserting blossoms and blooms (in water picks) in and around the design.

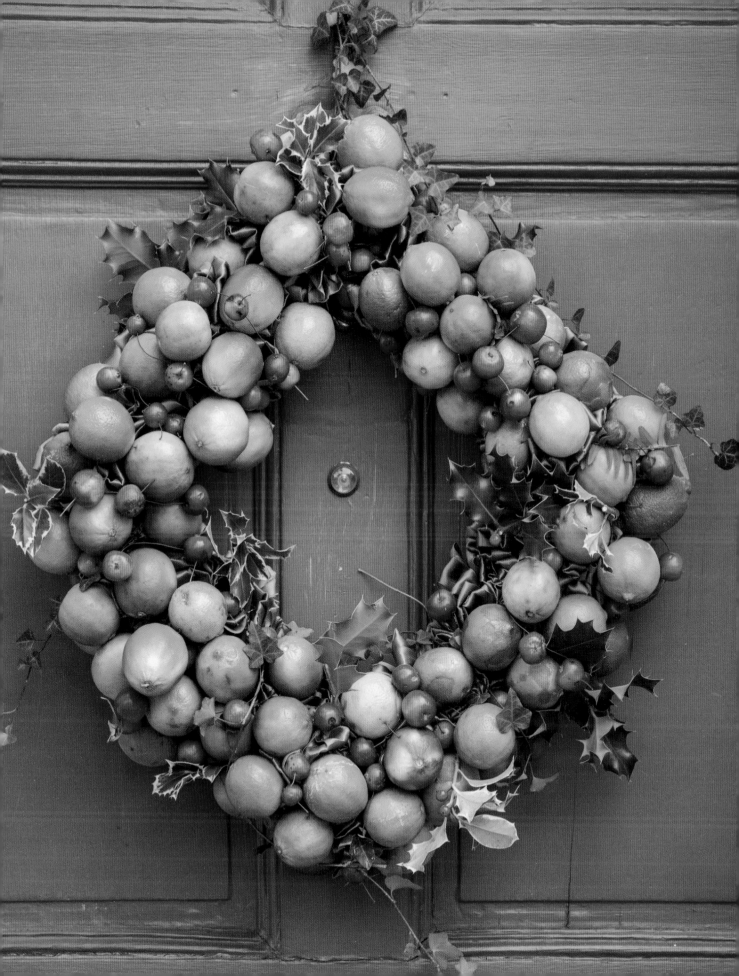

HOLIDAY FRUIT AND VEGETABLE WREATHS

Vegetable wreaths are another festive option for bringing natural style into the home. The advantage of using vegetables over fruit is that they tend to be longer-lasting. Potato wreaths, for example, can span the entire season. On the other hand, fruit tends to provide more colorful options for wreath designs. Whether you opt for fruit or vegetables, follow the same tips and techniques described on the previous page, wiring the elements together and adding layers of materials. Visit your local Farmers' Market or grocery store for endless inspiration

At the White House, our holiday wreath designs always encompassed a broad range of natural materials and unusual combinations, inspired by trips to the Farmers' Market and grocery store (and historic Colonial Williamsburg designs). Here are some of my recent creations featured on Old Town Alexandria doors, clockwise from the top: a wreath of purple potatoes, pearl onions and orange winter berries; a round wreath made of green peppers, and a diamond-shaped wreath made of lemons, holly berries and variegated foliage. Last year I surprised my neighbors with holiday wreaths for their doors: an oval-shaped plum and berry wreath and an orange wreath with fuchsia orchids and green hypericum berries.

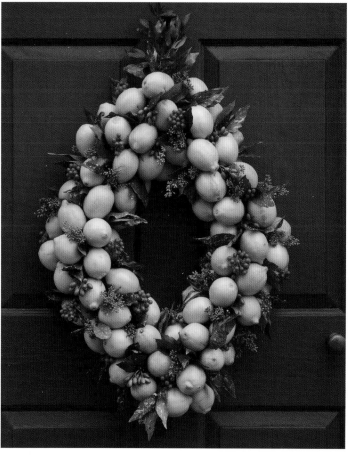

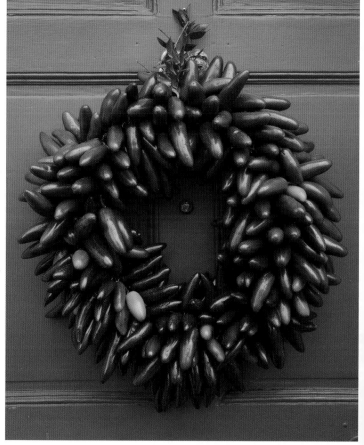

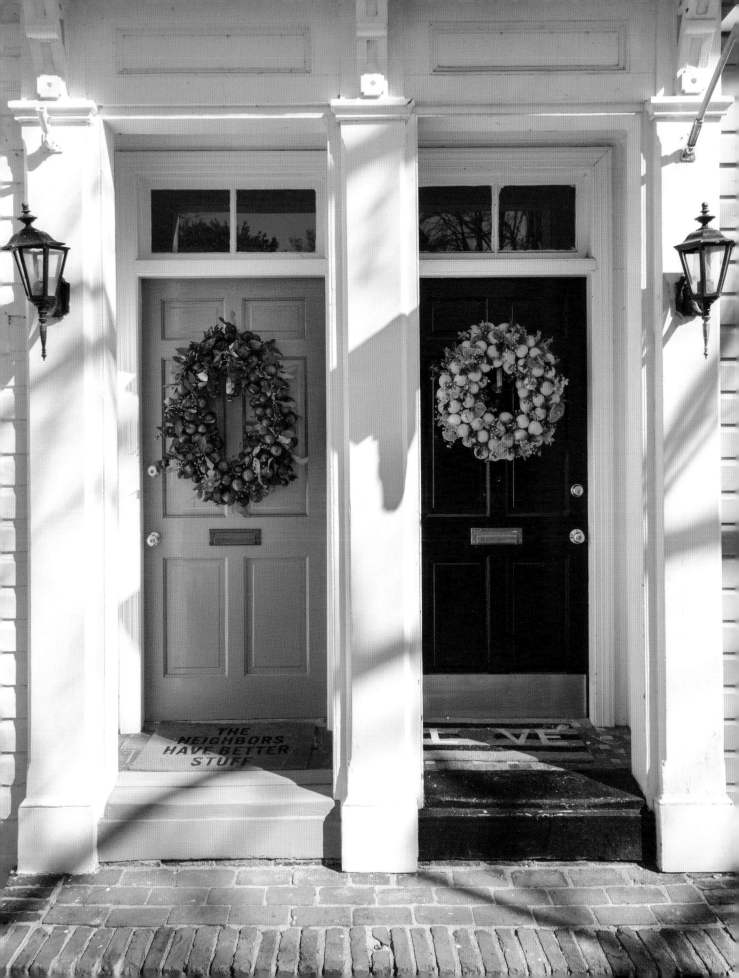

Booksellers

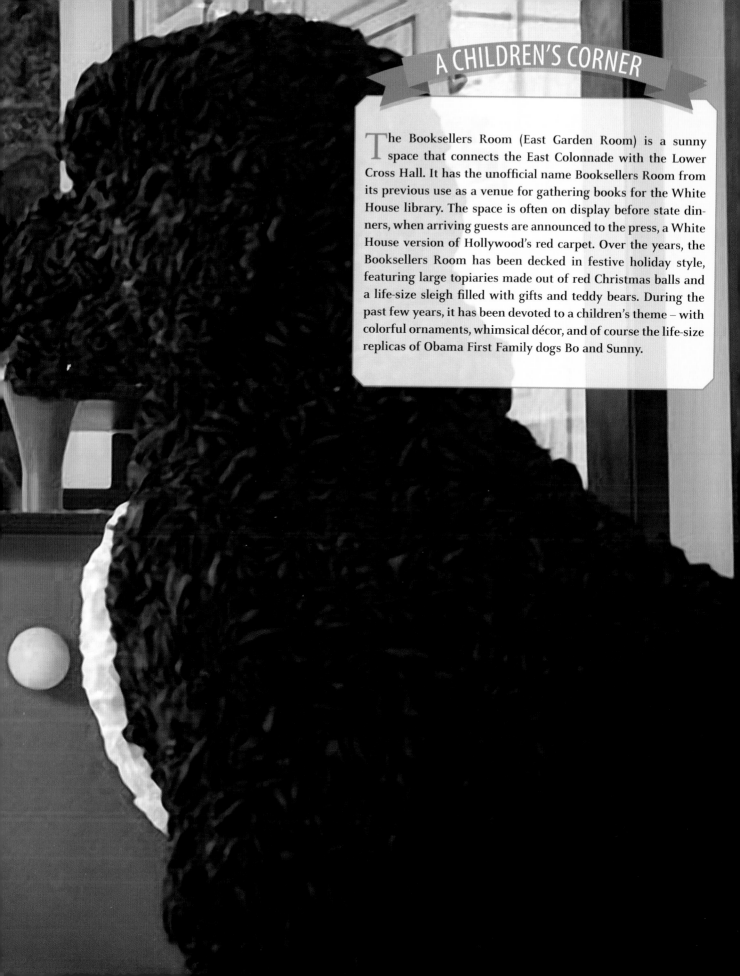

A CHILDREN'S CORNER

The Booksellers Room (East Garden Room) is a sunny space that connects the East Colonnade with the Lower Cross Hall. It has the unofficial name Booksellers Room from its previous use as a venue for gathering books for the White House library. The space is often on display before state dinners, when arriving guests are announced to the press, a White House version of Hollywood's red carpet. Over the years, the Booksellers Room has been decked in festive holiday style, featuring large topiaries made out of red Christmas balls and a life-size sleigh filled with gifts and teddy bears. During the past few years, it has been devoted to a children's theme – with colorful ornaments, whimsical décor, and of course the life-size replicas of Obama First Family dogs Bo and Sunny.

When designing for this space, I kept the First Lady's instructions in mind: she wanted a special place in the White House to be devoted to children where they would find playful and whimsical décor designed especially for them. The centerpiece displays were always Bo and Sunny – the lovable dogs who enchanted staff and visitors alike with their friendly demeanor, calm personalities, and adorable antics. We first started creating these replicas of the First Family dogs in 2010. That first year, when it was only Bo in the White House, we replicated him in a life-size form created from 40,000 twisted black and white pipe cleaners. The looped pipe cleaner garlands resembled Bo's short curly hair; it was the perfect material for re-creating his well-groomed black and white coat. We commissioned an artist to make the chicken wire frame that incorporated the distinctive features of the Portuguese Water Dog. In the flower shop, we arranged for the real Bo to stop by so that we could measure his markings. Given the mind-boggling number of individual pipe cleaners that would be fashioned into Bo's fur, we needed an army of volunteers to work on the project night and day for over five months. Some volunteers came into the flower shop where they sat in groups and wired the garlands in a technique that resembled knitting. Others would come and retrieve the materials, take them home to work on, and either bring them back or throw them to me from the other side of the White House gate. Once we had all of the material – bags and bags of intricately wired and folded pipe cleaner garlands, I called in a special group of volunteers to apply the garlands to the chicken wire frame. They used thin bullion wire to tie the garlands in place, taking care to cover the entire surface with the textured material, following the actual black and white markings of the real Bo. The entire process was fun and the time-consuming efforts paid off. During the tour, when pipe cleaner Bo was placed in position in the Booksellers area, he became a popular spot for photo opportunities and selfies. Bo – and then Sunny – became fixtures in our holiday designs. This pipe cleaner version of Bo was dubbed 'classic Bo' and was used many times over the course of the Obama administration.

p. 66 In 2014, I invited colleagues in the Office of Science and Technology Policy and Presidential Innovation Fellows to help me create robotic versions of the First Family's dogs Bo and Sunny. The 'Bo-bots' featured moving heads and motion sensor eyes that tracked visitors as they walked by. Additional volunteers created miles of looped ribbon garlands to cover the oversized chicken-wire frames. Here, the robotic dogs are prominently displayed in the Booksellers where they delighted visitors throughout the season.

Each year, the First Lady encouraged us to exceed our work from the previous year and explore new and even more ambitious ideas. So we always looked for ways to create new and inspiring versions of our Bo and Sunny displays, the focal point décor. The following year we created a bigger version of Bo using almost 20,000 black and white pompoms. Striking a different pose, sitting in repose, surrounded by hand-made paper trees, this Bo was also a focal point display. In 2012, we made Bo out of black and white felt loops and dressed him up in festive Christmas lights with a jaunty Santa hat. By 2013, Sunny joined the scene so we doubled the fun, creating a pair of Portuguese Water Dog topiary designs – this time rendered out of looped black and white satin ribbon. That was the year we introduced a new element – moving, wagging tails – using simple drugstore 'lawn deer' motors that were inserted in the hind area of the frames. The motors were attached to cords that plugged into outlets nearby. The low-tech approach, involving connecting the motor to the frame with rubber bands and wire hangers, worked well for the most part – until ribbon got caught in the motor and started to smoke, causing plumes of smoke to emerge from Bo's tail. Luckily, this occurred towards the end of the season and we could unplug the dogs for a safe, if motionless, end to the season. My work on Bo and Sunny culminated with the robotic version of the dogs we created in collaboration with the White House Office of Science and Technology Policy and the Presidential Innovation Fellows. The robotic dogs featured heads that were retro-fitted with simple Arduino motors programmed to move back and forth; Sunny even featured motion sensor eyes that tracked visitors as they walked by. The idea was to link new technologies with White House design, sharing it with school children via social media platforms so that they would be inspired to create their own robotic versions of Bo and Sunny. The collaborative project made a strong point about the value and importance of science education.

While the Bo and Sunny replicas were the focal point designs, special accessories complemented and accentuated the presidential pet theme. Bo-themed snowflakes ('Bo-flakes') featured charming scenes of Bo frolicking in the snow while the Bo and Sunny 'houndstooth'-patterned gift wrap paper was posted online for people to print out at home. Both these designs added a whimsical touch to the Bo and Sunny-themed displays. Another time, we created special 'Bo-tales' hand-crafted ornaments. These depicted Bo and Sunny engaging in a variety of holiday activities and charming vignettes: sledding, making cookies, hanging stockings above the mantel, decorating the tree, wrapping gifts, ice skating, sending greeting cards and car-

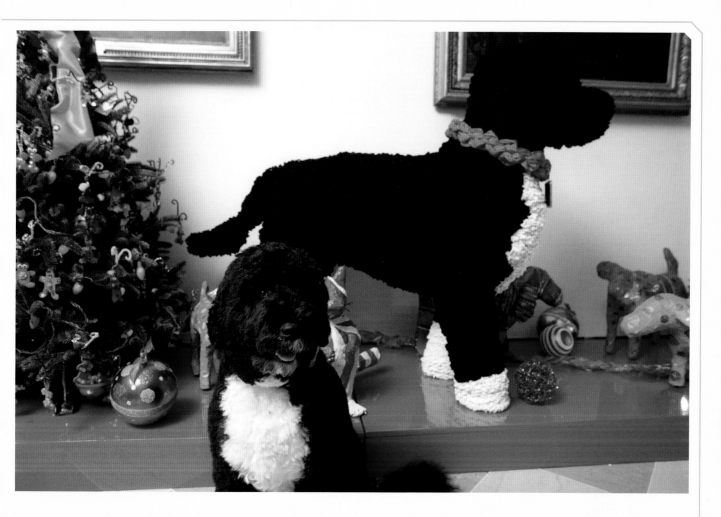

oling. The ornaments were displayed in the Booksellers Room and throughout the White House.

Color schemes changed over the years, but always emphasized a festive theme: classic Christmas colors of red and green amplified to contemporary shades of fuchsia and lime green and punched up with decorative patterns: harlequin diamonds, polka dots and circus-stripes. A riot of color and sparkly ornaments set off the black and white topiary dog frames. We also explored additional color schemes that incorporated seasonal colors from the landscape and inspiration from classic children's stories. For example, the children's book 'Polar Express' provided the inspiration for a wintry theme featuring flocked Christmas trees with white lights and sleigh bell ornaments; tall stacks of books shaped like trees; garlands of children's letters to Santa, glittered forest animal ornaments; silver sleigh bells and flocked pinecone wreaths. The children's wonderland scheme was carried out in shades of silver, evergreen, white and powder blue. Another

children's theme was inspired by the First Lady's garden – featuring fun fruit and vegetable ornaments, bright milk glass balls arranged in an ombre pattern, with coordinating wreaths and garlands and whimsical paper flower ornaments. Additional décor included garden friends: birds, bees, butterflies and bunnies.

All of these designs and colors added a sense of whimsy and fun to the space that was designed especially for children but became a delightful stop for everyone on the holiday tour. In the final analysis, the Booksellers Room was the site of some of our most fun and creative work.

The Bo topiary we made from 40,000 looped and wired pipe cleaners resulted in a life-like rendering of the First Family's dog that became a holiday classic. Over the years, pipe cleaner Bo often made appearances at Halloween, dressed in pirate, clown and Superman costumes. Here in 2010, the faux Bo is pictured with his real counterpart in the Booksellers as part of the children's holiday display.

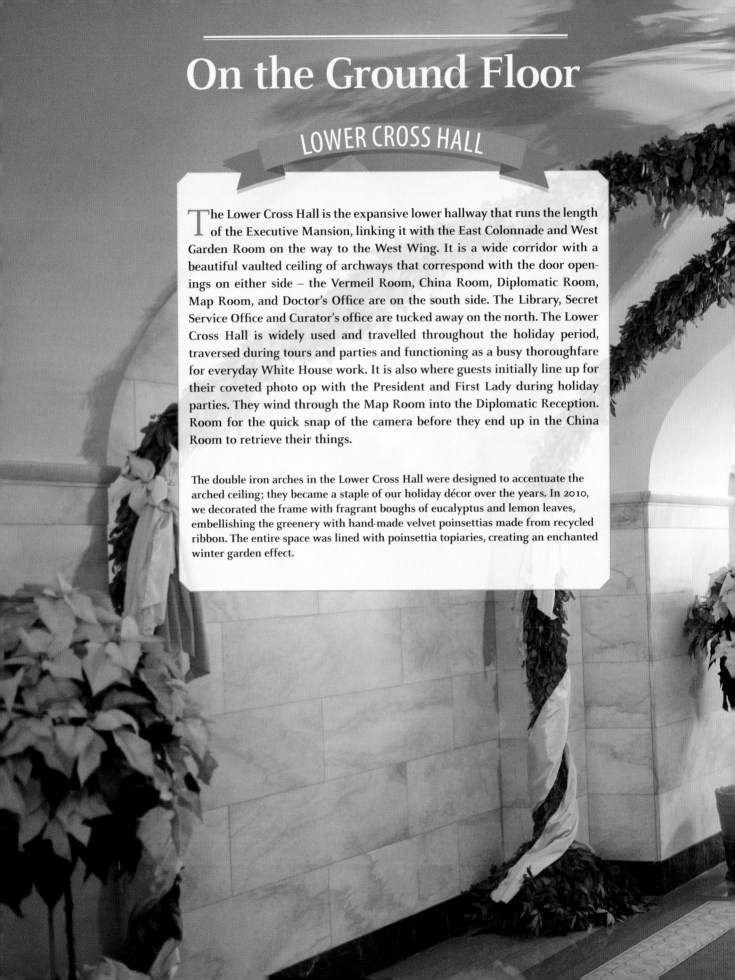

On the Ground Floor

LOWER CROSS HALL

The Lower Cross Hall is the expansive lower hallway that runs the length of the Executive Mansion, linking it with the East Colonnade and West Garden Room on the way to the West Wing. It is a wide corridor with a beautiful vaulted ceiling of archways that correspond with the door openings on either side – the Vermeil Room, China Room, Diplomatic Room, Map Room, and Doctor's Office are on the south side. The Library, Secret Service Office and Curator's office are tucked away on the north. The Lower Cross Hall is widely used and travelled throughout the holiday period, traversed during tours and parties and functioning as a busy thoroughfare for everyday White House work. It is also where guests initially line up for their coveted photo op with the President and First Lady during holiday parties. They wind through the Map Room into the Diplomatic Reception. Room for the quick snap of the camera before they end up in the China Room to retrieve their things.

The double iron arches in the Lower Cross Hall were designed to accentuate the arched ceiling; they became a staple of our holiday décor over the years. In 2010, we decorated the frame with fragrant boughs of eucalyptus and lemon leaves, embellishing the greenery with hand-made velvet poinsettias made from recycled ribbon. The entire space was lined with poinsettia topiaries, creating an enchanted winter garden effect.

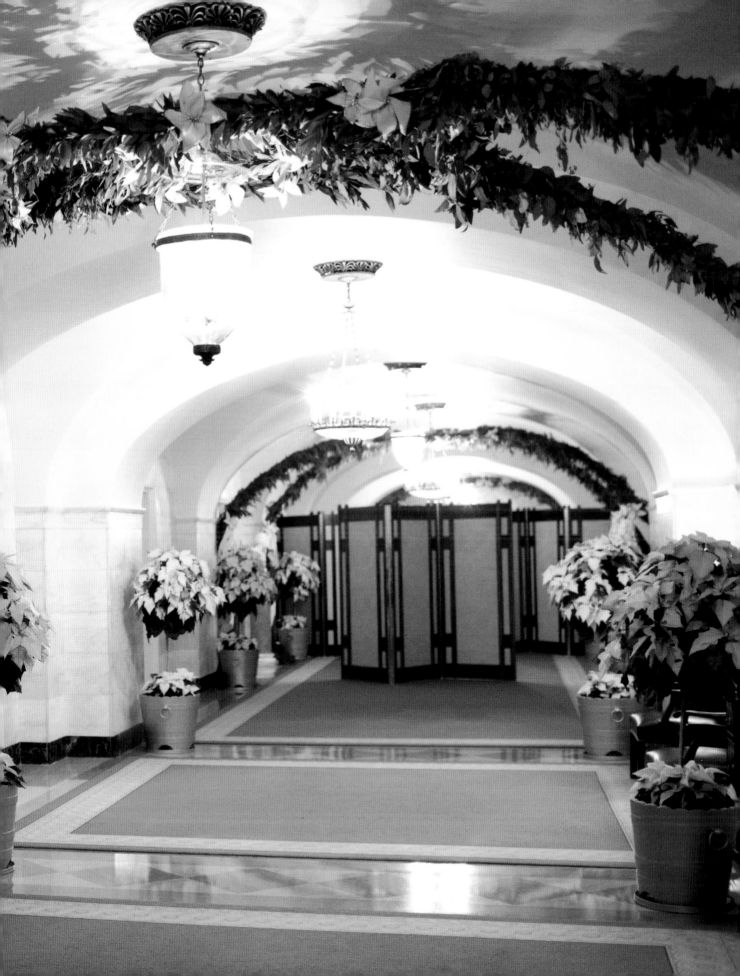

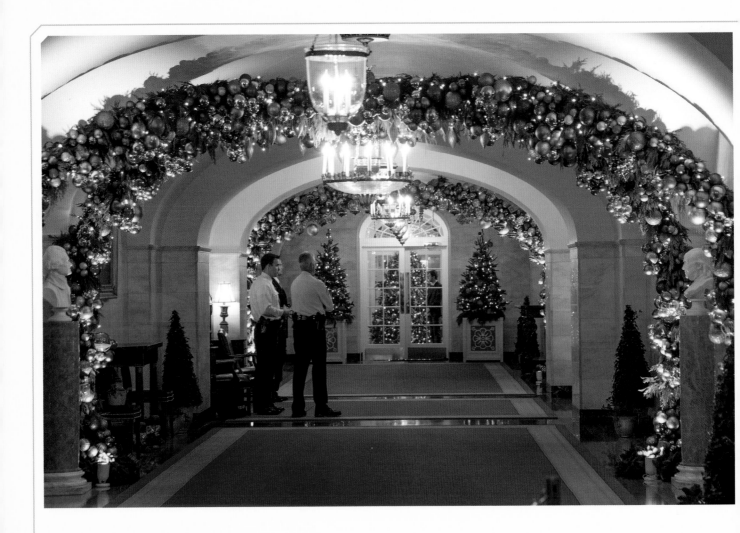

The center of the red-carpeted Lower Cross Hall holds small marble busts of former presidents that are positioned on columns. Portraits of former First Ladies, including Hillary Clinton, Laura Bush, Rosalyn Carter and Betty Ford line the corridor, anchored by 19th century marble-top pier tables placed underneath, creating an overall elegant and refined area. However, it did not always resemble an elegantly appointed, architecturally significant space. In the late 19th century, the Lower Cross Hall apparently had the air of an 'old and unsuccessful hotel' that was perennially overrun with rats, mildew and foul smells, with a damp and slimy brick floor and cobwebs everywhere.

For this version of the double arches in 2012, volunteers glued over 5,000 recycled multi-colored glass ornaments to the frames that were first wrapped in narrow fir garlands.

ARCHITECTURAL DETAILS. To develop holiday designs, we looked to the vaulted ceiling for inspiration, the most distinctive architectural element in the Lower Cross Hall. In researching ideas, my goal was to find a way to accentuate the vaulted ceiling with holiday decorations and greenery. With a relatively low ceiling, we could extend garlands and ornaments overhead, bridging the two sides of the corridor to create a unified visual aesthetic. Working with my architect friend and volunteer, we designed three double archways that would span the entire length of the Cross Hall. A local blacksmith fashioned iron arches as free-standing pieces that mirrored the curved shape of the ceiling and fit around the hanging chandelier. Over the years, these forms gave us the opportunity to decorate the space with a variety of natural materials, ornaments, and ribbons in a wide range of color schemes. The double arches became a key decorative element that we used year after year.

One of my favorite Lower Cross Hall displays was the time we used natural evergreen garlands accented with seeded eucalyptus and lemon leaves to decorate the double arches. The greenery was complemented by tall white poinsettia topiaries that lined the hallway. We chose poinsettias because of their special connection the Christmas story. Legend has it that the flower was first presented as a humble gift to decorate a manger scene in a Mexican village and then was introduced to the United States in 1825. They have been a beloved holiday staple ever since.

Overhead, we continued the poinsettia motif in the eucalyptus and lemon leaf garlands, fashioning flower ornaments out of recycled velvet ribbon and gold balls. We wired the velvet flowers to the garlands as if they were growing up into the greenery. This project was a perfect example of how we could take things we had on hand – spare ribbon, gold beads and wire – and turn them into decorations that would complement the décor. Over 1,000 ribbon poinsettias were made by volunteers over a period of several months leading up to the installation. The creamy white and green palette brightened up what can be a dark corridor, devoid of natural light. We added strings of light to the greenery and more lighting at the base of the arches for additional effect, creating the feeling of a winter garden.

Another time we used 5,000 recycled multi-colored glass ornaments from the White House collection to decorate the arches. The balls were tied into clusters and then hot-glued onto an evergreen garland base. To create maximum impact, we designed the balls to cover the entire surface of the double arches, including the platform bases. The volume of the colorful ornaments, fashioned into the triple arch design, created a festive and dynamic display.

Floral designs were a key decorative feature in the Lower Cross Hall during the holiday season. We place bouquets underneath the portraits of First Ladies, evoking a gallery effect.The flowers served as a finishing touch that brought the entire space to life. For containers, I often selected the Chinese export porcelain bowls favored by Jackie Kennedy. These were the perfect shape and size for presenting a classically elegant bouquet. We filled them with seasonal flowers and greens: roses, amaryllises, and paper white narcissus, mixed with evergreens (e.g., ce-

dar, pine, eucalyptus, etc.) and winterberries arranged in the garden style. The color schemes varied from year to year, but we often worked in monochromatic tones to create the most impact.

By lining the corridor with distinctive architectural elements, seasonal topiaries and bountiful displays of fresh flowers, our goal was to create an inspiring holiday backdrop in the historic – and well-travelled – Lower Cross Hall space.

A key component of all of our holiday installations involved adding fresh flower bouquets as a finishing touch. Here I am placing small arrangements of roses, orchids and berries in hand-made magnolia leaf-covered vases along the Lower Cross Hall corridor in preparation for a holiday party.

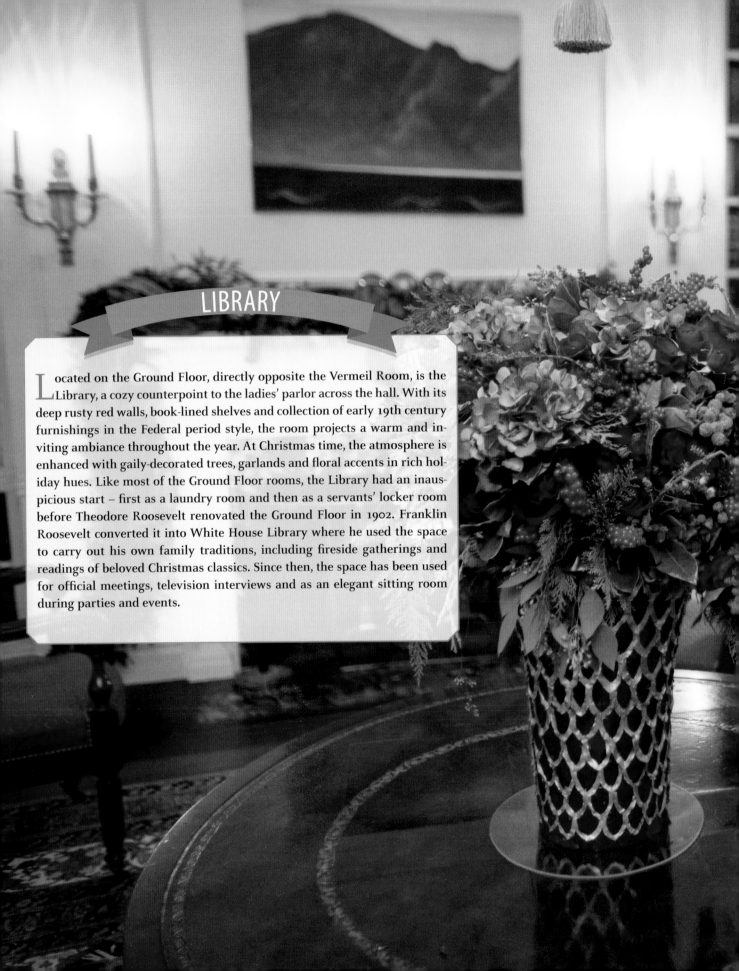

LIBRARY

Located on the Ground Floor, directly opposite the Vermeil Room, is the Library, a cozy counterpoint to the ladies' parlor across the hall. With its deep rusty red walls, book-lined shelves and collection of early 19th century furnishings in the Federal period style, the room projects a warm and inviting ambiance throughout the year. At Christmas time, the atmosphere is enhanced with gaily-decorated trees, garlands and floral accents in rich holiday hues. Like most of the Ground Floor rooms, the Library had an inauspicious start – first as a laundry room and then as a servants' locker room before Theodore Roosevelt renovated the Ground Floor in 1902. Franklin Roosevelt converted it into White House Library where he used the space to carry out his own family traditions, including fireside gatherings and readings of beloved Christmas classics. Since then, the space has been used for official meetings, television interviews and as an elegant sitting room during parties and events.

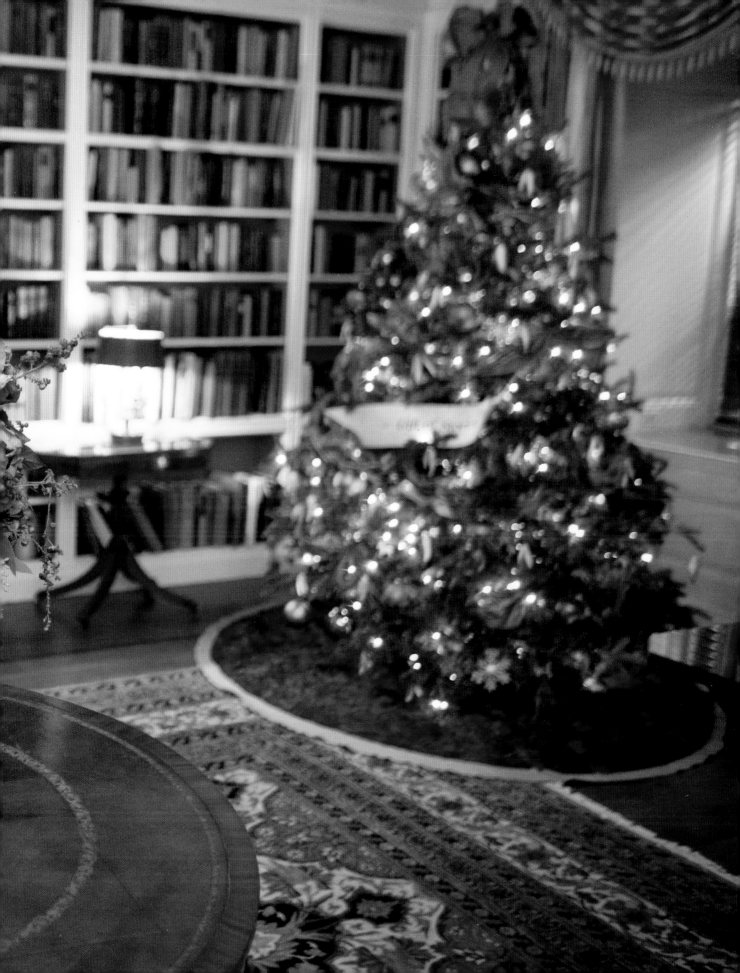

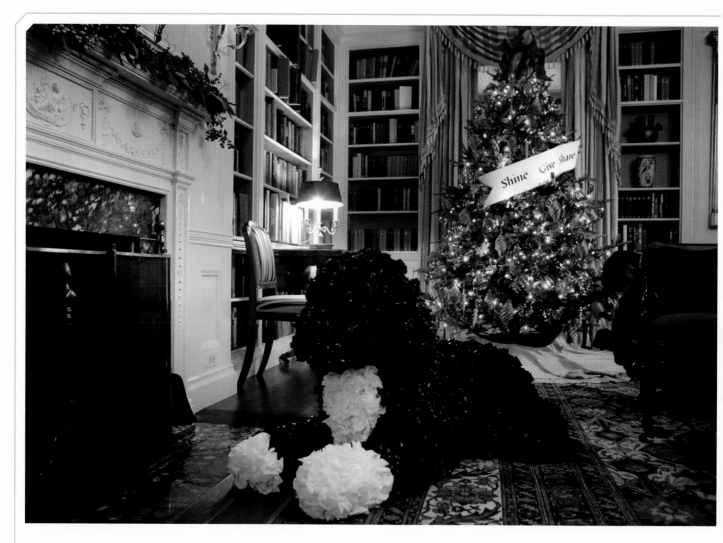

In 2011, each room of the White House featured a hand-crafted version of Bo made from a variety of black and white materials. Here, 'trash bag Bo', made from strips of folded and looped black and white trash bags, is situated in front of the Library fireplace, striking a relaxed pose.

p. 74 With its warm red colors and elegant furnishings, the Library is especially well-suited for festive holiday décor. We often decorated the tree and mantel in classic Christmas hues of forest green, burgundy red and gold which complemented the flowers and décor. This centerpiece bouquet of red roses, hydrangea and winter berries was set in a hand-made vase of burgundy copper beech and gilded lemon leaves, carved into a scalloped motif to create an integrated, natural effect.

All of the Ground Floor parlors are more intimate in scale and proportion than the rooms above them on the State Floor. In addition, they all feature classic, traditional furnishings and décor. To give the Library a festive holiday look, we focused on a few key areas: a 10 ft. holiday tree, a mantel garland and a large centerpiece bouquet for the round center table in the room, using colors that coordinated with the furnishings. This involved selecting decorations in traditional holiday colors – red, green, gold, and copper ribbons and ornaments in a variety of materials and finishes – silk, satin, glass, glitter and paper, enhanced with natural materials and greenery. We often gravitated towards burgundy and moss green shades that coordinate well with the upholstery and décor.

The tree is always positioned in a corner of the room directly across from the door, ensuring that it is visible for tours and yet out of the path of holiday revelers. Our decorating strategy focused on creating a multi-layered look of ornaments, textured ribbons, and special hand-made touches such as pinecone ornaments and paper cones embellished with gilded trimming. The tree coordinated with the mantel garland in both color and theme and was decorated using the same design strategy and techniques: starting with lights, ornaments, followed by ribbon swags and smaller ornaments, delicate crystal beads and branches as a finishing touch. Sometimes we would incorporate a literary or an educational theme into the mix given the Library setting. One year, we crafted a vase out of old, damaged books, repurposing it as a colorful urn for a holiday floral display.

In general, flowers took center stage in the Library during the holidays just like in the Vermeil Room across the hall. My concept was to make the container an important part of the overall display to create an integrated and cohesive look. Over the years, we crafted an entire collection of Library containers using a range of materials, colors and floral art techniques: gold beads and berries configured in a concentric circle motif, burgundy red copper beech and gilded lemon leaves applied in a scalloped motif, and magnolia leaves stacked in a diagonal pattern. All of these vases were filled with a bountiful array of seasonal flowers, usually in complementary shades of red and green.

In 2011, we created a replica of Bo (the First Family dog) in every room, including the Library. Throughout the State and Ground Floors, we used every black and white material we could think of – black and white ribbons, pipe cleaners, licorice and marshmallows, pompoms and buttons to create a variety of Bo displays, both large and small. In the Library, we designed a life size version made out of black and white trash bags. We cut the trash bags into strips, folding and wiring them into looped garlands to replicate Bo's fur and applying them over a chicken wire frame. Trash bag Bo was realistically positioned in front of the fireplace – not unlike a real pose Bo might assume during his typical day.

The Library, with its traditional red and green color scheme, Christmas tree, festive mantel garland – and fireside Bo – resembled a cozy setting that is embodied in many homes across America. In this idyllic vignette, the only missing

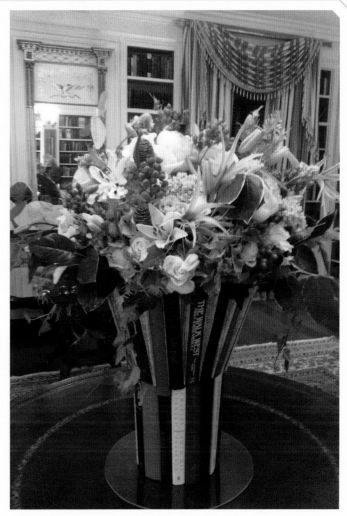

thing is a jolly Santa making his way down the chimney to spread joy and holiday cheer with his overstuffed bag of gaily wrapped Christmas gifts.

This focal point bouquet of creamy winter white flowers – roses, lilies, spider amaryllises, berries and variegated foliage – was arranged in an unusual vase made of old books that were glued to a simple bucket container. The design conveyed a subtle message about the importance of reading and literacy, an appropriate theme in the Library.

VERMEIL ROOM

The Vermeil Room is a lovely parlor on the Ground Floor of the White House that is named for its priceless collection of 18th century gold-plated silver on display in the room. The 1,575- piece collection of classical urns, vases, footed bowls and candelabra was bequeathed to the White House by Margaret Thompson Biddle in 1956. The extraordinary pieces seem to cast the entire room in a golden glow. The room's refined and feminine ambiance is defined by the portraits of First Ladies, including Eleanor Roosevelt, Lady Bird Johnson, Mamie Eisenhower, Pat Nixon, Lou Hoover, and Jacqueline Kennedy. It is also characterized by the collection of period antique furnishings: Duncan Phyfe sofa, lyre-back chairs, Federal Period side tables and a 19th century mahogany center table. A soft peach and gold color scheme is enhanced by the warm afternoon sun streaming in the south-facing windows. The entire room exudes an atmosphere of elegant tranquility.

During the holidays, we decorated the room with Christmas trees, mantel garlands and flowers that were designed to complement the room's period décor. For inspiration, I focused on color – a vintage palette of seashell-colored ornaments and ribbons in shades of pale coral, blush pink, tinsel silver and burnished gold that we also used in floral displays. To bring additional meaning and depth to the displays, we focused on the contributions and legacies of the First Ladies whose portraits hang in the room. To commemorate Jackie Kennedy's choice of the original 'Nutcracker' White House Christmas theme, for example, we incorporated ballerina and vintage glass ornaments, sheet music, tulle fabric details and organza ribbons in the floral decorations, the tree and mantel designs. Another year, we looked to inspirational messages of First Ladies to guide décor decisions, including Eleanor Roosevelt's famous quote that the 'future belongs to those who believe in the beauty of their dreams' – which inspired us to create ethereal decorations of glistening crystal branches and winter birds to articulate an aspirational, dream-link mood. Many of the First Ladies depicted in the room took a strong interest in flowers and gardening that we highlighted in fanciful, floral-themed ornaments and décor. Mamie Eisenhower, known for her fondness of the color pink – and pink carnations – provided inspiration for both holiday decorating schemes and floral displays.

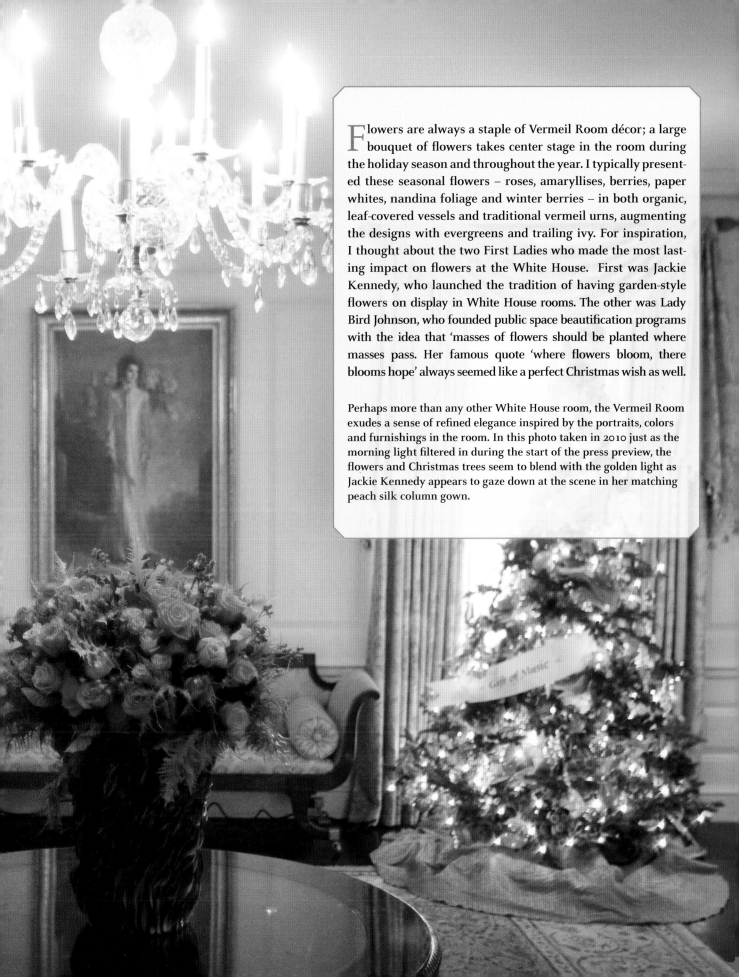

Flowers are always a staple of Vermeil Room décor; a large bouquet of flowers takes center stage in the room during the holiday season and throughout the year. I typically presented these seasonal flowers – roses, amaryllises, berries, paper whites, nandina foliage and winter berries -- in both organic, leaf-covered vessels and traditional vermeil urns, augmenting the designs with evergreens and trailing ivy. For inspiration, I thought about the two First Ladies who made the most lasting impact on flowers at the White House. First was Jackie Kennedy, who launched the tradition of having garden-style flowers on display in White House rooms. The other was Lady Bird Johnson, who founded public space beautification programs with the idea that 'masses of flowers should be planted where masses pass. Her famous quote 'where flowers bloom, there blooms hope' always seemed like a perfect Christmas wish as well.

Perhaps more than any other White House room, the Vermeil Room exudes a sense of refined elegance inspired by the portraits, colors and furnishings in the room. In this photo taken in 2010 just as the morning light filtered in during the start of the press preview, the flowers and Christmas trees seem to blend with the golden light as Jackie Kennedy appears to gaze down at the scene in her matching peach silk column gown.

GILDED BRANCH AND RIBBON VASEE

During the Christmas season, I always incorporate a metallic touch in my own décor and floral displays to add notes of festive holiday splendor and cheer. Set against the glow of twinkling Christmas lights and the warm glow of candlelight, classic gold and silver finishes sparkle, bringing light and magic to holiday displays. At the White House, I found that metallic touches mixed well with a variety of color palettes, complementing pieces in the historic collection and a variety of individual room furnishings and decor. The Vermeil Room, with its impressive collection of gilded urns, vases, and bowls, was especially well-suited for gold and silver embellishments. Because flowers are always a key feature in the Vermeil Room – during the holidays and throughout the year – the centerpiece display, including the vase, became important decorative elements. For these vessels, I often used natural elements, including leaves and branches, to introduce the idea of winter, creating a textural, organic effect. Here is an idea for creating a branch and ribbon-covered vase, using a simple garland technique, for a focal point holiday floral display.

WHAT YOU'LL NEED

- 1 large flared plastic floral bucket (17 inches tall with a 12 inch opening)
- 2 rolls of 2 ½ inch plum-colored ribbon (or another coordinating color)
- 1 roll of double-sided tape
- 2 bunches of sequined, gilded branches (from the craft store)
- 1 roll of gold paddle wire

STEP-BY-STEP TECHNIQUES

1. Prepare the bucket by taping the ribbon onto the bucket in diagonal strips, attaching the ends securely at the top and bottom of the vase.

2. Add strips of ribbon in the same fashion until the entire bucket is covered with this base color.

3. Cut the gilded branches into 3 inch pieces.

4. Create a garland of branches by wrapping the gilded wire securely around the end of one piece several times, twisting the wire and then adding the next piece (leaving about 3 inches in between branch segments) in the same fashion.

5. Continue to create several long lengths of garland.

6. Starting at the bottom, attach the garland to the ribbon-covered vase by wrapping the wired branches in rows, creating a random pattern of overlapping branches, allowing the ribbon to show through.

7. Continue wrapping until you reach the top.

8. Tie off the end of the garland onto one of the branch pieces to secure the garland in place.

9. Fill the bucket with coordinating flowers and winter foliage.

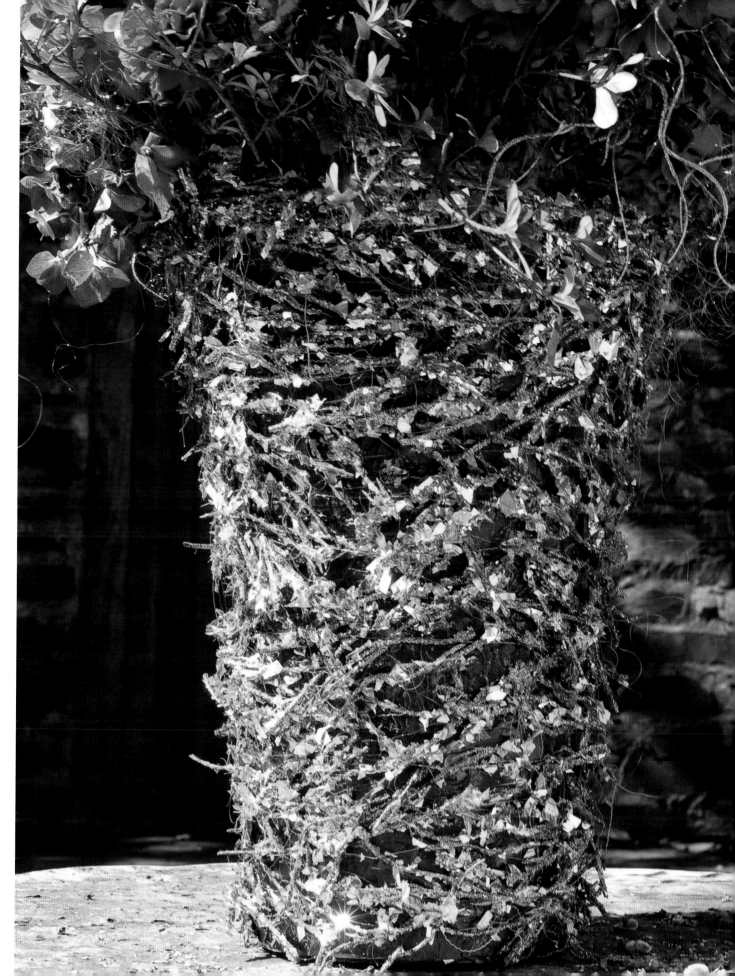

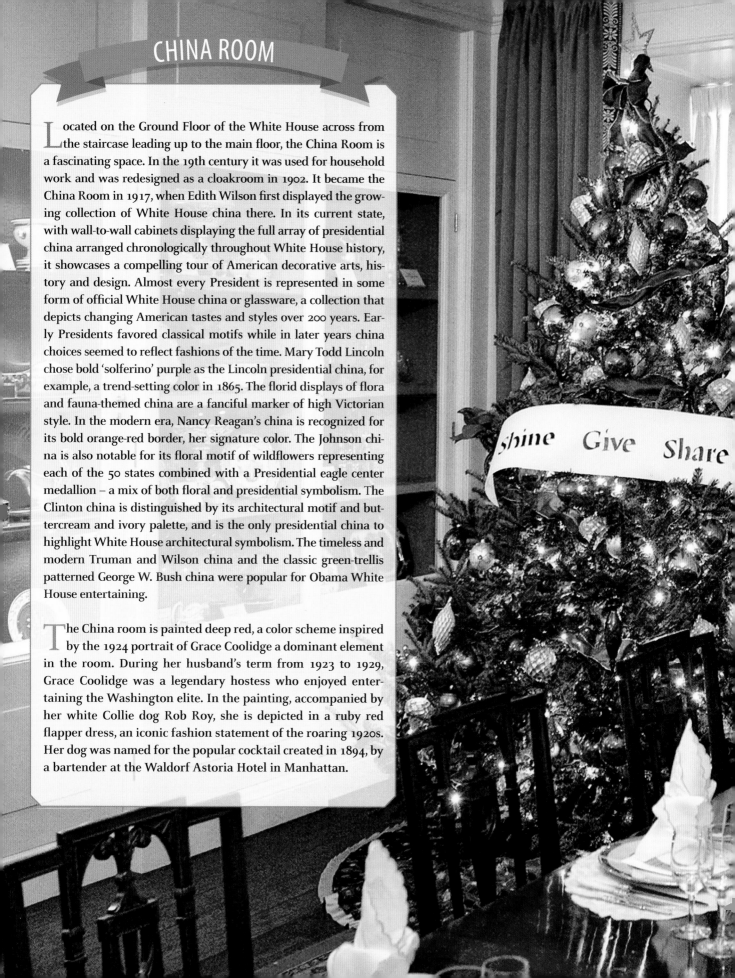

Located on the Ground Floor of the White House across from the staircase leading up to the main floor, the China Room is a fascinating space. In the 19th century it was used for household work and was redesigned as a cloakroom in 1902. It became the China Room in 1917, when Edith Wilson first displayed the growing collection of White House china there. In its current state, with wall-to-wall cabinets displaying the full array of presidential china arranged chronologically throughout White House history, it showcases a compelling tour of American decorative arts, history and design. Almost every President is represented in some form of official White House china or glassware, a collection that depicts changing American tastes and styles over 200 years. Early Presidents favored classical motifs while in later years china choices seemed to reflect fashions of the time. Mary Todd Lincoln chose bold 'solferino' purple as the Lincoln presidential china, for example, a trend-setting color in 1865. The florid displays of flora and fauna-themed china are a fanciful marker of high Victorian style. In the modern era, Nancy Reagan's china is recognized for its bold orange-red border, her signature color. The Johnson china is also notable for its floral motif of wildflowers representing each of the 50 states combined with a Presidential eagle center medallion – a mix of both floral and presidential symbolism. The Clinton china is distinguished by its architectural motif and buttercream and ivory palette, and is the only presidential china to highlight White House architectural symbolism. The timeless and modern Truman and Wilson china and the classic green-trellis patterned George W. Bush china were popular for Obama White House entertaining.

The China room is painted deep red, a color scheme inspired by the 1924 portrait of Grace Coolidge a dominant element in the room. During her husband's term from 1923 to 1929, Grace Coolidge was a legendary hostess who enjoyed entertaining the Washington elite. In the painting, accompanied by her white Collie dog Rob Roy, she is depicted in a ruby red flapper dress, an iconic fashion statement of the roaring 1920s. Her dog was named for the popular cocktail created in 1894, by a bartender at the Waldorf Astoria Hotel in Manhattan.

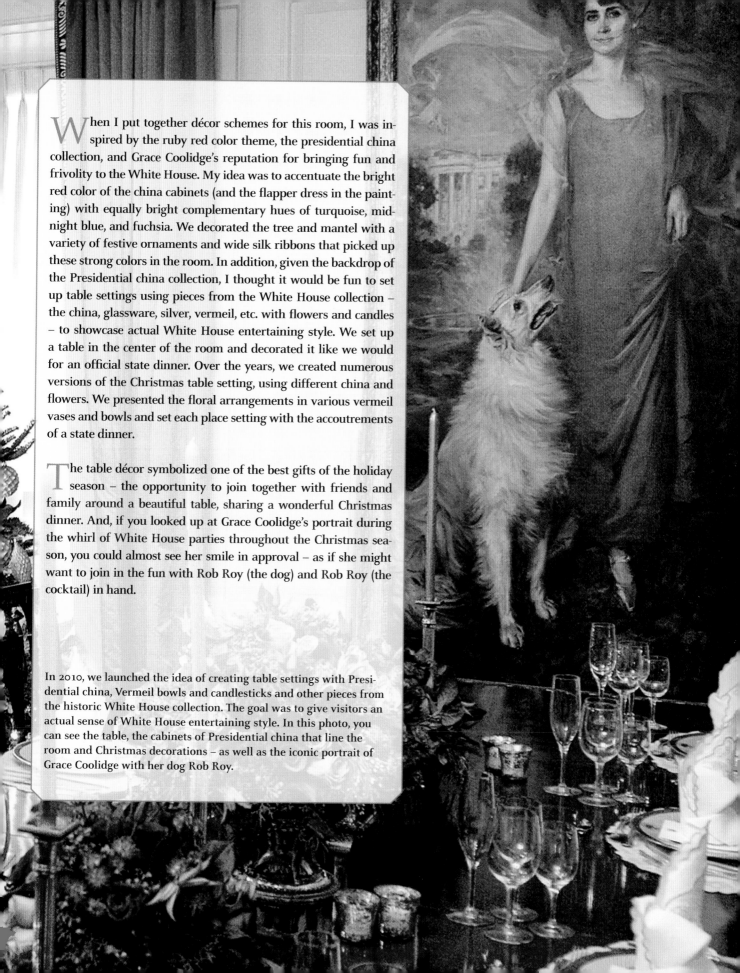

When I put together décor schemes for this room, I was inspired by the ruby red color theme, the presidential china collection, and Grace Coolidge's reputation for bringing fun and frivolity to the White House. My idea was to accentuate the bright red color of the china cabinets (and the flapper dress in the painting) with equally bright complementary hues of turquoise, midnight blue, and fuchsia. We decorated the tree and mantel with a variety of festive ornaments and wide silk ribbons that picked up these strong colors in the room. In addition, given the backdrop of the Presidential china collection, I thought it would be fun to set up table settings using pieces from the White House collection – the china, glassware, silver, vermeil, etc. with flowers and candles – to showcase actual White House entertaining style. We set up a table in the center of the room and decorated it like we would for an official state dinner. Over the years, we created numerous versions of the Christmas table setting, using different china and flowers. We presented the floral arrangements in various vermeil vases and bowls and set each place setting with the accoutrements of a state dinner.

The table décor symbolized one of the best gifts of the holiday season – the opportunity to join together with friends and family around a beautiful table, sharing a wonderful Christmas dinner. And, if you looked up at Grace Coolidge's portrait during the whirl of White House parties throughout the Christmas season, you could almost see her smile in approval – as if she might want to join in the fun with Rob Roy (the dog) and Rob Roy (the cocktail) in hand.

In 2010, we launched the idea of creating table settings with Presidential china, Vermeil bowls and candlesticks and other pieces from the historic White House collection. The goal was to give visitors an actual sense of White House entertaining style. In this photo, you can see the table, the cabinets of Presidential china that line the room and Christmas decorations – as well as the iconic portrait of Grace Coolidge with her dog Rob Roy.

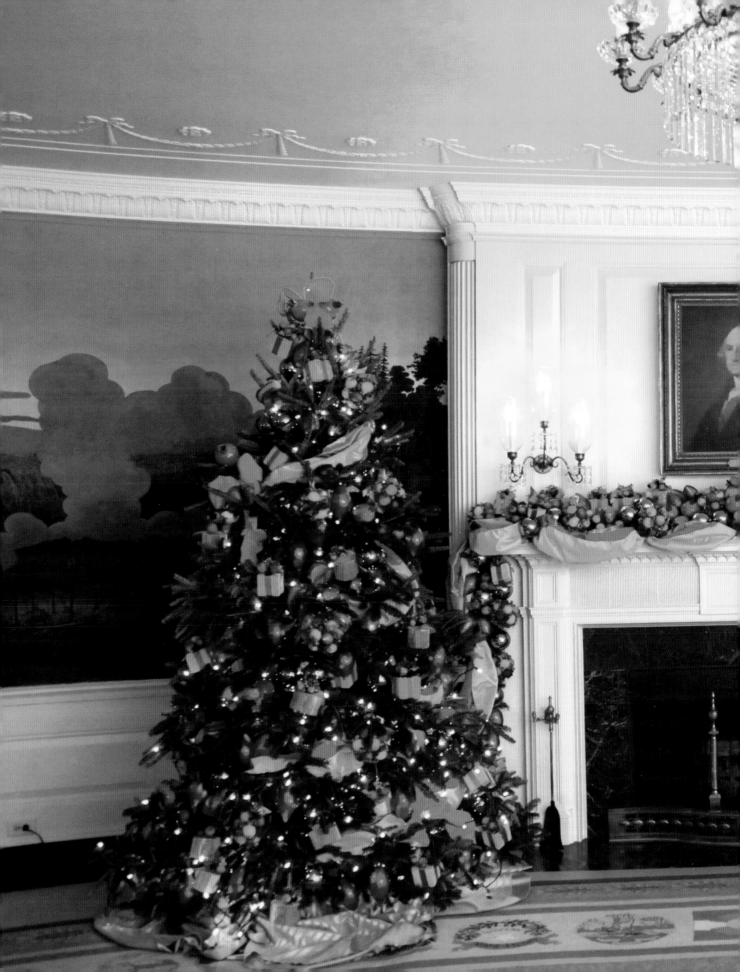

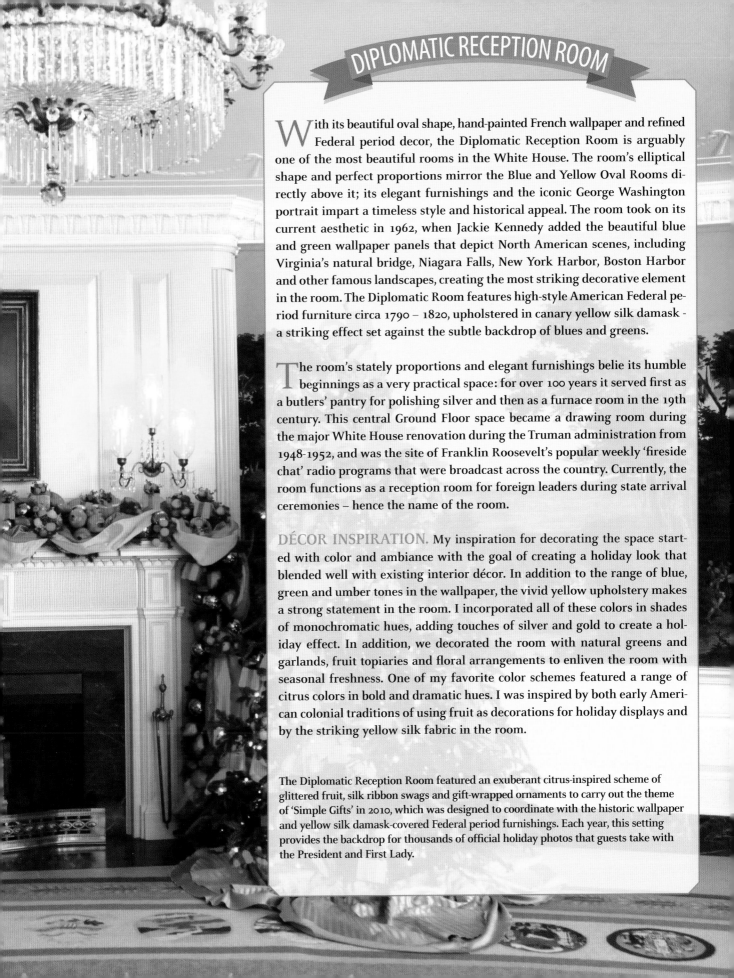

DIPLOMATIC RECEPTION ROOM

With its beautiful oval shape, hand-painted French wallpaper and refined Federal period decor, the Diplomatic Reception Room is arguably one of the most beautiful rooms in the White House. The room's elliptical shape and perfect proportions mirror the Blue and Yellow Oval Rooms directly above it; its elegant furnishings and the iconic George Washington portrait impart a timeless style and historical appeal. The room took on its current aesthetic in 1962, when Jackie Kennedy added the beautiful blue and green wallpaper panels that depict North American scenes, including Virginia's natural bridge, Niagara Falls, New York Harbor, Boston Harbor and other famous landscapes, creating the most striking decorative element in the room. The Diplomatic Room features high-style American Federal period furniture circa 1790 – 1820, upholstered in canary yellow silk damask - a striking effect set against the subtle backdrop of blues and greens.

The room's stately proportions and elegant furnishings belie its humble beginnings as a very practical space: for over 100 years it served first as a butlers' pantry for polishing silver and then as a furnace room in the 19th century. This central Ground Floor space became a drawing room during the major White House renovation during the Truman administration from 1948-1952, and was the site of Franklin Roosevelt's popular weekly 'fireside chat' radio programs that were broadcast across the country. Currently, the room functions as a reception room for foreign leaders during state arrival ceremonies – hence the name of the room.

DÉCOR INSPIRATION. My inspiration for decorating the space started with color and ambiance with the goal of creating a holiday look that blended well with existing interior décor. In addition to the range of blue, green and umber tones in the wallpaper, the vivid yellow upholstery makes a strong statement in the room. I incorporated all of these colors in shades of monochromatic hues, adding touches of silver and gold to create a holiday effect. In addition, we decorated the room with natural greens and garlands, fruit topiaries and floral arrangements to enliven the room with seasonal freshness. One of my favorite color schemes featured a range of citrus colors in bold and dramatic hues. I was inspired by both early American colonial traditions of using fruit as decorations for holiday displays and by the striking yellow silk fabric in the room.

The Diplomatic Reception Room featured an exuberant citrus-inspired scheme of glittered fruit, silk ribbon swags and gift-wrapped ornaments to carry out the theme of 'Simple Gifts' in 2010, which was designed to coordinate with the historic wallpaper and yellow silk damask-covered Federal period furnishings. Each year, this setting provides the backdrop for thousands of official holiday photos that guests take with the President and First Lady.

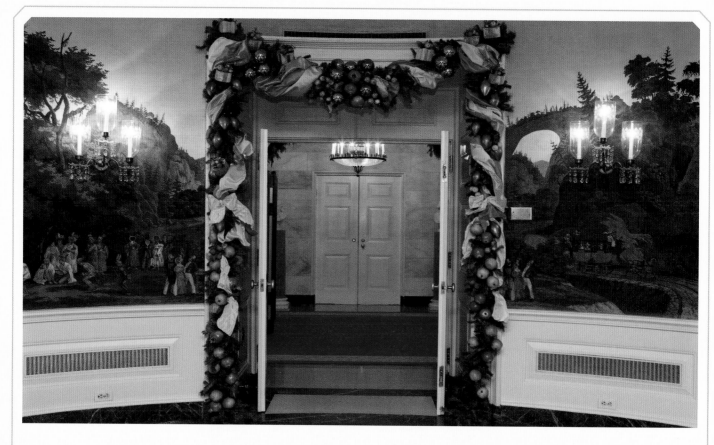

The focal point piece was the mantel garland, the backdrop to the official photos that are taken with the President and First Lady. The design involved creating opulent swags of fruit and ribbons layered over a base of greens, featuring faux pomegranates, oranges, limes and accented with small gift-wrapped packages and glass ornaments in the same bright shades. We duplicated the look on the two Christmas trees flanking the fireplace. For additional natural touches, we added orange, lemon and lime topiaries on side tables throughout the room. The mix of fresh flower and fruit designs complemented the faux fruit displays and gave an overall feeling of natural décor.

A blue and green color scheme – with accents of white, lavender and silver – was another color palette that worked well in the room. The colors of the ornaments and ribbons in shades of turquoise blue and lime green coordinated with the wallpaper; the silver and lavender embellishments created depth and interest in the displays. Christmas trees and garlands were decorated in a similar palette with lime green and blue ornaments and coordinating ribbons inspired by the colors of the historic wallpaper. Bouquets of white flowers and evergreens – amaryllises, roses and paper whites with cedar and pine boughs in moss-covered vases and vermeil urns further enhanced the subtle effect, adding lightness and a delicate scent to the space. Whether bold and bright or classic and understated, a wide range of design schemes always worked well in the Diplomatic Room. The décor created a festive backdrop for parties and events, the official photo op, and the space the First Family used to go in and out of the South Portico door.

CONCLUSION. When Jackie Kennedy renovated the Diplomatic Room in 1962, with panoramic wallpaper titled 'Scenes of North America', her goal was to convey the best of American style by creating an elegant place for welcoming dignitaries where they would be surrounded by the amazing natural beauty of our country. During the holidays, we enjoyed the opportunity to amplify that sentiment with a combination of elegant Christmas decorations and seasonal flowers and greens.

Here is a close-up view of the over-the-door garland that is designed to bring out the bold citrus colors and festive holiday décor in the Diplomatic Room.

CARVED CITRUS ARRANGEMENT

During the holidays, citrus fruits are an effective way to add color and impact to holiday designs; they are also a time-honored decorative tradition popularized at Colonial Williamsburg. Whether used in wreaths, garlands, topiaries or table decorations, they bring wonderful scent and holiday cheer to both indoor and outdoor displays. To complement the fruit and flower-themed display in the Diplomatic Reception Room one year, we created topiaries and flower arrangements with a citrus theme, including vases made of carved oranges, lemons and limes.

WHAT YOU'LL NEED

- 1 base plate
- 1 block of floral foam oasis (soaked): 10 inches long x 7 inches wide x 6 inches tall
- 10 pounds of oranges
- 1 box of floral u-pins
- Mixed flowers and greens in citrus hues
- Knife (for carving the foam and fruit)
- Clippers

STEP-BY-STEP TECHNIQUES

1 Carve the floral foam to the desired size and soak it thoroughly in water.

2 Prepare the oranges by cutting them into quarters, removing all of the pulp and saving the rind.

3 Place the foam on the baseplate. Starting at the bottom, pin the quartered sections of orange to the floral foam using the u-pins, adding oranges around the sides of the form in rows until it is completely covered, leaving the top open for flowers.

4 Note: take care to cover the pins with the orange sections so that they are not visible.

5 Next, create a seasonal bouquet of flowers and greens, starting with a base layer of greens inserted on the top of the foam to define the overall shape.

6 Add flowers and a few trailing vines, turning the base as you design to ensure that the finished bouquet is balanced.

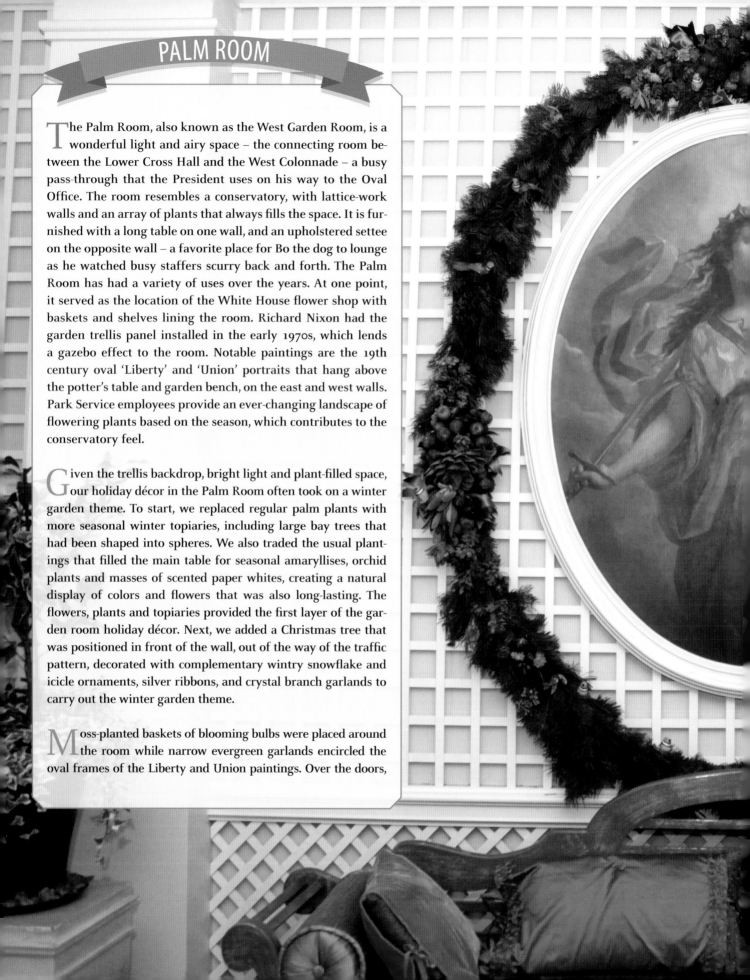

PALM ROOM

The Palm Room, also known as the West Garden Room, is a wonderful light and airy space – the connecting room between the Lower Cross Hall and the West Colonnade – a busy pass-through that the President uses on his way to the Oval Office. The room resembles a conservatory, with lattice-work walls and an array of plants that always fills the space. It is furnished with a long table on one wall, and an upholstered settee on the opposite wall – a favorite place for Bo the dog to lounge as he watched busy staffers scurry back and forth. The Palm Room has had a variety of uses over the years. At one point, it served as the location of the White House flower shop with baskets and shelves lining the room. Richard Nixon had the garden trellis panel installed in the early 1970s, which lends a gazebo effect to the room. Notable paintings are the 19th century oval 'Liberty' and 'Union' portraits that hang above the potter's table and garden bench, on the east and west walls. Park Service employees provide an ever-changing landscape of flowering plants based on the season, which contributes to the conservatory feel.

Given the trellis backdrop, bright light and plant-filled space, our holiday décor in the Palm Room often took on a winter garden theme. To start, we replaced regular palm plants with more seasonal winter topiaries, including large bay trees that had been shaped into spheres. We also traded the usual plantings that filled the main table for seasonal amaryllises, orchid plants and masses of scented paper whites, creating a natural display of colors and flowers that was also long-lasting. The flowers, plants and topiaries provided the first layer of the garden room holiday décor. Next, we added a Christmas tree that was positioned in front of the wall, out of the way of the traffic pattern, decorated with complementary wintry snowflake and icicle ornaments, silver ribbons, and crystal branch garlands to carry out the winter garden theme.

Moss-planted baskets of blooming bulbs were placed around the room while narrow evergreen garlands encircled the oval frames of the Liberty and Union paintings. Over the doors,

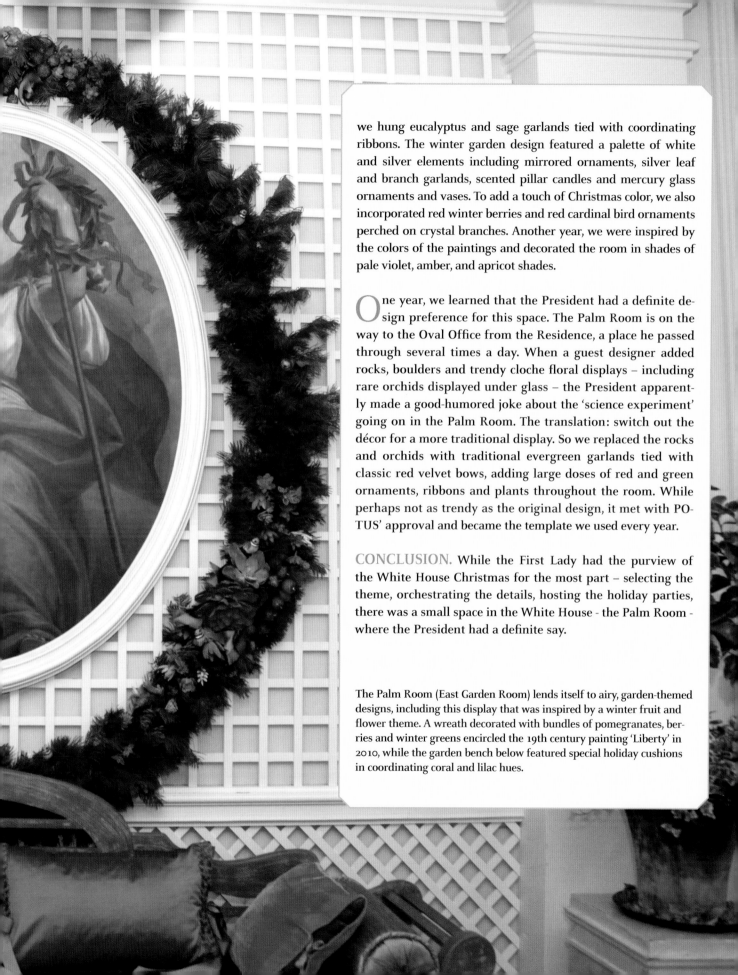

we hung eucalyptus and sage garlands tied with coordinating ribbons. The winter garden design featured a palette of white and silver elements including mirrored ornaments, silver leaf and branch garlands, scented pillar candles and mercury glass ornaments and vases. To add a touch of Christmas color, we also incorporated red winter berries and red cardinal bird ornaments perched on crystal branches. Another year, we were inspired by the colors of the paintings and decorated the room in shades of pale violet, amber, and apricot shades.

One year, we learned that the President had a definite design preference for this space. The Palm Room is on the way to the Oval Office from the Residence, a place he passed through several times a day. When a guest designer added rocks, boulders and trendy cloche floral displays – including rare orchids displayed under glass – the President apparently made a good-humored joke about the 'science experiment' going on in the Palm Room. The translation: switch out the décor for a more traditional display. So we replaced the rocks and orchids with traditional evergreen garlands tied with classic red velvet bows, adding large doses of red and green ornaments, ribbons and plants throughout the room. While perhaps not as trendy as the original design, it met with POTUS' approval and became the template we used every year.

CONCLUSION. While the First Lady had the purview of the White House Christmas for the most part – selecting the theme, orchestrating the details, hosting the holiday parties, there was a small space in the White House - the Palm Room - where the President had a definite say.

The Palm Room (East Garden Room) lends itself to airy, garden-themed designs, including this display that was inspired by a winter fruit and flower theme. A wreath decorated with bundles of pomegranates, berries and winter greens encircled the 19th century painting 'Liberty' in 2010, while the garden bench below featured special holiday cushions in coordinating coral and lilac hues.

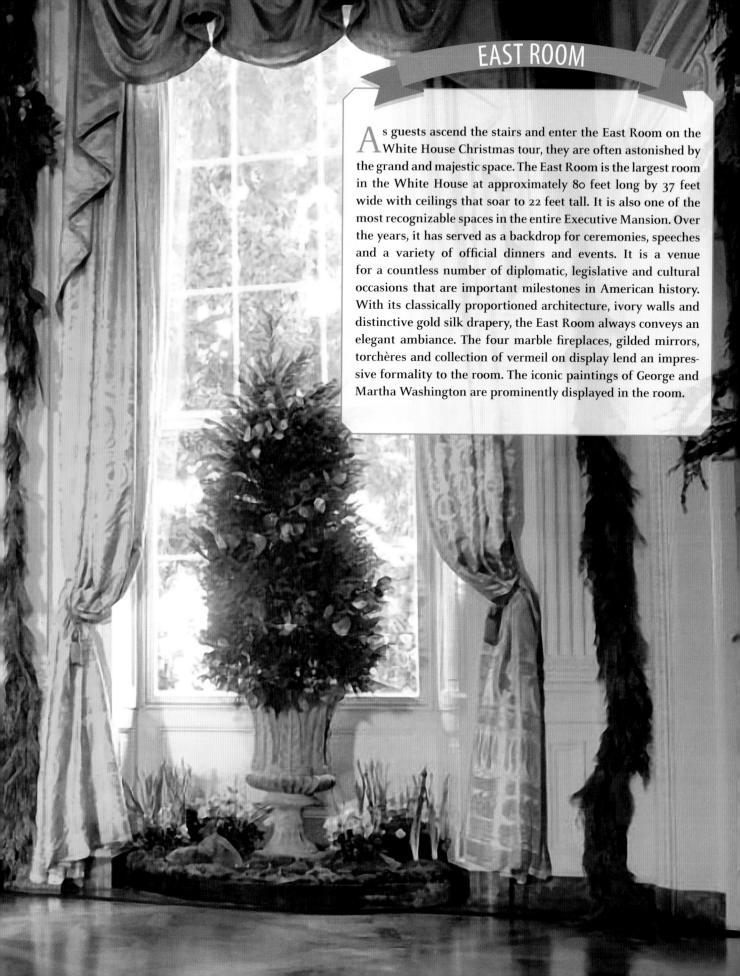

EAST ROOM

As guests ascend the stairs and enter the East Room on the White House Christmas tour, they are often astonished by the grand and majestic space. The East Room is the largest room in the White House at approximately 80 feet long by 37 feet wide with ceilings that soar to 22 feet tall. It is also one of the most recognizable spaces in the entire Executive Mansion. Over the years, it has served as a backdrop for ceremonies, speeches and a variety of official dinners and events. It is a venue for a countless number of diplomatic, legislative and cultural occasions that are important milestones in American history. With its classically proportioned architecture, ivory walls and distinctive gold silk drapery, the East Room always conveys an elegant ambiance. The four marble fireplaces, gilded mirrors, torchères and collection of vermeil on display lend an impressive formality to the room. The iconic paintings of George and Martha Washington are prominently displayed in the room.

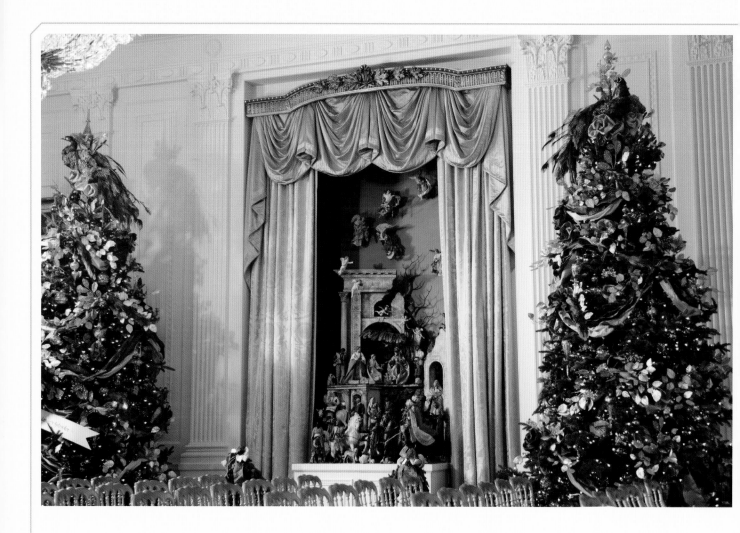

The East Room has been a traditional venue for celebrating the White House Christmas, and its beauty is enhanced during the holiday season with festive decoration. In one famous scene in 1835, Andrew Jackson transformed the East Room into a winter wonderland for children that featured a cotton snowball fight and an impressive spread of candies and cakes. In 1888, Frances Cleveland decorated the East Room tree with gifts that were given out to prominent people in Washington. President Roosevelt posed there for a family portrait and Christmas card in 1939, in front of the White House Christmas tree which gleamed with snow and silver trimming. The East Room was the site of the official White House Christmas tree for many years until Jackie Kennedy moved it to the

Blue Room in 1961. Since 1967, First Ladies have prominently displayed the 18th century Italian presipio, a carved wood and terra cotta nativity scene that was a gift from the Italian government that same year, in the East Room, creating a wonderful White House tradition. In recent years, First Ladies have decorated the East Room for Christmas in a variety of beautiful schemes, creating breathtaking displays that always put their personal stamp on White House holiday style.

There are many memorable moments in East Room holiday decorations. In 2004, First Lady Laura Bush made a lasting impression with her snow-covered tree display, transforming the East Room into a realistic wintry scene. Visitors recount

p. 90 In 2011, the East Room featured dramatic displays of sculptural garlands in graduated widths, four 16 ft. tall Christmas trees decorated with thousands of vintage-inspired ornaments, and topiary trees in classical urns that were under-planted with moss and scented flowers.

As the largest and most majestic White House Room, the East Room was the venue for some of our most opulent displays, including these trees festooned with silk ribbons, colorful ornaments, gold leaves and topped with hand-made peacocks crafted from natural materials.

how upon encountering the room they felt as if they had entered a secret enchanted forest, even shivering as they experienced the realistic representation of a snowy winter landscape. The twinkling, icy display was so authentic it created a feeling they never forgot. The décor was something the housekeepers never forgot either. It turns out the boxes of 'snow' that were dumped on the tops of the trees and around the bases were a synthetic flake made of tiny shredded plastic pieces that floated everywhere once the material escaped from its contained box. No matter how much sweeping and vacuuming the crew did to keep the perpetual snowstorm in check, the faux flakes flew free, embedding themselves in nooks and crannies of the East Room, annoying the housekeepers who occasionally still find evidence of the fake snow today. When I learned that there was a large supply of boxes of leftover 'snow' at the warehouse, I tried to think of ways to repurpose the materials and put it to good use. After experimenting with different ideas – including adding glue and water to make a paste, or mixing it with white bread and glycerine to create various shapes and solid form designs – the verdict was clear. The shredded plastic flakes turned into a wet, gooey mess that never dried or solidified. It seemed to have no redeeming aesthetic value. So I reluctantly let it go, purging all of the white plastic snow, much to the relief of the housekeeping team. To this day, however, that snowy scene in the East Room remains a favorite of many White House visitors.

EAST ROOM INSPIRATION. When I worked on East Room designs, my strategy focused on developing inspiring colors, concepts, and placements. Given the room's spacious dimensions, I thought about scale and proportion – the East Room requires a cohesive theme that creates balance, drama and impact throughout the vast space, featuring both a mix of large-scale ornaments and smaller details. Given the room's elegant formality, I made a point of using traditional designs and elements that fit within the context of the classic architectural space, including large trees (16 feet tall), oversized wreaths, garlands and swags that mirrored motifs in the room. The best strategies involved placing the trees at the perimeters, flanking the crèche and positioned in the bay windows at either end. A wide range of colorful décor worked well with the neutral cream walls and bold gold draperies and vermeil accessories.

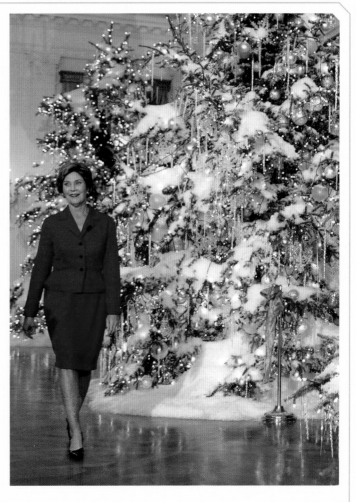

First Lady Laura Bush created a memorable Christmas in the East Room in 2004, when hundreds of pounds of fake snowflakes were dropped from a cherry picker onto the tops of multiple trees, blanketing the entire room in a realistic wintry scene.

BIRDS AND FLOWERS. One of my favorite décor schemes highlighted the simple gifts of nature, centering around a peacock theme featuring birds and flowers in vivid colors of turquoise blue and purple, with accents of emerald green and gold. Jeweled peacock ornaments and wide silk ribbons in a range of turquoise, sapphire, and purple tones festooned the trees, while large evergreen wreaths with braided ribbons decorated the gilded mirrors. We used a mix of materials and finishes – ribbons, glass and glitter ornaments, crystal branches and garlands – to create a lush and layered effect. To carry out the nature-inspired theme, we invited a guest florist from Michigan to make peacock tree-toppers out of natural materials. He used

For an East Room theme evoking nature's splendor and the winter garden, we chose a vivid palette of turquoise, emerald green, sapphire blue, and purple, incorporating peacock ornaments and other floral and fauna motifs that was carried out in trees, garlands, wreaths and flowers throughout the room.

flowers, grasses and dried seed pods to craft eight peacocks plus a dove made out of eucalyptus leaves and feathers – a symbol of peace – for the military tree. In the East Room the majestic hand-crafted peacocks were placed on the tops of the trees, enhanced by a pouf of trailing silk turquoise and violet ribbons, delicate white lights and topped by a gilded finial. Additional peacocks were placed on the garlands around the door. The organic, hand-crafted birds, combined with the festive ornaments and accessories, created a magical and inspiring effect.

VINTAGE BOTANICAL. Another year, the decorations took on a botanical tone with a classically beautiful display of natural wreaths and garlands in a sophisticated color scheme of fuchsia, plum, topaz, gold and antique rose. The mirrors were draped with delicate rose-colored ribbons and the sculptural garlands that varied in thickness from thick to thin. Hundreds of tiny glitter pinecone ornaments were hung on the four 16 foot trees. Each window was under-planted with a winter gar-

den scheme of scented paper white narcissus, moss and ferns, creating a lush garden effect. Re-purposed gold leaves from the White House collection were added to the trees and garlands; some of the leaves were antiqued with copper paint to create additional depth of color. We created floral displays for the center table and vermeil urns on the mantel featuring tiger amaryllises, poinsettias, garden roses, yellow tree peonies with seasonal foliage, including golden cedar, pine, boxwood and juniper. Trees were decorated with jewel-toned ornaments and red fruits while bay leaf garlands and delicate rose ribbons embellished the mirrors and mantels.

We often used the large gilded mirrors above the East Room mantels to display holiday wreaths and garlands that were then reflected across the room. These wreath and garland designs from 2010 were replicated in each of the four fireplaces, and coordinated with the peacock and nature-inspired theme of 'Simple Gifts.'

WINTER WONDERLAND. A popular concept focused on celebrating classic Christmas themes and stories with fanciful vignettes and décor, with the goal of capturing the excitement and delight of children as they anticipate the joys of the Christmas season. Paper snowflakes, charming hand-crafted ornaments and gilded paper rosettes decorated the trees, while evergreen garlands and swags tied with ribbons in a palette of lime green, gold and snow white provided festive seasonal touches. Snow globes and snowflakes carried out the wintry theme. For table décor, we used mirrored containers with silver snowflake appliques for our flower displays – large arrangements of white lilies, roses, paper whites and amaryllis layered with snowberries and winter greens.

In all of these displays, our goal was to honor the storied traditions of the East Room, celebrate its beautiful architectural details and bring the room to life with inspiring colors, innovative craft projects and glorious natural designs.

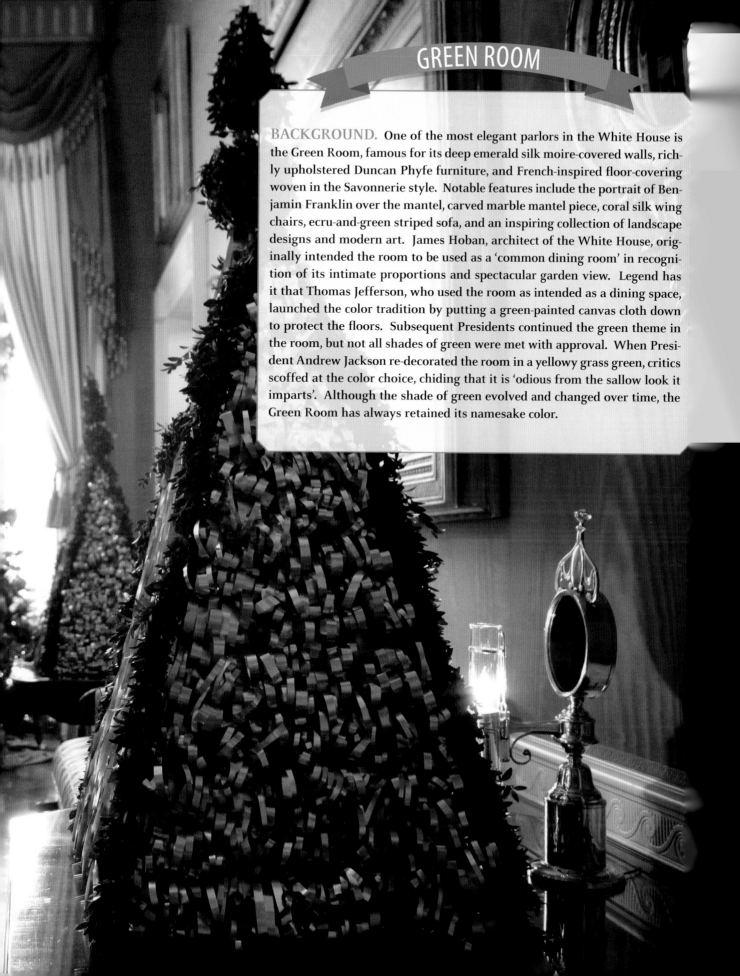

BACKGROUND. One of the most elegant parlors in the White House is the Green Room, famous for its deep emerald silk moire-covered walls, richly upholstered Duncan Phyfe furniture, and French-inspired floor-covering woven in the Savonnerie style. Notable features include the portrait of Benjamin Franklin over the mantel, carved marble mantel piece, coral silk wing chairs, ecru-and-green striped sofa, and an inspiring collection of landscape designs and modern art. James Hoban, architect of the White House, originally intended the room to be used as a 'common dining room' in recognition of its intimate proportions and spectacular garden view. Legend has it that Thomas Jefferson, who used the room as intended as a dining space, launched the color tradition by putting a green-painted canvas cloth down to protect the floors. Subsequent Presidents continued the green theme in the room, but not all shades of green were met with approval. When President Andrew Jackson re-decorated the room in a yellowy grass green, critics scoffed at the color choice, chiding that it is 'odious from the sallow look it imparts'. Although the shade of green evolved and changed over time, the Green Room has always retained its namesake color.

Mostly, however, the Green Room has been used for gentler and happier pursuits: as a delightful party room by Grace Coolidge, a card room during the Monroe administration, and as a site for private gatherings and official teas over the years. It was the favorite room of several First Ladies, including Helen Taft, wife of President William Howard Taft who sat for her official photograph there in 1909. Laura Bush used the Green Room to host both official events and informal gatherings. Mrs. Bush also chose the room to have her official White House portrait painted, wearing a midnight blue velvet gown. Michelle Obama had a family portrait taken in the Green Room and chose the room for small events and interviews. The personal stories of Presidents and First Ladies impart a special aura to the Green Room. Quiet and contemplative, peaceful and serene, the Green Room is a lovely oasis in the midst of the intense demands of White House life.

DECORATING THE GREEN ROOM. To come up with ideas for holiday décor and design schemes in the Green Room, We focused on nature, classic Christmas traditions, and colors. By emphasizing the use of natural materials as well as ornaments and decorations from the White House collection, our goal was to highlight and complement the colors and important furnishings of the room rather than detract from or overshadow them. The idea was to make the entire room come alive with holiday spirit. As I studied photographs of White House Christmases past, I noted that an understated design scheme was always beautiful and appropriate in the room imparting a timeless sense of classic Christmas. The space required strong colors and a cohesive design plan in order for the decorations to not get lost in the strong, saturated colors of the space. My approach involved developing design plans, projects and proposals inspired by the serene mood and rich history of the space that emphasized color – shades of green as well as complementary colors of coral, red and rose – decorated by hand-made embellishments: seasonal flowers in organic vases, evergreen wreaths and mantel designs accented with elegant, colorful ribbons. We focused on several key focal point areas: the trees, wreaths, and mantel design with floral accents throughout the room. Winter white and mistletoe green worked well in the room with crystal and silver tones – evoking a classic

John Quincy Adams was the first President to actually name the space the 'Green Parlor', his preferred setting for family dinners and official events. The Sheffield silver coffee urn, a prized family possession of the Adams family, is still on display in the Green Room, a deliberate nod to its dining room past. The Green Room has been the site of many important moments in American history, the most famous being when President James Madison signed the nation's first declaration of war here in 1812. This launched a chain of events that led to the burning of the White House by British troops in 1814. The Green Room was the site of a heart-breaking scene in 1862, when William Wallace Lincoln, the 11 year old son of President Abraham Lincoln was embalmed there after his death.

p. 96 In 2011, we decorated the Green Room in a palette of green and silver with accents of white flowers in hand-crafted silver containers. The trees were made from re-cycled aluminum cans that volunteers applied to pyramids and embellished with narrow boxwood garlands.

This classic topiary design of winter greens, branches and red berries was used in the Green Room in 2012, providing a touch of traditional color and seasonal textures that complemented the nature-inspired room décor.

winter wonderland of snow-covered trees and vintage Christmas in a nostalgic Currier and Ives scene. We also worked in hues of apricot, plum and evergreen to accent the deep coral upholstery and mossy green walls in the classic Italian della Robbia tradition. One year, we re-purposed the red cranberry and pepper berry wreaths and vases that had been displayed in the Red Room to work in the Green Room, adding a layer of lichen-covered branches and pine cones to create a natural, organic display. Some of my favorite Green Room ideas included jeweled and sugared fruit garlands and wreaths with velvet ribbons, gilded gold trees and wreaths accented with pine and cedar boughs, and red winter berry and pinecone floral pieces and coordinating mantel swag.

This photo shows one of the four pepper berry topiary trees that we installed in the windows of the Red and Green Rooms in 2009, embellished with vintage rose-colored ribbons.

SEASONAL AND ENVIRONMENTAL THEMES. In addition to using seasonal elements, bold colors and traditional decor, we focused on the meaning and messaging of the designs. During my tenure, an important policy theme that became an underlying message in the Green Room was environmental conservation. We showcased simple, unassuming elements such as newspaper, pinecones, recycled cans, etc. that could be re-purposed and re-imagined in creative and beautiful ways. Given my background as a policy analyst and communications strategist, I saw how an environmental approach could help support important Administration messages about recycling, conservation and sustainable design. We started with seasonal, nature-inspired themes: fruit, flowers, birds, the win-

ter forest, a fanciful garden – ideas that celebrated nature – and then developed sketches and ideas for projects, crafts and details that carried out environmental themes. We delved into the treasure trove of White House ornaments, re-fashioning vintage decorations to give them a new look and creating new decorations using recycled materials. Trees made of recycled newspapers and magazines were folded, glittered and decorated with ribbons and natural materials, creating the focal point pieces in the room that we then augmented with wreaths and garlands made of similar recycled materials. Fresh bouquets of winter season flowers and greenery, placed on tables throughout the room, were always an essential part of the overall display. In the Green Room, it was inspiring to craft projects out of simple, accessible and inexpensive natural materials such as leaves, berries and branches – and to blend in decorative elements from the White House collection and recycled materials.

PEPPER-BERRY TREES.

Many of my favorite projects involved detailed and labor intensive volunteer work that achieved a creative result. One year the volunteers made large pepper berry topiary trees that were placed in both the Red Room and Green Room windows. Pepper berries are a winter plant with texture and color that works well in bouquets, wreaths and garlands. The concept involved creating trees made entirely of pepper berries to focus attention on the soft red color and texture of the material. We collected hundreds of bunches of dried pepper berries that volunteers painstakingly glued and pinned to the foam topiary bases, adding swags of antique velvet ribbon as a finishing touch. The pepper berry trees were positioned in the window planter boxes that were painted in coordinating colors. Festooned with antique velvet ribbons and bows, the trees were a festive sight – until the pepper berries started dropping and bouncing on the floor, pinging across the room, getting crushed underfoot by thousands of holiday visitors. This warranted a housekeeping (and curatorial) alert – and a stern warning – to put pepper berries on the 'do not fly' list of problematic and banned materials going forward.

GLITTER PAPER TREES.

One of my all-time favorite projects (that also came under housekeeper scrutiny) was a topiary tree design made entirely out of recycled newspaper, decorated with gold paint and glitter. The concept was to create inspiring shapes and textures from simple, recycled material. We asked our White House colleagues to bring in their old newspapers, gathering hundreds of pounds of newspaper. Using a cone topiary form, we made small paper cones out of newspaper that were then pinned onto the form, spray painted gold and glittered. The trees were very architectural in tone and style; we finished off the designs with sprigs of winter greenery, adding a natural touch to the clean, geometric forms. A friend with a sharp mathematical mind calculated and measured the design so that the newspaper cones were pinned on with precision. The 10 ft. tall trees were placed in the windows on a base of birch tree trunks. The finial on top of the tree was made of folded paper in the style of an origami ornament which was also spray-painted gold and glittered. When using inorganic material (such as paper, cans, etc.), it is always important to include a touch of strategically placed natural materials – evergreen accents – to keep the entire display feeling fresh and lively.

ALUMINUM CAN TREES.

Another example of how we used simple, recycled materials to create inspiring designs was the soda can trees made from recycled aluminum cans that were cut, folded and fringed and then applied to pyramid shaped forms. We asked a colleague in the West Wing to collect soda cans at the end of the day and bring them to us in the flower shop. An evolving group of volunteers cut off the ends of the cans, saving the interior material, which was fashioned into various patterns that we used on the trees. After accumulating enough materials – gleaned from approximately 2,000 cans – I again called on my talented friend to re-create her precision work which required pinning each piece on the cone form to create a uniform, shimmery effect. The result was surprising: instead of stiff, sharp edges, the crimped and folded cans were surprisingly soft and delicate, creating an overall floating feeling of ethereal lightness. We finished off the designs with narrow garlands of boxwood that lined the edges of the pyramid forms. The design echoed the silver collection in the room, referencing a classical garden ornament, and conveyed a strong environmentally friendly theme of recycling.

FLORAL EMBELLISHMENTS.

Throughout the White House at Christmas time, flowers provide the finishing touch, a way to bring the rooms to life and create a cohesive décor presentation. Our goal was always to coordinate the flowers with the overall theme, creating integrated presentations and displays. For example, to carry out the recycled can theme, we glued the tab tops of aluminum cans to plastic containers to make unusual vase designs. That same year we cut mirrored paper into patterns to create coverings for buckets that complemented the aluminum can trees as well as the historic silver collection in the room. In 2010, the year

used gold and glittered paper elements, we carried out the recycled paper theme by making a trio of rose pots in glittered and textured newspaper-covered containers. In 2011, to complement the Green Room's winter season and natural décor, we created vases made from pine cone scales that volunteers glued around plain glass cubes.

CONCLUSION. I remember a peaceful moment towards the end of the season. It was a quiet night following a full day of back to back holiday parties; the last of the merrymakers were gently escorted out the door shortly after 9:30 p.m. I went up to the Green Room to switch out the flowers for the next day. The Green Room still glowed and sparkled reminiscent of the lively parties hosted by Grace Coolidge and other First Ladies, but in the aftermath of the party, it took on its more typical, quiet and contemplative mood. Just as I weighed the pros and cons of whether to work another hour or two to keep ahead of the hectic holiday schedule, I glanced up at the portrait of Benjamin Franklin, whose words of wisdom in Poor Richard's Almanac came to mind: 'early to bed, early to rise, makes a man healthy, wealthy and wise.' And then I noticed the Jacob Lawrence painting 'The Builders' that conveys a counterpoint message of unwavering diligence and relentless hard work – a painting that First Lady Laura Bush particularly liked because she said it signified people working together towards a common goal. After a moment of contemplation and internal debate, I decided to split the difference by working a little longer, preparing some flowers and then calling it a day.

The Green Room paper cone tree made from a simple material – gilded, recycled newspaper – created a surprisingly architectural effect when it was put in place atop a base of birch logs.

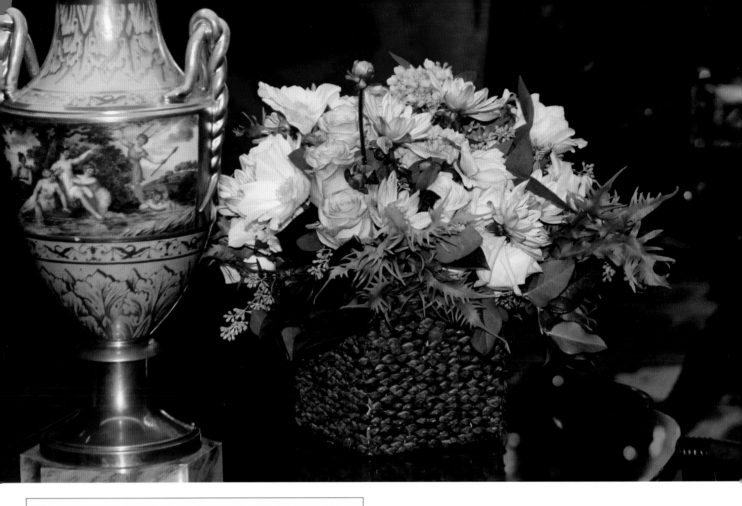

PINE CONE CUBE VASE

WHAT YOU'LL NEED

- 1 glass cube vase
- Masking tape
- Bag of pine cones
- Hot glue gun (and glue sticks)
- Clippers

STEP-BY-STEP TECHNIQUES

1 Using clippers, cut individual pine cone scales from the cones, cutting as close to the base of the pinecone as possible.

2 Wrap the glass cube with masking tape to provide a surface for gluing the individual pine cone pieces.

3 Starting at the top, glue pine cone scales in rows around the vase, round side up, applying the next row in an overlapping fish scale motif.

4 Add seasonal flowers and greenery to make a naturally festive, integrated holiday design.

ROSE TRIO
NEWSPAPER POTS

WHAT YOU'LL NEED

- 3 small containers
- Masking tape
- Newspapers
- Scissors
- Stapler
- Hot glue gun (and glue sticks)
- Gold spray paint
 Optional: Spray adhesive and gold glitter
- Red roses

STEP-BY-STEP TECHNIQUES

1 Wrap the small containers with masking tape.

2 Cut the newspaper into narrow 3/8 inch strips, folding them into ½ inch loops, stapling them into 1 inch sections.

3 In a random pattern, glue the stapled newspaper sections onto the base, covering the entire surface.

4 Spray the finished piece with gold spray paint.

5 Optional: After the gold paint dries, spray a light coat of spray adhesive and sprinkle gold glitter over the top of the container.

6 Add a pavé of red roses in all of the containers.

SODA CAN TREE

A common theme in our holiday designs was to focus on ecological designs that highlighted the concept of creative recycling. It was both practical, a money-saving decision as well as a strategic choice that allowed us to lead by example, sending a powerful message about making environmentally-friendly, sustainable choices. During my tenure, I always felt that some of our most innovative holiday projects involved creating designs from simple materials that were either inexpensive or free. The strategy was to make White House designs interesting and accessible, especially ideas that people could create at home. The soda can trees in the Green Room were made from recycled aluminum cans from the White House complex – an item that was always in plentiful supply. Aesthetically, the silvery aluminum material complemented the green and coral tones in the room as well as the collection of antique silver. The logistics involved gathering the recycled cans each day over a period of several weeks until we had about 2,000 in total – enough to create several trees of varying sizes. At that point, a team of volunteers prepared the cans by cutting off the ends and cutting and crimping them into various shapes. They carefully pinned the aluminum material on to Styrofoam bases to create shimmery, silvery versions of the classic Christmas tree that conveyed a symbolic 'green' theme for the iconic Green Room.

WHAT YOU'LL NEED

- Recycled aluminum cans
- A styrofoam pyramid shaped base
- Silver spray paint
- Snippers (for cutting cans)
- Stapler
- Straight pins
- Boxwood clippings
- Bind wire
- Bouillon wire

Tip: Be sure to wear protective gloves when cutting cans.

STEP-BY-STEP TECHNIQUES

1 Prepare the Styrofoam base by spraying it with silver paint, covering the entire surface with color.

2 Prepare the cans by cutting off the ends, using sharp snippers to remove the tops and bottoms, saving the interior part of the can.

3 Cut, fold and crimp the material into loops, frills, cones, etc. that can be stapled and pinned to the foam tree forms.

4 Starting at the top, pin the folded loops or crimped strips to the pyramid form, applying the aluminum material in even rows, covering the entire surface.

5 Using the bouillon wire and 3 – 4 boxwood pieces, tie the boxwood clippings into 3 – 4 inch bundles.

6 Using the bind wire as the base, create a narrow garland by wrapping the boxwood bundles with the bouillon wire, attaching the bundles to the bind wire base, taking care to keep the garland even.

7 Pin the garland to the edges of the pyramid to define the form.

8 Finish the tree with a boxwood-covered finial.

9 Use the aluminum cans to make wreaths, vases and garlands, etc. using the same techniques.

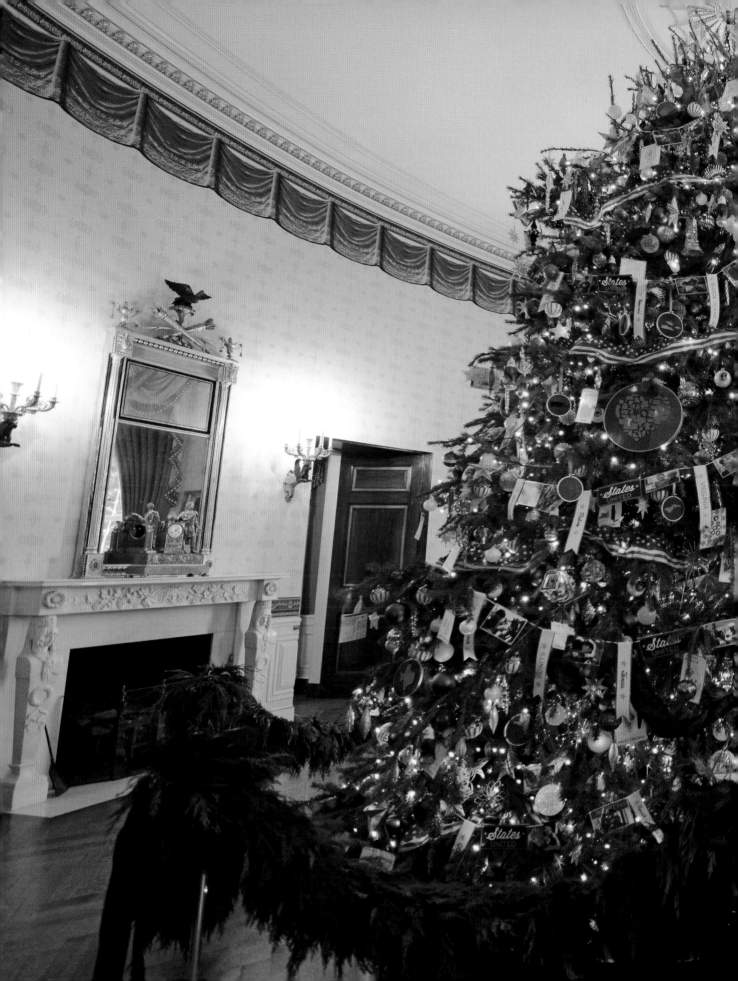

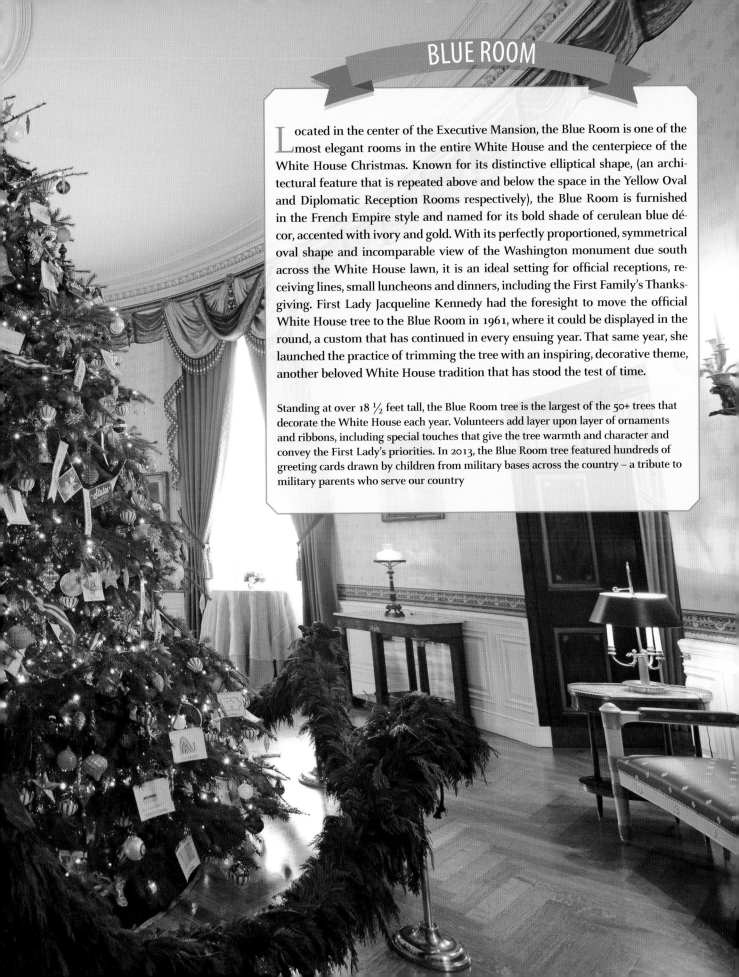

BLUE ROOM

Located in the center of the Executive Mansion, the Blue Room is one of the most elegant rooms in the entire White House and the centerpiece of the White House Christmas. Known for its distinctive elliptical shape, (an architectural feature that is repeated above and below the space in the Yellow Oval and Diplomatic Reception Rooms respectively), the Blue Room is furnished in the French Empire style and named for its bold shade of cerulean blue décor, accented with ivory and gold. With its perfectly proportioned, symmetrical oval shape and incomparable view of the Washington monument due south across the White House lawn, it is an ideal setting for official receptions, receiving lines, small luncheons and dinners, including the First Family's Thanksgiving. First Lady Jacqueline Kennedy had the foresight to move the official White House tree to the Blue Room in 1961, where it could be displayed in the round, a custom that has continued in every ensuing year. That same year, she launched the practice of trimming the tree with an inspiring, decorative theme, another beloved White House tradition that has stood the test of time.

Standing at over 18 ½ feet tall, the Blue Room tree is the largest of the 50+ trees that decorate the White House each year. Volunteers add layer upon layer of ornaments and ribbons, including special touches that give the tree warmth and character and convey the First Lady's priorities. In 2013, the Blue Room tree featured hundreds of greeting cards drawn by children from military bases across the country – a tribute to military parents who serve our country

THE BLUE ROOM TREE. By any measure of holiday splendor, the Blue Room tree is a spectacular sight. With its breathtaking height soaring 19 feet in the air and a girth that spans almost 12 feet across, the Blue Room tree is the main element of the White House Christmas. Decorated with thousands of ornaments and dozens of strands of bright white lights, the tree is a majestic symbol of the strength of the American spirit. It serves as the official White House Christmas tree, conveying a full range of meaning and metaphor. The tree is a timeless, yet ever-changing holiday tradition, overlaid with elements of contemporary design. It represents a snapshot of the American spirit and culture, aesthetic taste and modern decorative trends at any given moment in time. Whether it is decorated in a patriotic or nostalgic theme, with a nod to early American traditions or as a celebration of nature, each year the Blue Room tree tells a fascinating story of who we are and what we value. The tree is a tale of both American dreams and historical heritage, offering a glimpse into the personal priorities of the White House's current occupants.

The historic symbolism is also significant – the Blue Room tree has been part of every First family's holiday traditions and the centerpiece of the White House Christmas for over 50 years. Jackie Kennedy chose the 'Nutcracker Suite', decorating the tree with ornaments and ballet figurines in celebration of her daughter Caroline's favorite ballet. Playing out on the White House stage, the Nutcracker ballet theme enhanced Jackie Kennedy's image as a style icon and a young mother with a youthful outlook. Lady Bird Johnson followed in the Kennedy footsteps with uplifting Americana themes for the Blue Room, striking a nostalgic emphasis designed to unite citizens around our common heritage during divisive times. For three years, Pat Nixon chose 'An American Flowers' theme, commissioning beautiful hand-made velvet and satin ball ornaments made by disabled Americans that are still part of the White House collection today. Several First Ladies, including Betty Ford, Rosalynn Carter and Nancy Reagan, looked to American history for inspiration, selecting early American traditions and folk art as Blue Room motifs. Pat Nixon honored former Presidents and founding fathers – Madison and Monroe – with gold decorations and gold foil fans, and also turned to nature for inspiration, choosing a theme of 'Nature's Bounty' that was based on artwork in the White House collection. In retrospect, some themes can seem a touch odd or dated – like the large Victorian dolls peering out from the 1980 tree – while other choices stand the test of time, showing enduring appeal for example the Nutcracker theme that has been re-interpreted by several First Ladies. The tradition

of choosing a Christmas theme, decorating the White House and adorning the Blue Room tree with inspirational meaning is a custom that every First Lady has embraced with enthusiasm. It is an opportunity to put her own stamp on White House holiday style to create inspirational holiday meaning as well as to create a lasting legacy of broader significance through symbolic décor.

SELECTING THE BLUE ROOM TREE. Long before the tree is delivered to its place of honor in the Blue Room, prospective Blue Room trees are carefully tended and groomed year after year on American tree farms. A typical Blue Room-designated tree can take about 24 years to grow, an arduous process that requires both patience and perseverance. Growers enter an annual contest sponsored by the National Christmas Tree Growers Association, which selects a winning farm to provide the prestigious honor of donating the Blue Room tree. One year, I joined the official White House delegation – the Chief Usher, the White House groundskeeper and horticulturalist – in the quest to pick out the Blue Room tree – and the other 50+ trees that are part of the White House Christmas portfolio. On a gray, fall day in early October, we climbed into an unmarked White House van and were whisked away to that year's top tree farm in central Pennsylvania, almost a four-hour drive from the White House. Once there, we did some scouting and marking of the trees, tagging each of them for a specific White House room. The official Blue Room tree would be officially 'selected' the following morning when the HGTV (Home and Garden Television) camera crew arrived to film the process.

In the morning, as the drizzle continued, we hiked through the soggy field until we came upon a section that contained some exceptionally large trees. There were three possibilities from which we could select the winning Blue Room tree. With the television cameras rolling, the Chief Usher presided over the group, listing the essential elements of the iconic Blue Room tree: it must be a perfect shape without flaws, he said, have good color and fragrance, with strong needles firmly attached to the branches. Of course, overall height and width are key considerations, so the team took meticulous measurements of the top three tree contenders that were tagged with yellow flags.

The selection of the Blue Room tree is a time-honored White House tradition that involves travelling to an American Christmas tree farm in October to inspect and evaluate all of the potential large-scale trees. Here I am in 2010 as part of an official White House delegation along with the owners of a tree farm in Lehighton, Pennsylvania, standing in front of the winning tree – a perfect 18 ½ foot Douglas fir tree that we eventually decorated in an 'America the Beautiful' theme.

With the cameraman following close behind, the horticulturalist strolled purposefully around each tree, taking notes, sniffing the branches and commenting about the merits of one tree vs. the next. Because it was my first foray into Presidential Christmas tree choosing, I paid close attention to the details and nuanced differences they discussed. From my perspective of analyzing the trees for decorative purposes, each one appeared to pass the test.

After a moment of high drama where the White House delegation engaged in the mock weighing of pros and cons of one tree over the next, noting the difficult decision at hand, the group landed on a unanimous (pre-determined) choice: the

Each year, the day after Thanksgiving, the Blue Room tree arrives at the White House by horse-drawn carriage as musicians play 'O Christmas Tree'. The tree grower then presents the tree to the First Lady for approval as workers gear up for its installation – a monumental but well-rehearsed task that has been fine-tuned over many years.

towering 19 foot Douglas fir with a perfectly symmetrical shape and light citrus-pine fragrance. Meanwhile, the crew gathered footage for the behind-the-scenes documentary that would air in mid-December. Staff and crew burst out in applause. The Chief Usher handed me the large red, white and blue bow to place on the winning tree. We all posed in front of it for the official picture, including staff and the family of the grower. This annual excursion is a quaint ritual that is embedded in White House tradition, a key part of creating the White House Christmas. The next step was for Blue Room tree – and the other 55 trees of various sizes – to be cut and baled, and trucked down to Washington, D.C. for the annual formal presentation to the First Lady.

THE PREPARATIONS. On the day after Thanksgiving, the White House holiday season kicks into high gear. Inside the White House, behind the scenes, there is a virtual whirlwind of activity in preparation for the imminent arrival of the Blue Room tree with the full Christmas installation following closely on its heels. Each White House team focuses on individ-

ual tasks at hand and most of them have memorized specific routines by heart. In the Blue Room, workers roll up carpets, place down tarps, and move priceless furniture and decorative elements to storage. Others are preparing for the arrival of trees, ornaments and volunteers that will all descend on the White House over the next few days. A key task is the removal of the elaborate Blue Room chandelier, which is slowly and carefully taken down from the central ceiling medallion by the electricians and placed into its own rolling crate for safekeeping. Next, Park Service personnel set the giant tree-stand in place in the center of the room. Then they stand waiting in the wings until the actual arrival of the tree. With the logistical plans in place, the chefs and butlers focus on setting the stage for tea in the Red Room where the First Lady will host the Pennsylvania grower and his family. These White House holiday preparations and rituals are honed over time and many years of practice, repeated again and again, year after year. All of the behind-the-scenes hub-bub continues throughout the day and is captured by HGTV as the cameramen struggle to keep up with the quick pace and multiple moving parts of Day 1 of the five-day holiday decorating extravaganza.

THE ARRIVAL. Around 11 a.m., the stage is set for the pageantry and presentation of the Blue Room tree to the First Lady. Dressed in old-timey costumes and tri-corn hats, two Park Service workers slowly drive the festive wreath and rib-bon-bedecked horse-drawn wagon, which carries the massive tree, up the west side of the drive until it reaches the North Portico where the First Lady comes out to greet the tree grower and his family. A scrum of press cameras and reporters are cordoned off across the drive, their cameras trained on every move. It's customary for the First Lady to inspect the tree, 'approving' it for the place of honor in the Blue Room. Although it's never once happened to my knowledge, one wonders what would occur if a First Lady rejected the tree. Would an alternate choice magically be waiting in the wings? After posing for pictures, the group retreats to the Red Room for conversation and tea. The presentation of the Blue Room tree is a lovely and much-anticipated tradition that every First Lady carries out year after year. Once the official presentation is complete, work resumes at an accelerated pace. Park Service personnel remove the baled tree from the wagon, carry it up the North Portico steps, across the Grand Foyer and straight into the Blue Room where it is hoisted with ropes into perfect position. The ropes are removed and the tree is allowed to settle before the electricians move in with thousands of colored lights and hundreds

of strings of energy efficient LED white lights. Most of the time it is a seamless, well-orchestrated process that happens quickly. . . . but I remember the time in 2014, when the tree was too wide to make it through the doors. After several hours of attempts, the workers finally put the tree in place – but only after the carpenters took the extreme step of removing both the North Portico and Blue Room doors, gaining a few extra inches to accommodate the super-sized tree. There is a brief glimpse of the fracas on HGTV where the workers can be seen racing towards the door holding the tree like a battering ram, only to be thwarted time after time in their attempt to squeeze it through the North Portico opening. In her remarks at the press preview that year, the First Lady marveled at the 'biggest tree ever' in the Blue Room, alluding to the delivery drama.

Park Service personnel install the tree after electricians remove the chandelier using a rope and pulley technique – and some good old-fashioned muscle power.

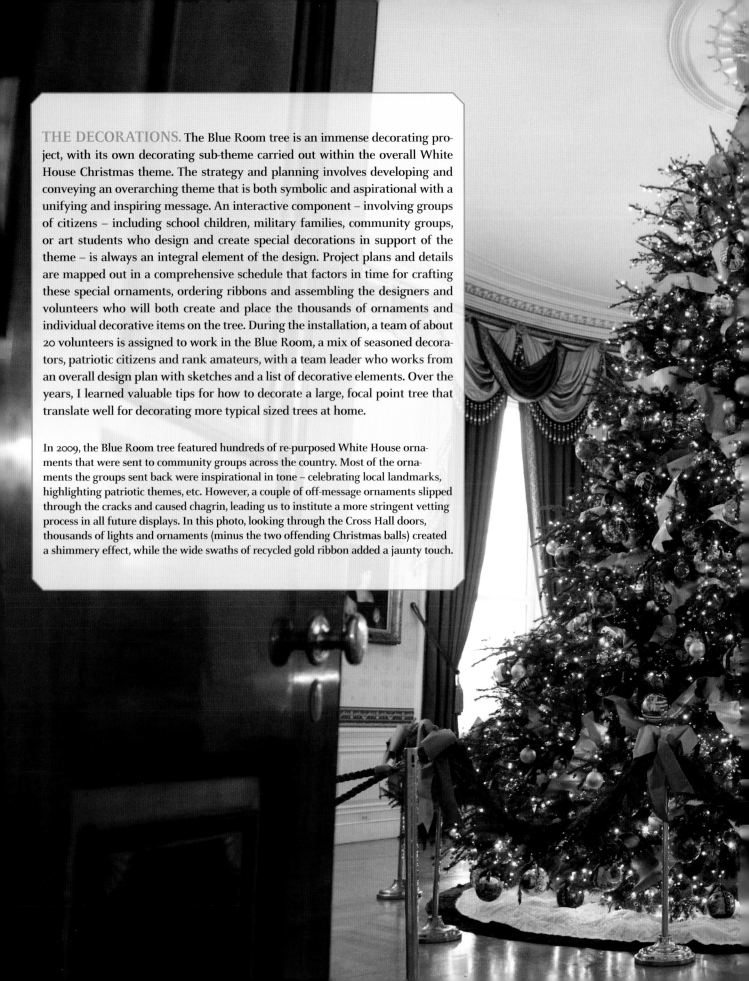

THE DECORATIONS. The Blue Room tree is an immense decorating pro-ject, with its own decorating sub-theme carried out within the overall White House Christmas theme. The strategy and planning involves developing and conveying an overarching theme that is both symbolic and aspirational with a unifying and inspiring message. An interactive component – involving groups of citizens – including school children, military families, community groups, or art students who design and create special decorations in support of the theme – is always an integral element of the design. Project plans and details are mapped out in a comprehensive schedule that factors in time for crafting these special ornaments, ordering ribbons and assembling the designers and volunteers who will both create and place the thousands of ornaments and individual decorative items on the tree. During the installation, a team of about 20 volunteers is assigned to work in the Blue Room, a mix of seasoned decora-tors, patriotic citizens and rank amateurs, with a team leader who works from an overall design plan with sketches and a list of decorative elements. Over the years, I learned valuable tips for how to decorate a large, focal point tree that translate well for decorating more typical sized trees at home.

In 2009, the Blue Room tree featured hundreds of re-purposed White House orna-ments that were sent to community groups across the country. Most of the orna-ments the groups sent back were inspirational in tone – celebrating local landmarks, highlighting patriotic themes, etc. However, a couple of off-message ornaments slipped through the cracks and caused chagrin, leading us to institute a more stringent vetting process in all future displays. In this photo, looking through the Cross Hall doors, thousands of lights and ornaments (minus the two offending Christmas balls) created a shimmery effect, while the wide swaths of recycled gold ribbon added a jaunty touch.

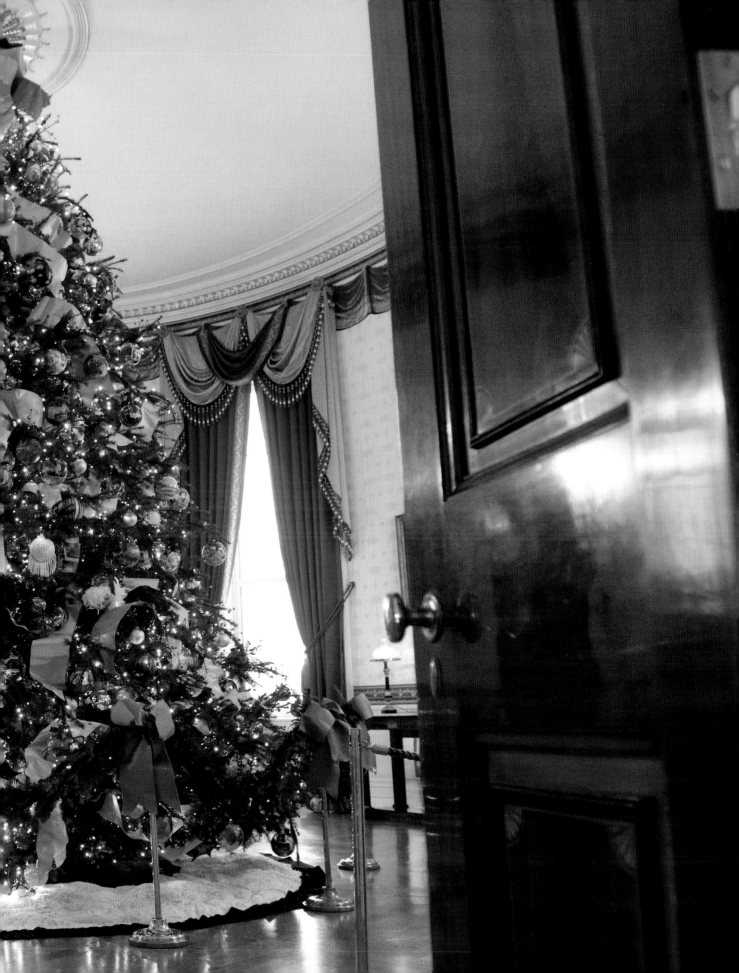

While the overall look of the Blue Room tree is new and different each year, the foundation of the design relies on the past – the vast array of ornaments and decorations that are part of the White House collection accumulated over many years. Each Blue Room design requires well over 3,500 individual ornaments to cover its massive girth. By re-purposing and re-fashioning elements from previous years, incorporating special touches such as children's greeting cards sent to troops, photos of military homecomings, and patriotic symbols and badges, we could create a multi-layered base design with overlays of new elements and handmade ornaments. Early in the New Year, we developed ideas and plans for the Blue Room tree. One of my favorite iterations was the 2010 design that highlighted the bounty of America's vast agricultural heritage, the symbols of the heartland, and iconic American traditions. With assistance of students from the Savannah College of Art and Design, we created a vintage-style tree that celebrated America's state and county fairs. The pastel color scheme and hand-made ribbons with farm motifs and natural materials, including sheaves of wheat woven into and around the tree and decorating the top, conveyed the overall theme of 'Simple Gifts.' The tree was beautiful aesthetically – introducing a new motif and surprising, non-traditional color scheme – but the power of its presentation was in the meaning in the all-American symbolism of the ornaments and décor. A hand-made tree skirt measuring 18 feet across, featuring the lyrics to 'America the Beautiful,' completed the presentation. Other years, we focused on variations of a military theme, creating patriotic trees that celebrated active military personnel and their families, fallen service members, and the people and organizations that support the military through the First Lady's 'Joining Forces' policy initiative. The tree was bedecked with photographs and greeting cards, medals and badges, and patriotic banners. It was a celebration of American service and sacrifice rendered in shades of red, white and blue; highlight and supporting the nation's military members and their families, bringing them to the forefront of the White House holiday.

THE SYMBOLISM OF THE BLUE ROOM TREE.

The overall design of the Blue Room tree always imparts the personal priorities and sentiments of the First Lady, yet the final presentation seems to convey much more. With an inspiring concept, a symbolic mix of materials, and a compelling story about the volunteers who create the ornaments and help put them on the tree, the Blue Room tree creates a unique narrative of timeless American tradition. While the theme and décor of the Blue Room tree change every year and in every administration, the message remains the same: the tree represents and honors everyday Americans while celebrating the beauty and magic of Christmas.

Recently I learned that a volunteer who has been decorating the White House for decades has quietly and surreptitiously wielded a personal version of holiday diplomacy that has mostly gone undetected for almost 40 years. Unbeknown to the presidential families that inhabit the White House, this volunteer takes the initiative to secretly hide the same symbolic glass ornaments year after year amidst the thousands of decorations in the Blue Room tree, no matter the person or political party in power: a pickle, a pig and a frog. In the German tradition, the pickle brings the promise of good luck, the pig brings prosperity and the frog brings progress – all wonderful messages for our country and for the symbolic Blue Room tree. These special ornaments are a constant reminder that no matter the theme, the political party, or the Presidential family in residence, the White House – and the Blue Room tree – are symbols that unite all Americans. The volunteer's thoughtful gesture provides a wonderful sense of continuity and an uplifting message for all of us, year after year, highlighting the sense of tradition at the White House.

For the 2010 theme of 'Simple Gifts', students and alumni of the Savannah College of Art and Design (SCAD) created beautiful ribbon ornaments that carried symbolic meaning. The ornaments paid homage to the ribbons that are awarded at county fairs and were designed to highlight an iconic symbol from each state or region across the U.S.

DECORATING LARGE TREES

Tip: Place large, shiny ornaments – especially those with a gold, silver or copper metallic finish – deep in the interior of the tree. This will bounce the light and illuminate the tree from within.

Tip: Calculate the correct number of lights for your tree by using at least 100 – 200 for every vertical foot – and more if you like a dense, bright look.

STEP-BY-STEP TECHNIQUES

1 Start with an overall theme and a cohesive color scheme.

2 Sketch the design and assemble all of the elements: ornaments, ribbons, accessories, etc. using a mix of sizes, colors and finishes (shiny, sparkly, natural, etc.)

3 Light the tree working in vertical sections, weaving the strands well into the interior of the tree.

4 Hang the largest ornaments first, balanced at different levels around the tree. Place some of the large ornaments in deep to create a sense of depth.

5 Add the widest garlands and ribbons to create line and movement in the overall design.

6 Fill in the tree with colorful ornaments, adding color, texture and various finishes.

7 Finish the tree with special home-made touches placed in prominent positions to give a personal touch to the tree.

This photo depicts the completed 2010 Blue Room tree that volunteers topped with sheaves of wheat and finished off with a special hand-made tree skirt that spelled out the words to 'America the Beautiful'.

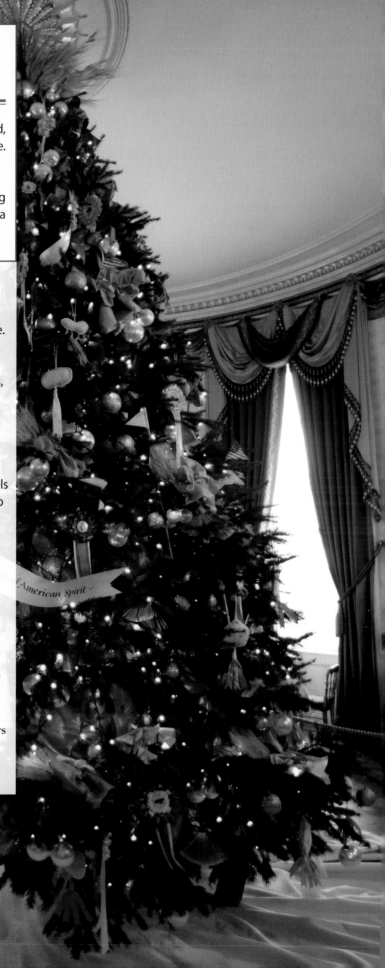

CUSTOM RIBBON DESIGNS

Large, focal point décor elements (like the Blue Room tree) require large-scale decorations to achieve aesthetic balance, especially when they are used in expansive rooms. Too-skimpy ribbons or too-tiny ornaments can distract the eye and detract from the overall presentation. Because high-quality extra-wide ribbon is such an expensive proposition, I sought ways to create custom ribbon designs that could be placed on large trees (as well as on garlands and wreaths) using materials we already had on hand. We went to the White House warehouse where decades of holiday ribbons and ephemera are stored away, waiting to be rediscovered and put on display. I especially enjoyed delving into the large rolling bins of ribbon that were lined up in the back of the warehouse. There, the unique ribbons in every holiday hue were an endless source of inspiration and creative opportunity. Year after year, we re-fashioned the ribbon in geometric-patterned motifs – a new detail that could be used to decorate trees, vases, wreaths and garlands. The custom ribbon work is a great way to use leftover ribbons and to add a new layer of detail and craft-work to holiday displays.

WHAT YOU'LL NEED

- Wide wire-edged ribbon or fabric (10 – 18 inches across) for the base layer
- Ribbons in various colors and widths (for the decorative pattern)
- Marking pen and ruler
- Tracing paper
- Hot glue gun (and glue sticks)
- Spray adhesive

Tip: Peruse a variety of pattern books for design inspiration. Geometric patterns (stripes, polka dots, triangles, etc.) are particularly effective.

Tip: Use a spare amount of hot glue, only what is minimally needed to secure the motif to the base ribbon to avoid leaving marks..

STEP-BY-STEP TECHNIQUES

1 Identify a geometric pattern and copy it to tracing paper. TIP: Xerox the pattern to achieve the desired size and scale.

2 Trace the design on your base ribbon.

3 Measure the decorative ribbon and cut out the pattern pieces, taking care to keep them uniform in size.

4 Using the spray adhesive on the base layer, apply the individual ribbon pieces. Add hot glue if necessary on the edges to secure the ribbon.

5 Continue adding pieces of ribbon to complete the pattern and create the desired length of custom ribbon.

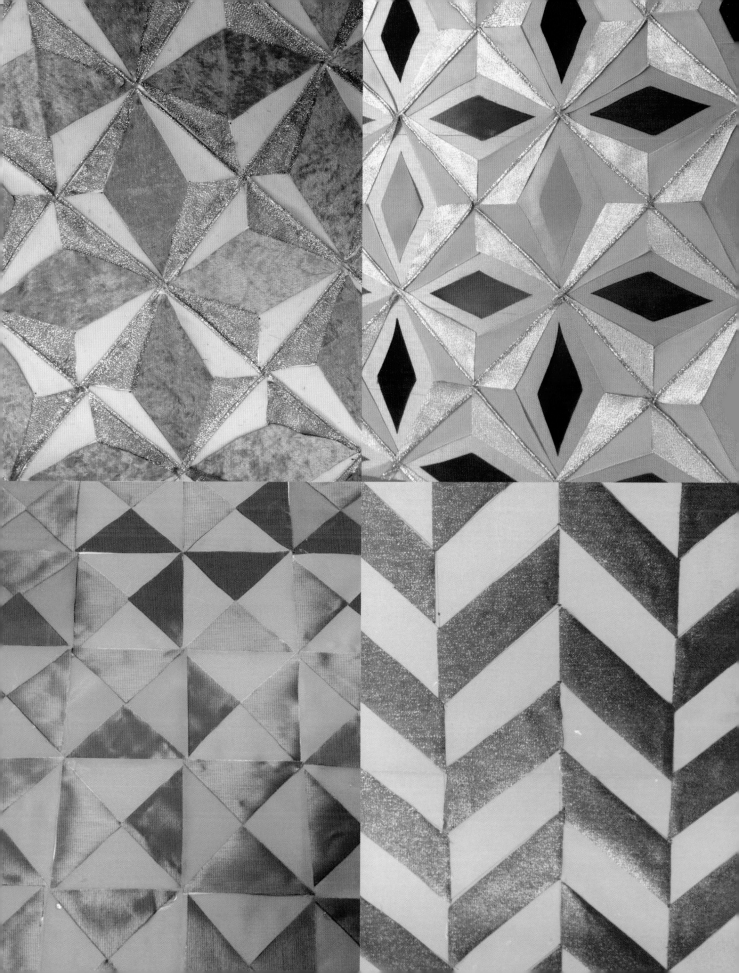

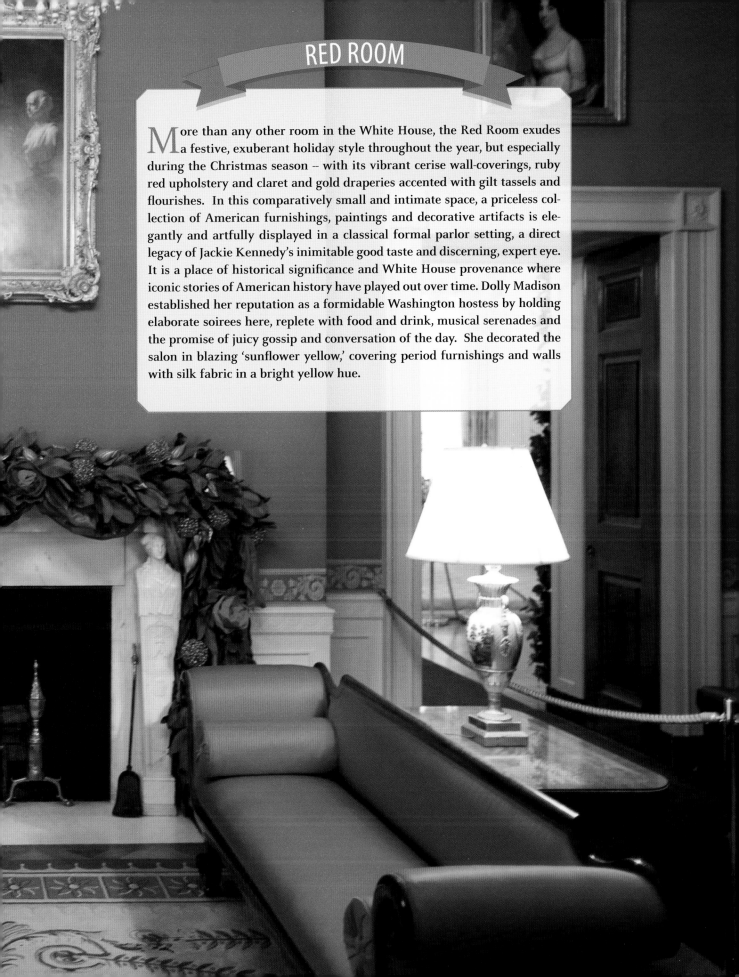

RED ROOM

More than any other room in the White House, the Red Room exudes a festive, exuberant holiday style throughout the year, but especially during the Christmas season -- with its vibrant cerise wall-coverings, ruby red upholstery and claret and gold draperies accented with gilt tassels and flourishes. In this comparatively small and intimate space, a priceless collection of American furnishings, paintings and decorative artifacts is elegantly and artfully displayed in a classical formal parlor setting, a direct legacy of Jackie Kennedy's inimitable good taste and discerning, expert eye. It is a place of historical significance and White House provenance where iconic stories of American history have played out over time. Dolly Madison established her reputation as a formidable Washington hostess by holding elaborate soirees here, replete with food and drink, musical serenades and the promise of juicy gossip and conversation of the day. She decorated the salon in blazing 'sunflower yellow,' covering period furnishings and walls with silk fabric in a bright yellow hue.

The Red Room obtained its official name in the 1840s, when it was refurbished with red fabrics, tapestries and floor coverings. At the turn of the 20th century, Theodore Roosevelt reimagined the space as a 'smoking room' where male guests adjourned for post-dinner cigars and brandy. In the 1930s, Eleanor Roosevelt broke new ground when she invited women reporters to join her in the Red Room for informal conversations. These discussions of cooking and housekeeping tips evolved into more expansive conversations of domestic policy topics, a harbinger of major cultural change regarding women's roles and influence in the policy arena. Nancy Reagan, who famously made red her signature color, relished and showcased the Red Room as both a place for official entertaining and for private family gatherings. After re-decorating the Red Room in 1961, with neoclassical furniture in the Empire style, Jackie Kennedy commissioned an artist to paint a watercolor rendition of the space, which became the official Presidential Christmas greeting card in 1962. A passionate aficionado of French style furnishings and interior decor, she had a reproduction of a 19th century Savonnerie carpet made to add a timeless touch of elegant French flair to the Red Room design. It was her favorite White House room.

To create the Red Room Christmas décor, we focused on color, key elements and important holiday traditions. The rich color of the Red Room is actually a complex mix of cerise red with underlying shades of blue and purple so it looks most beautiful with coordinating colors in equally vibrant hues. With a red color so saturated, it's important to lead with color as the most critical design element in the room, so we mostly used intense shades of red along with coordinating tones of purple, fuchsia and plum when conjuring holiday décor schemes. Our next step was to map out specific plans and design details for each decorative element: the mantel garland, Christmas trees, wreaths, cranberry topiary, and floral accents. we considered both the overall composition and the balance of coordinating details – tying everything together with a unifying theme. And, finally, we focused on incorporating iconic White House traditions – including the cranberry topiary tree – in the overall mix of plans and designs. The Red Room was always an inspiring room to decorate during the holidays.

A Red Room arrangement of fruit, flowers and foliage was arranged in a hand-made vessel of cranberries and pepper berries in 2011.

p. 118 The Red Room cranberry piece is a cherished White House tradition, involving the use of cranberries in a holiday floral topiary display. Over the years, we incorporated a variety of hand-made floral art designs to carry out this long-standing tradition. In 2010, I created a de-constructed cranberry sphere made of wood, pine and cranberries, fashioned into a transparent and displayed on a Vermeil urn.

Over the years my favorite elements were the hand-made projects that inspired visitors with their creative vision, hand-made craftsmanship and exquisite detail. These included a vase crafted from yellow billy balls, green china berries, and red hypericum in an illusion cube motif inspired by the most valuable piece in the White House collection: the Red Room's early 19th century marble-top table inlaid with a similar geometric pattern. Other favorite projects included the sugar flower and fruit urns that were fashioned completely from gum paste by a local artisan and the striped-patterned floral vessel made from simple winter-berry covered buckets.

The main White House tradition that we honored each year in the Red Room was the cranberry topiary display, a classic cone of fresh cranberries that sits on an evergreen base. The tradition of crafting the topiary piece is fairly recent, dating back only to 1975, but it's one of those tangible elements that people came to expect, dutifully executed year after year in the same way by the same volunteer. The cranberry topiary is a symbol of history and tradition, passed down from one First Family to the next. During my tenure, I felt it was important to show that we could take a special White House tradition and continue to inspire people by re-inventing it in new and innovative ways. The idea would be to take the cranberry element and re-fashion it in various iterations and forms. So, my first year, I created a new shape: a transparent sphere, a deconstructed cranberry ball made from wood and wire, princess pine and cranberries, presented in a gold Vermeil urn – a classically elegant shape in a modern interpretation. By making our special crafts out of simple materials that were either inexpensive or free, we implemented creative, yet accessible décor. I was pleased when people were inspired to try these design projects at home.

Over the next few years, I focused on turning the cranberry piece into a floral container that we could use to display the fresh flowers that always provided the finishing touch to our White House holiday decorations. Vases were made from cranberries and pepper berries, and sugar paste urns were decorated with flowers, birds, berries and vines. I loved how these pieces carried out time-honored traditions, but infused them with new and modern design aesthetic. These special pieces energized the overall displays and gave people a sense of anticipation about something new and inspiring they might see. The Red Room was transformed into a combination of new and beloved historic traditions that helped to create the intangible feeling of a magical White House Christmas.

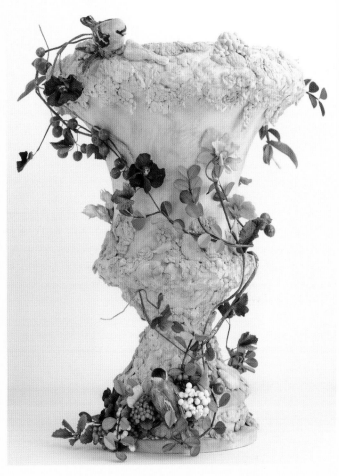

This version of the Red Room cranberry vase with flowering vines and cardinal birds was made out of sugar paste by local artist Maggie Austin.

Decorating the Red Room is always a plum volunteer assignment, with its prominent displays, vivid color scheme and iconic traditions – volunteers love being part of this esteemed design team. One year, an earnest volunteer put the finishing touches on an intricately decorated Red Room tree, fussing and tweaking the ornaments to get the perfect presentation. Spying an extra length of wire dangling from one of the ornaments, she reached for her clippers and cut the wire – inadvertently cutting the light string too, which plunged the tree into darkness. The fumble-fingered decorator worried that her transgression would annoy the electricians and possibly lead to her demotion or even ouster as a volunteer. Just as she was pondering her precarious predicament, the electrical team walked by. It was an easy fix, they said reassuringly, as they whipped out a length of wire to splice and repair the severed cord. Before they left the Red Room, one of the electricians took the volunteer's clippers and wrapped duct tape completely around them, rendering the tool useless. He handed it back to her in a mock presentation ceremony as the entire room burst into laughter – a light-hearted moment in the midst of the arduous work week.

At the end of the holiday season, as we celebrated the last party at the White House, the one that honors the contractors and part-time staff who work with us during the busy season, I joined my friends and colleagues in the Red Room for one final toast to the season. As we sat together on the sumptuous sofa facing the roaring fire, I became lost in the moment, experiencing the space in an entirely new light. Rather than view the Red Room through the lens of my work-a-day responsibilities that involved the routine checking of flowers and decorations, replacing arrangements and broken ornaments, and racing around to set up back-to-back holiday parties, I became aware that we were experiencing something very special. With the steady gaze of Anjelica van Buren, the daughter-in-law of President Martin van Buren, staring down at us in the portrait above the garland-bedecked fireplace mantel, the magic of the Red Room ambiance was unmistakable. In that majestic, yet intimate setting, the Christmas decorations served as further embellishments to the historical venue, infusing the entire room with the warmth of holiday style. The Red Room sparkled and glowed that night – and we felt honored and lucky to be there.

Two hand-made sugar flower vases – one featuring a princess pine topiary and the other a lush display of green flowers and ferns with red berries – add bold colors and texture to the Red Room in 2013.

The Red Room is most beautiful in the morning light and in the evening when candles and firelight cast the room in a luminous glow. This photo was taken at the start of the season in 2011

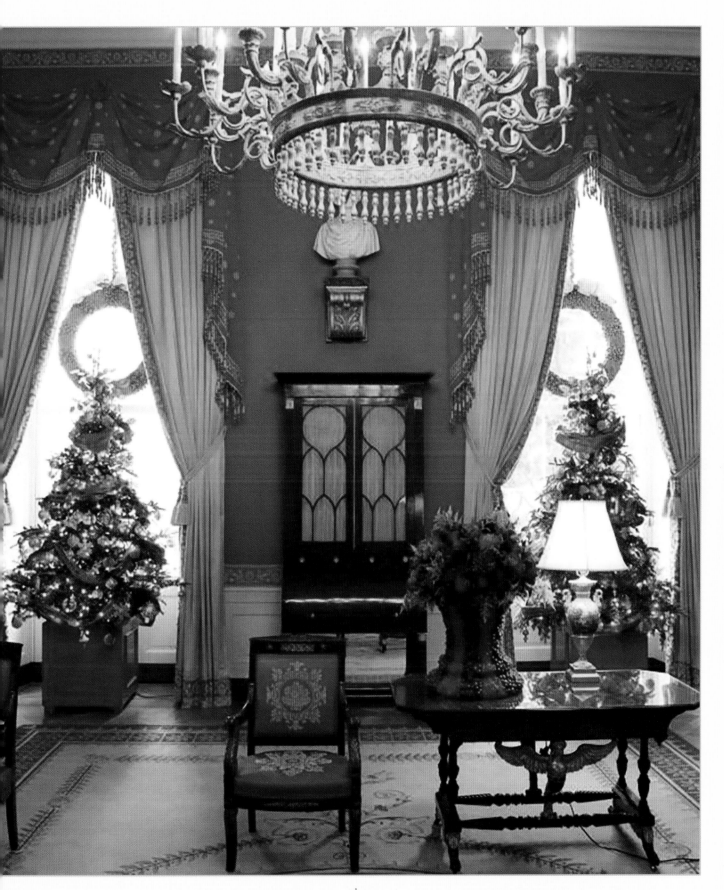

RED ROOM BERRY VASE

Hand-made organic containers are an excellent way to create an overall integrated look to holiday floral displays, bringing seasonal elements – berries, evergreens, pinecones, etc. – into the design to enhance the feeling of the winter season and holiday mood. I first learned how to make beautiful natural containers when I studied floral designs in Paris. I'll never forget the 'winter white bouquet' we made that featured a juniper and mistletoe vase filled with white scented flowers and evergreen foliage. The textured base, made from a simple plastic pot covered in sprigs of greenery, created an elegant, wintry display, establishing the illusion that the flowers were growing out of the evergreen base. At the White House, I used natural leaf-covered containers throughout the year, but especially during the holidays, when we could experiment with a variety of materials and colors to coordinate with all of our themes and holiday designs. The Red Room holiday containers usually featured a cranberry theme, a choice that paid homage to the White House cranberry topiary tradition. By creating floral vessels with a berry motif, my goal was to honor the cranberry tradition by re-inventing the design with a modern twist. Here are tips and techniques for creating a striped red berry vase like the ones we used in the Red Room in recent years.

WHAT YOU'LL NEED

- A plastic container or bucket
- Masking tape
- Marking pen
- Measuring tape or ruler
- Hot glue gun (and glue sticks)
- Red (floral/craft) spray paint
- Faux berries in 2 different varieties
 (e.g., cranberries and pepper berries)

STEP-BY-STEP TECHNIQUES

1 Apply masking tape to a plastic container or bucket, cutting long strips to completely cover the entire surface.

2 Using the spray paint, apply an even coat of paint on the bucket, covering the masking tape.

3 Using a pen and ruler, mark off vertical stripes on the container, taking care to space them evenly.

4 With a hot glue gun, apply rows of pepper berries and cranberries around the vase, alternating the berry stripes, until the container is completed covered with berries.

5 Add red seasonal flowers and greens: amaryllis, roses, ranunculas or carnations to create a unique and dramatic floral display.

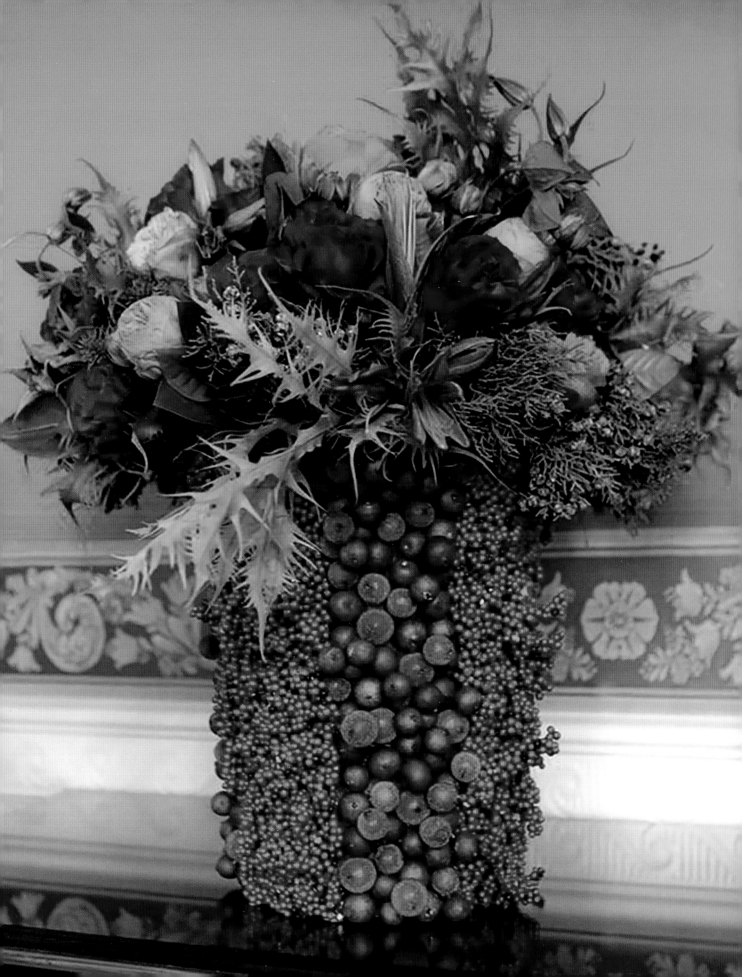

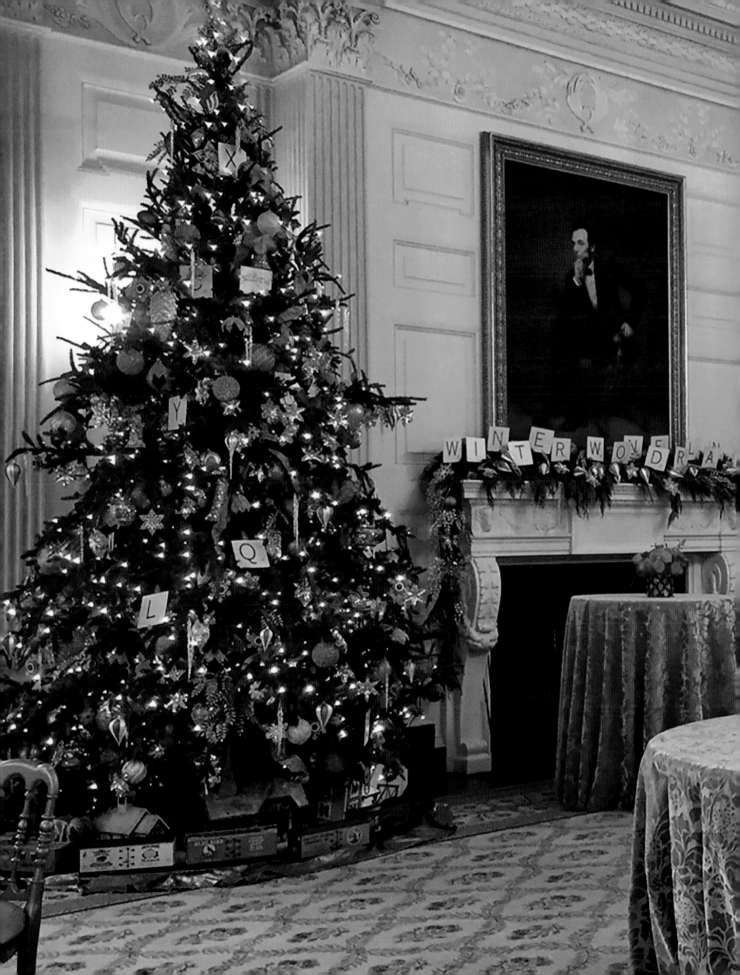

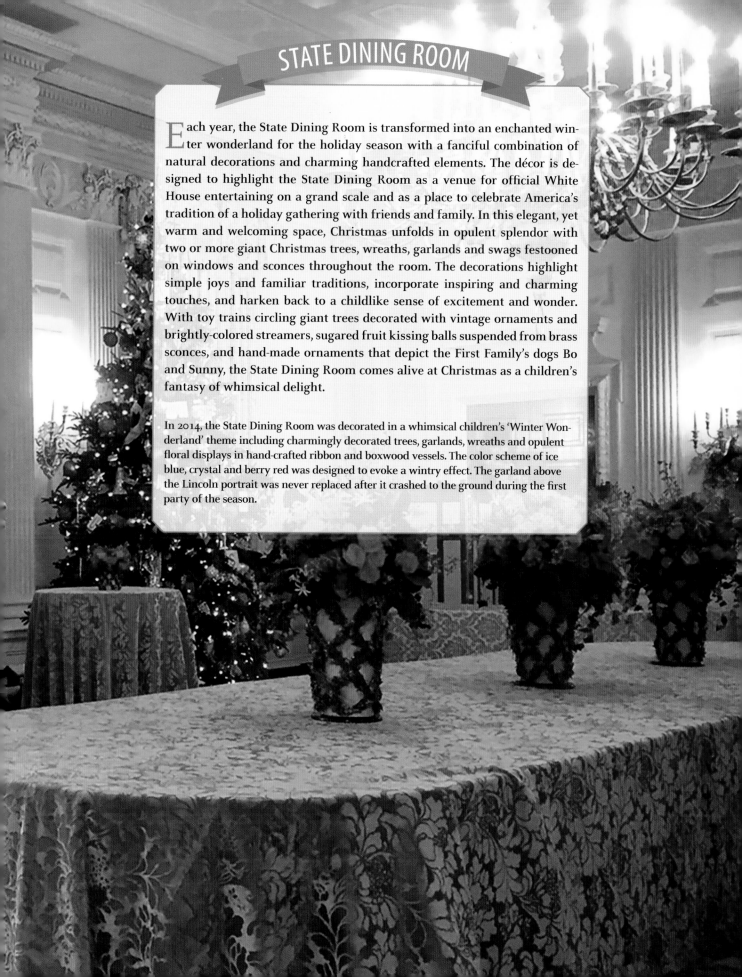

STATE DINING ROOM

Each year, the State Dining Room is transformed into an enchanted winter wonderland for the holiday season with a fanciful combination of natural decorations and charming handcrafted elements. The décor is designed to highlight the State Dining Room as a venue for official White House entertaining on a grand scale and as a place to celebrate America's tradition of a holiday gathering with friends and family. In this elegant, yet warm and welcoming space, Christmas unfolds in opulent splendor with two or more giant Christmas trees, wreaths, garlands and swags festooned on windows and sconces throughout the room. The decorations highlight simple joys and familiar traditions, incorporate inspiring and charming touches, and harken back to a childlike sense of excitement and wonder. With toy trains circling giant trees decorated with vintage ornaments and brightly-colored streamers, sugared fruit kissing balls suspended from brass sconces, and hand-made ornaments that depict the First Family's dogs Bo and Sunny, the State Dining Room comes alive at Christmas as a children's fantasy of whimsical delight.

In 2014, the State Dining Room was decorated in a whimsical children's 'Winter Wonderland' theme including charmingly decorated trees, garlands, wreaths and opulent floral displays in hand-crafted ribbon and boxwood vessels. The color scheme of ice blue, crystal and berry red was designed to evoke a wintry effect. The garland above the Lincoln portrait was never replaced after it crashed to the ground during the first party of the season.

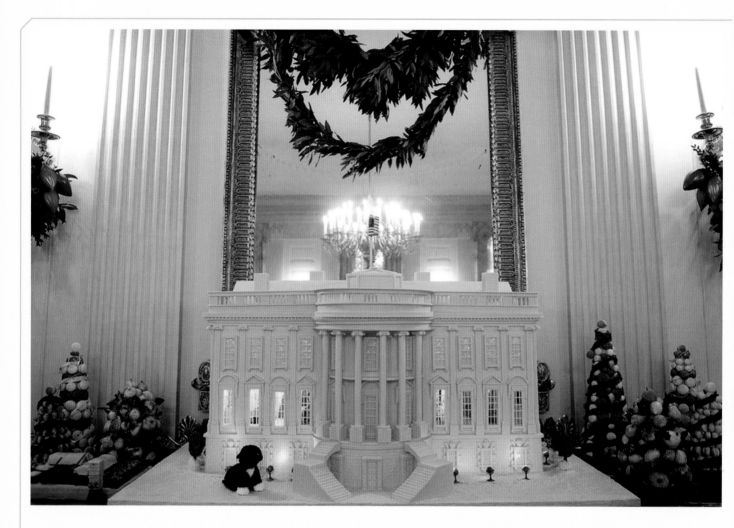

The iconic White House gingerbread house has the place of honor in the State Dining Room as a focal point piece on the White House tour. A tradition since the early 1970s, the gingerbread house seems to get bigger and more elaborate every year, with each pastry chef striving to create new and unusual elements. The construction of the gingerbread house begins in October and continues until the dramatic installation occurs right after Thanksgiving. After weeks of meticulous behind-the-scenes work, the massive 500 pound structure is finally delivered to its prominent place of display, delighting and enchanting visitors throughout the season.

The formality of the room provides inspiration for the décor. The wood paneled walls, patterned after an 18th century neoclassical English house, feature Corinthian pilasters and delicately carved friezes. The imposing portrait of Abraham Lincoln hangs above the carved marble fireplace, dominating the room and lending an air of serenity. A large multi-armed silver-plate chandelier illuminates the room, complemented by eight brass sconces hanging on the walls. Marble-top pier tables with carved eagle supports ring the perimeter of the room while a large mahogany 19th century table occupies the prominent center space. Silk damask draperies with a floral, basket and ribbon motif in shades of coral, green, pink and turquoise add a colorful dimension to the décor.

My inspiration for holiday décor centered on the purpose of the room as a place for celebratory gatherings throughout the season. In 2010, our concept featured sugared fruit and lemon leaf garlands accented with festive ribbons and topiary displays in a palette of tangerine, coral, lemon yellow, copper

The White House gingerbread house is an annual tradition that dates back to the early 1970s. The 400 pound edition of the gingerbread house created for the 2011 season featured miniature replicas of the White House state rooms and a larger-than-life sugar paste rendering of Bo.

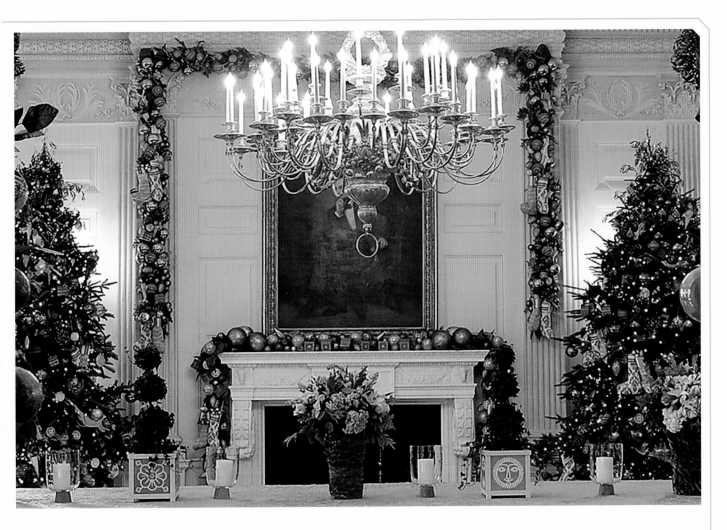

and gold. Mixed garden style bouquets of coral poinsettias, garden roses, seasonal foliage, orchids and hellebores in unstructured arrangements were placed on the large center table and on the side pier tables. These bouquets were presented in handcrafted vessels made from inexpensive copper flashing, cut into scalloped pieces that were glued onto simple flared buckets. The fanciful look included handcrafted fresh lemon leaf garlands embellished with recycled gold leaves from previous White House Christmases.

Another year, we created a vintage Christmas carousel theme with old-fashioned toy trains, carousel horse ornaments, candy canes, crepe paper spheres, bottlebrush trees, bunting garlands, vintage glass ornaments and Christmas trees adorned with ribbon streamers evoking a carousel effect. To carry out the theme and coordinate with the colors in the silk damask drapery, we used a vibrant palette of candy colors: red, yellow, blue, orange, pink and citron green. A wide range of colors always worked well in the room. One concept featured a sugar plum fairy garden in shades of white gold, plum, blush pink, and shimmering crystal. For that look, we wove vintage ornaments and silk ribbons into the garlands and trees and hung evergreen swags with ribbons and ornaments on the brass sconces. The theme of a children's winter wonderland provided inspiration for special handcrafted decorations based on beloved children's stories that symbolized the festive spirit of the season. A color palette of winter white, ice blue, berry red and silver with accents of crystal was carried out in both the Christmas décor and large bouquets of red roses and amaryllises in handcrafted ribbon and boxwood vases.

Even with its expansive proportions and priceless collection of American decorative arts, the State Dining Room conveys a warm and welcoming tone that is enhanced with holiday décor. Here, the mantel is hung with oversized ornaments, woolen Christmas stockings and wooden blocks to create create a whimsical, fanciful design.

LEMON LEAF GARLAND

With an emerald color that dries into silvery sage green and a long-lasting quality, lemon leaf salal is a versatile choice for holiday greenery and decor. Because it is inexpensive and readily available year-round, lemon leaves work well in topiary, wreath and garland designs and mix nicely with fruit and vegetable displays. At the White House, lemon leaves were a staple in my designs throughout the year, but especially at Christmas when we wove them into floral vessels and lush garlands. Here is a technique for making a mantel garland with gilded leaf embellishments; it is a technique that can be used for any kind of holiday greenery including magnolia, fir, juniper and other evergreen foliage.

WHAT YOU'LL NEED

- Measuring tape
- A length of cording or rope (1/2 inch in diameter)
- Green paddle wire
- 8 – 10 bunches of lemon leaf salal tips (depending on garland length)
- Wire snippers
- Clippers
- 6 inch wired wood picks
- Gold leaves (from the craft store)

STEP-BY-STEP TECHNIQUES

1 Measure the mantel and cut a length of cord to fit, including enough to create a swag and tails on each side.

2 Prepare the lemon leaves by cutting them into 5 inch pieces, bundling 3 – 4 pieces together with the paddle wire to create even bunches. Make dozens of lemon leaf bunches.

3 Attach the bundles to the base cording by wrapping the paddle wire around the base of the bunch 3 – 4 times, securing each one tightly to the cording. Take care to add bundles all the way around the cording to create a lush effect, adding the next layer an inch or two below the tied bundles.

4 Continue attaching bundles in this fashion until the entire length of cording is covered.

5 Finish the garland by inserting individual gold leaves into the garland using the wired wood picks.

6 Attach the garland on the mantel by attaching wired loops to the back of the cording, allowing the garland to hang gracefully.

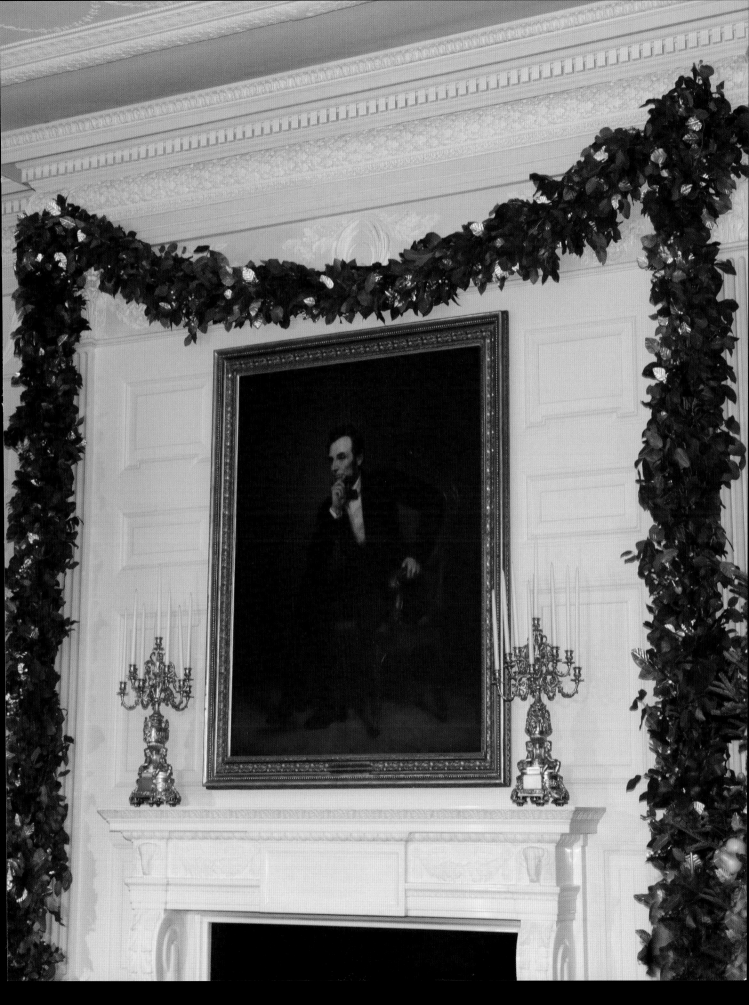

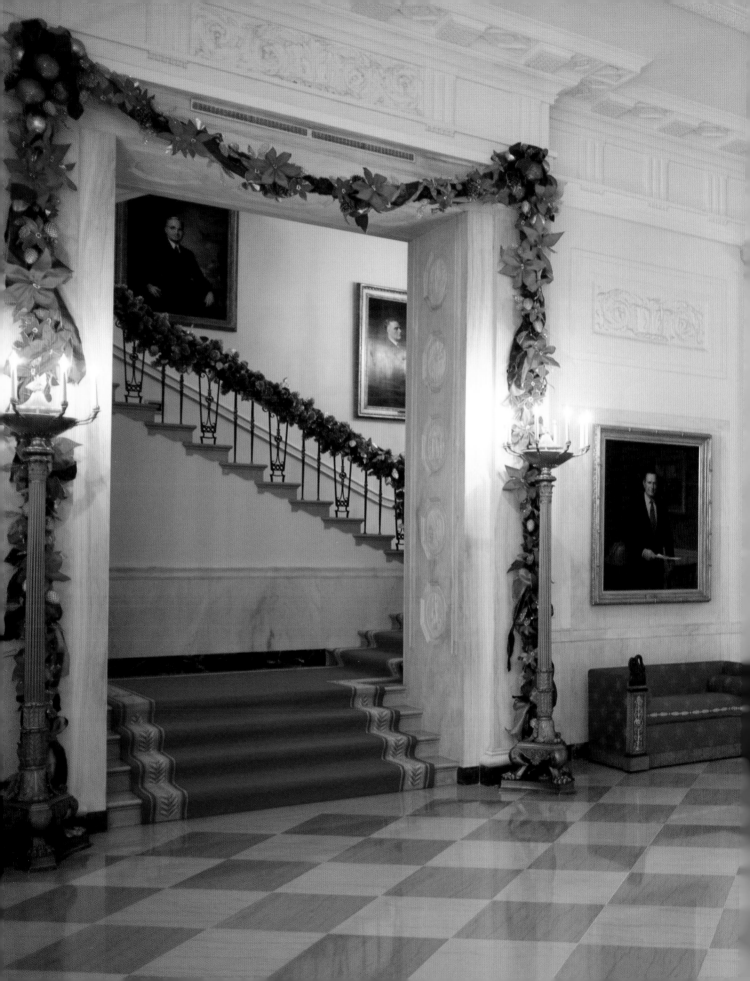

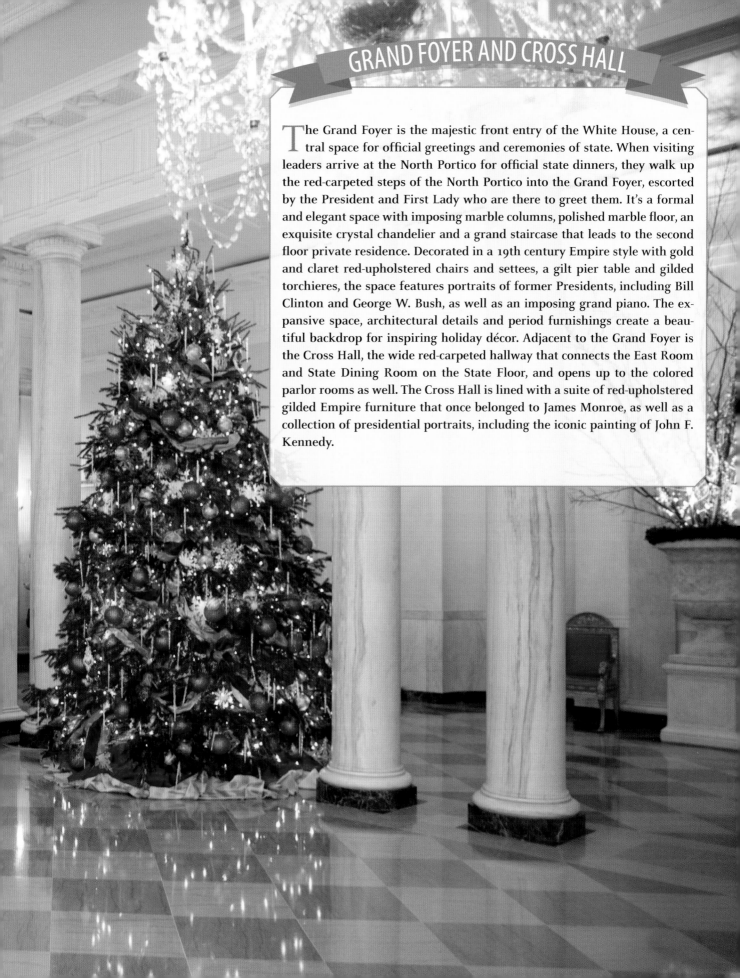

The Grand Foyer is the majestic front entry of the White House, a central space for official greetings and ceremonies of state. When visiting leaders arrive at the North Portico for official state dinners, they walk up the red-carpeted steps of the North Portico into the Grand Foyer, escorted by the President and First Lady who are there to greet them. It's a formal and elegant space with imposing marble columns, polished marble floor, an exquisite crystal chandelier and a grand staircase that leads to the second floor private residence. Decorated in a 19th century Empire style with gold and claret red-upholstered chairs and settees, a gilt pier table and gilded torchieres, the space features portraits of former Presidents, including Bill Clinton and George W. Bush, as well as an imposing grand piano. The expansive space, architectural details and period furnishings create a beautiful backdrop for inspiring holiday décor. Adjacent to the Grand Foyer is the Cross Hall, the wide red-carpeted hallway that connects the East Room and State Dining Room on the State Floor, and opens up to the colored parlor rooms as well. The Cross Hall is lined with a suite of red-upholstered gilded Empire furniture that once belonged to James Monroe, as well as a collection of presidential portraits, including the iconic painting of John F. Kennedy.

Over the years, First Ladies have decorated the space in a variety of different schemes, usually incorporating red as a dominant tone. The large columns provide an ideal framework for lush garlands that are typically draped throughout the space. One of the more intriguing treatments was when Pat Nixon wrapped the columns in red fabric, creating a striking look but probably one that would not pass curatorial muster today, since decorative materials are not allowed to touch historic structures and surfaces. Decorations typically feature large Christmas trees, wreaths in the windows and on the mirror, topiaries and flower arrangements. In 2006, Laura Bush installed giant trees made of live poinsettias to create a lovely and natural presentation. The Grand Foyer is where the official White House menorah celebrating the Jewish holiday of Hanukkah is placed – a White House tradition dating back to 2001, when George W. Bush hosted the first White House Hanukkah party.

There have been a number of inspiring decorations in this space, but my favorite version was the winter garden theme display in 2010. The overarching inspiration was the architectural space – the grand proportions, marble columns, carved niches, and classical motifs which called for large-scale elements: 14 foot trees, oversized wreaths, lush garlands and tall urn displays of winter branches. The décor theme was inspired by the natural beauty of the winter season. Large urns of birch and beech branches wrapped with rock crystals and delicate white lights were placed symmetrically, flanking the doors of the North Portico and the Blue Room to invoke a wintry effect. Volunteers made one thousand hand-made red velvet poinsettias which graced the garlands hanging throughout the space. The four large Christmas trees were decorated with snowflake and cardinal bird ornaments as well as layers of red and gold glass balls from the White House collection. A color palette of cardinal red, regal gold, sparkly crystal and evergreen conveyed the spirit of a winter landscape. The combination of original hand-made elements paired with traditional Christmas trees and garlands in the sweeping space created an overall ethereal effect, evoking the spare beauty of winter and the majesty of nature.

p. 132 For this Christmas installation in the Grand Foyer in 2010, we crafted 1,000 poinsettias made from recycled velvet ribbon to decorate the wreaths, trees and garlands throughout the space. A classic color palette of red, green, snow white and sparkly crystal – evoking a seasonal theme – always worked well, coordinating with the furnishings and architectural elements.

AN OVERNIGHT PROJECT. One of the only times I pulled an all-nighter at the White House was when we completely switched out the Grand Foyer and Cross Hall garlands in the wee hours of the night before the opening day of the Christmas season in 2011. A guest designer initially selected a narrow two-inch garland to drape the massive columns of the Grand Foyer space and the plans progressed unfettered all the way to installation. As volunteers completed the garland installation, a number of whispers, at first quiet and then growing louder – could be heard. The garlands looked too skimpy, the worker bees and long-time staff worried, not at all like the lush and elegant displays that are usually in place. Not surprisingly, when the reviewers conducted a walk-through around 5 p.m., the verdict was unanimous: the skimpy garland must come down and be replaced that night with a more traditional garland so that the revised scheme would be in place before the first tours started at 7:30 a.m. the next morning. I was notified of the need to replace the garland after the walk-through but learned that we would not be able to start the work until 10 p.m. that night after the first party ended. The challenge was that the volunteers (all 100 of them) had just gone home, leaving a dearth of helping hands.

My first step was to put on a big pot of coffee and then dial the hotline number of my local wholesale supplier to see if it would even be possible to obtain the emergency supply of thick garland on such short notice (and not an insignificant amount), long after regular business hours. Yes, my rep confirmed, they had the garland and could deliver it to the White House by 10 p.m. I confirmed the replacement amounts required for each space. Then, I called two local volunteers with the unusual request – 'do you want to join me for a White House adventure this evening?' Luckily for me, they both were game. I went upstairs to the Cross Hall and Grand Foyer to map out our plan for the nighttime caper. In addition to the decorating volunteers, we would need carpenters and overnight engineers to help with the de-installation and replacement installation of the garland. I estimated that if we started at 10 p.m. we would finish by 5 a.m. in the morning.

From the vantage point of the Cross Hall, the view of the Blue Room tree is always inspiring, especially in 2010 when gigantic urns of beech and birch branches wrapped in crystal flanked the view of the tree decorated in an 'America the Beautiful' theme.

As the last unsuspecting guest left the holiday party that evening, our night shift team swept into action. Moving quickly, the rolling scaffold was installed in the grand foyer for the carpenters to use to take down the thin garland strands. We proceeded to remove all of the decorations from these garlands – hundreds of gilded pinecones and gold leaves, and small glass ornaments. Scooting around on the marble floor, we moved back and forth across the space in a rush to complete the ornament removal and add them to the new garlands. Meanwhile, the carpenters laid out the replacement garlands that arrived at the North Portico and began the arduous process of re-hanging them throughout the Cross Hall and Grand Foyer spaces. As the hours passed and the clanging of scaffold, hammers and raucous laughter of carpenters grew louder, it was surreal to think that the First Family was fast asleep in the residence directly above us. We finished our overnight escapade just before 5 a.m. well before the first tours commenced. After a couple of hours of sleep, I was back at the White House by 8 a.m. with double coffees in hand. As I watched the enthusiastic tourists make their way through the Grand Foyer and Cross Hall that morning, totally oblivious to what had gone on just a few hours before, I was once again reminded how surreal working at the White House could be.

SNOWY WEATHER. We learned a great deal about the effects of inclement weather on White House holiday tours, housekeeping and 'snow melt' products. Occasionally during the month of December, Washington, D.C. could be hit with snow and ice storms of epic proportions. The White House always tried to keep previously scheduled holiday tours in place for those intrepid visitors who made the commitment to venture out into the elements on their way to see the decorations. This created some challenges and required a great deal of planning. Park Service personnel took the lead to clear sidewalks leading up to the entrance, laying down chemical 'snow melt' to keep the sidewalks from becoming slippery. What no one realized is that the 'snow melt' crystals were then tracked in on the shoes of thousands of visitors throughout the White House, where they ended up on the shiny marble floors of the Cross Hall. Housekeepers take great pride in the beautifully polished floors that they meticulously wax and buff each day using a power buffer and commercial wax that shines the floors to an impossible sheen.

It turns out that the 'snow melt' crystals interacted with the wax to create an indoor ice rink on the polished surface of the Grand Foyer marble floor. The chemical reaction caused visitors to fall down in droves, their contact with the floor confirmed with a range of loud thuds and splats that reverberated throughout the space. Housekeepers reported that people were 'dropping everywhere' but no one was sure what to do. And then the President's staffer for legislative affairs took a nasty spill, breaking both her arm and her wrist. Skilled at making a persuasive legal case, she wrote a no-nonsense memo about the need to take immediate action to mitigate dangerous liability and to prevent serious injuries. Within a couple of days, special 'walk-off' mats that are designed to gather the crystals from visitors' shoes were installed in the East Colonnade, well before guests made it up to the marble Cross Hall floors. The problem was resolved and the practical (if not aesthetically pleasing) mats have remained in place ever since.

CONCLUSION. The Grand Foyer and the Cross Hall are among the most important spaces at the White House, making a strong first impression as the primary and formal entrance during official events. They also make a last impression as visitors leaves the space through the North Portico doors on the holiday tour. With its tall ceiling, spacious proportions and elegant furnishings, the beauty of the space is enhanced during the holiday season with sparkling décor and twinkling lights – as well as the music of the Marine Band that can be heard throughout the state floor. When the President and First Lady descend the grand staircase to greet holiday revelers who eagerly await them in the Grand Foyer, everyone knows that the White House party is officially underway.

The volunteer team in 2010 was especially talented and energetic. In the Cross Hall, they crafted 1,000 red ribbon poinsettias for garlands and wreaths which were hung by French-braided ribbons.

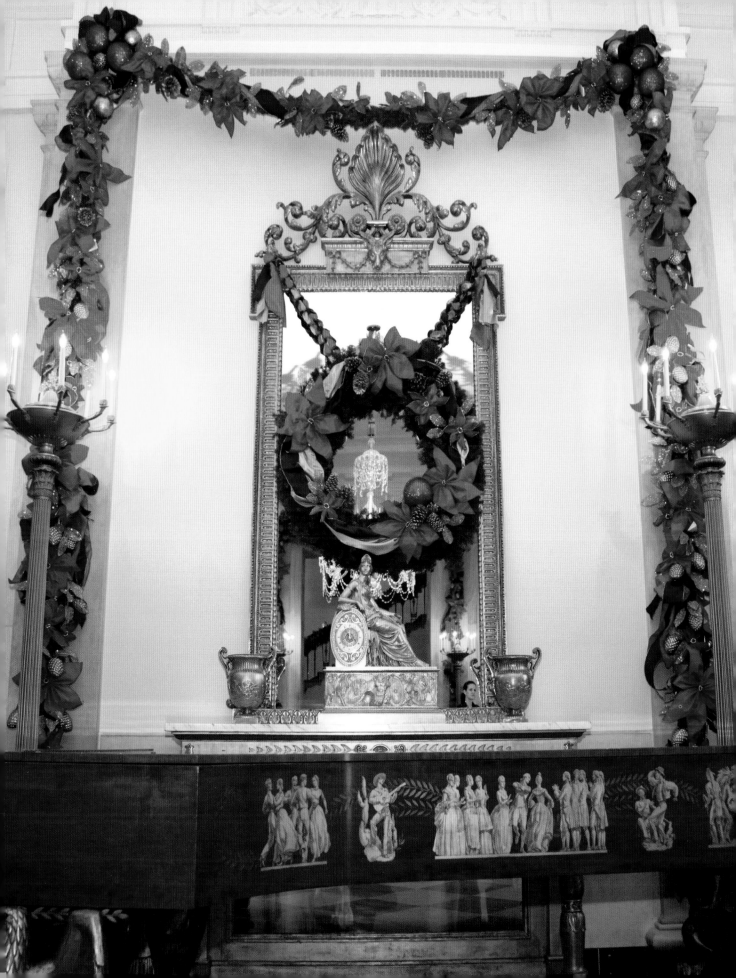

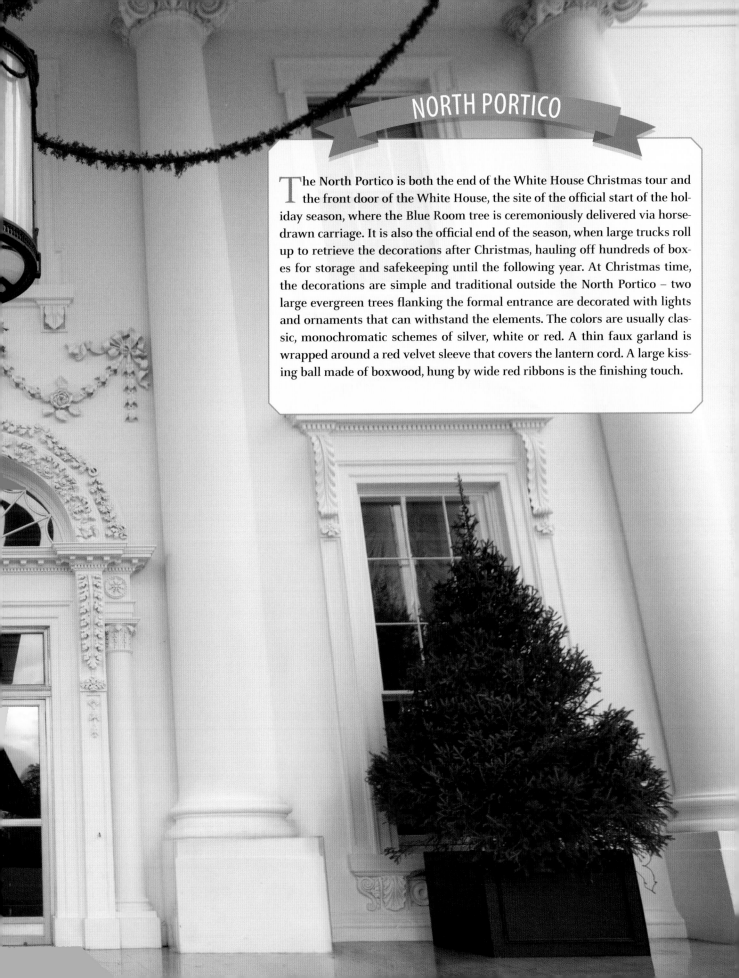

NORTH PORTICO

The North Portico is both the end of the White House Christmas tour and the front door of the White House, the site of the official start of the holiday season, where the Blue Room tree is ceremoniously delivered via horse-drawn carriage. It is also the official end of the season, when large trucks roll up to retrieve the decorations after Christmas, hauling off hundreds of boxes for storage and safekeeping until the following year. At Christmas time, the decorations are simple and traditional outside the North Portico – two large evergreen trees flanking the formal entrance are decorated with lights and ornaments that can withstand the elements. The colors are usually classic, monochromatic schemes of silver, white or red. A thin faux garland is wrapped around a red velvet sleeve that covers the lantern cord. A large kissing ball made of boxwood, hung by wide red ribbons is the finishing touch.

HOLIDAY TEARDOWN. At the end of the season, just a day or two after Christmas, the North Portico becomes a hub of activity – where workers stage all of the decorations before they go back to the warehouse. Seventy-five volunteers arrive at the White House to assist with taking down all of the decorations, packing them up in an organized fashion and carrying them outside though the North Portico to be loaded on Park Service trucks. It is usually a two-day affair. On the first day, staff prepare for the volunteers to arrive, placing boxes and labels in each room, setting out tarps and tools and getting a start on removing the décor. The volunteers are deployed in teams, room by room, with a detailed game plan on what they need to accomplish in each room and how to organize the decorations. The Blue Room team is the largest group with about 15 volunteers; the same expert crew has been coming every year for over 15 years to remove decorations from the Blue Room tree. After the 'tear down', volunteers finish the de-decorating process, the electricians swoop in to remove all of the lights from the trees, the park service workers and carpenters remove the trees and garlands and the housekeepers finish up with a thorough cleaning of both the State and Ground floor rooms. It's an exact reversal of the process that we use at the beginning of the season. The strategy is to save everything that can be used again, preserve special items for the presidential library, and throw away disposable items like garland and evergreen wreaths.

One year, as we were finishing up the 'tear down' of the holiday decorations and loading up the last boxes of décor, I noticed an odd sight that immediately caught my attention because it appeared to violate our strategy of saving important pieces. The first sign of trouble was the black bucket: the cheap plastic liner that we used in the iconic sugar flower and cranberry vase in the Red Room was sitting on the North Portico landing, waiting to be loaded onto the storage truck, but the vase itself was nowhere to be found. The disposable liner was inexplicably saved while the sugar vase (a triumph of artistic achievement that had taken over six months to make) was missing in action. I knew

that East Wing staff wanted to save the piece for inclusion in the Christmas display in the future Obama presidential library so I raced inside the North Portico doors and went straight to the Red Room. By then it had been totally stripped of its holiday décor. 'Where is the Red Room vase?' I asked. Housekeepers were vacuuming, they shrugged, they didn't know. I went from room to room asking workers who were moving furniture, electricians who were packing up lights, Park Service personnel who were cleaning up the last remnants of dried out Christmas trees. No one had seen it, no one knew where it was. Just as I was beginning to give up hope, a volunteer appeared out of the blue. She said that she had found the Red Room vase. It was peeking out of a big trashcan. The vase had been unceremoniously tossed in the garbage and was a brief moment away from oblivion. Having watched that season's HGTV special, which highlighted and celebrated the accomplishments of the sugar artist's work, she knew how special and valuable the piece was for the White House collection. She retrieved the vase on her own volition and took it to the flower shop for safekeeping. Amazingly, there was very little damage incurred despite its rough handling. No one ever confessed to throwing the vase away and I made sure that going forward we had strict protocols in place for disposal of decorative items. The important point was that we saved the vase for its future display. We even used the cheap black liner again.

Walking through the North Portico of the White House at the end of a Christmas tour, an official party, or after teardown of the decorations is always a breath-taking experience. Standing next to the imposing ionic columns on the landing, you see the fountain and Pennsylvania Avenue in front and the iconic Federal style façade of the White House as you turn to look back. And in December, you often feel the sudden blast of the cold north wind, which both signals the end of a unique experience and even inspires visitors to think about what the next White House Christmas will entail. In every case, guests depart with wonderful memories that provide a source of inspiration throughout the year.

p. 138 The beautiful architectural details of the North Portico entrance provided endless inspiration for holiday and floral décor over the years. At Christmas time, simple decorations, such as the boxwood kissing ball, evergreen trees and narrow fir garlands, provided an elegant touch that let the inherent beauty of the White House shine through.

This iconic Red Room sugar flower vase, made with exquisite precision and attention to detail, took a talented volunteer over six months to make. In 2013, it was filled with red, fuchsia and purple seasonal flowers and foliage that complemented the fruit and flower motif of the vase. To this day, it remains one of my favorite artistic collaborations.

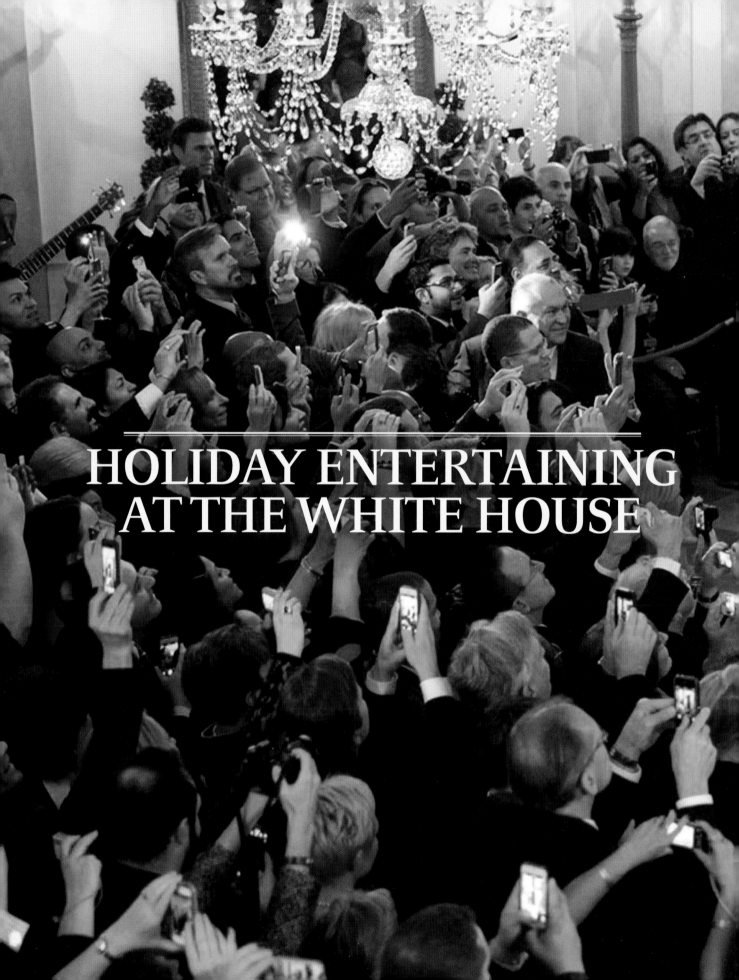

HOLIDAY ENTERTAINING
AT THE WHITE HOUSE

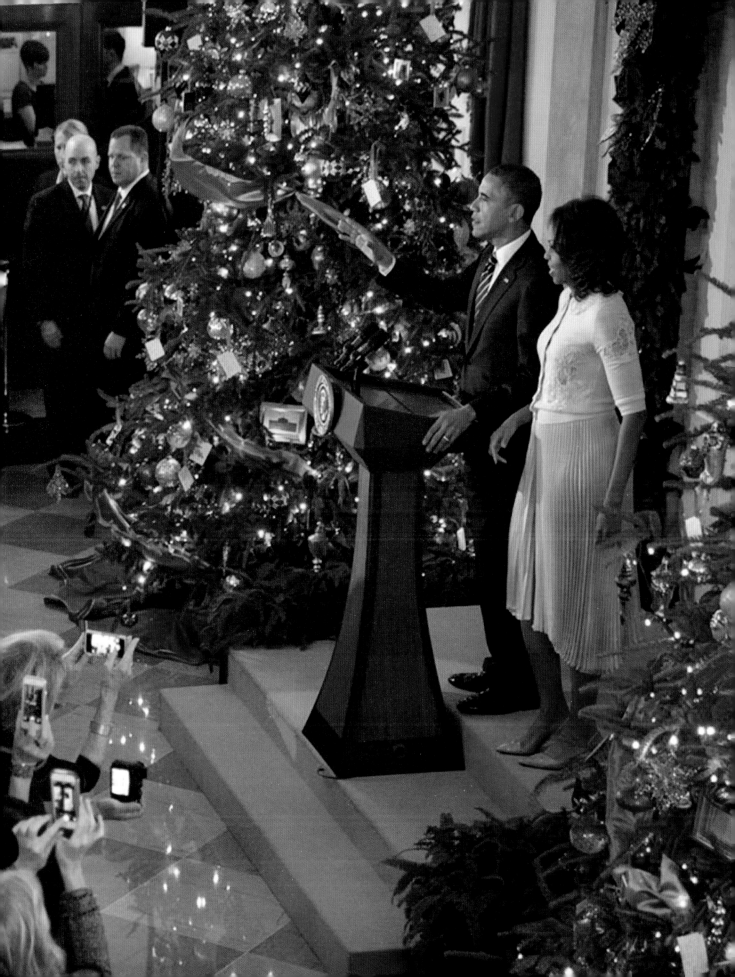

HOLIDAY PARTIES. When the holiday decorations are installed and finally in place – the culmination of months of planning and thousands of hours of meticulous work, there is no time to relax or admire the extraordinary work of the talented volunteers. Almost immediately after the press preview and the official launch of the holiday season, it is a race against time to kick off the season of White House entertaining with the very first party. It is the 'thank you' party for decorating and correspondence volunteers as well as other staffers who were involved in creating the White House Christmas. The party is a lovely annual tradition and much-coveted invitation that volunteers look forward to with great anticipation. The party features an impressive assortment of traditional holiday treats and White House specialties laid out on lavish buffets in the State Dining and East Rooms, while butlers serve free-flowing champagne to the happy revelers. The party culminates with the First Lady's appearance at a presidential podium in the Grand Foyer where she greets the hard-working volunteers and thanks them for their help. Volunteers are so excited that they clamber up onto the James Monroe settees to get a better view as she descends the grand staircase – at least until the curators come to shoo them away. Occasionally, they become so overwhelmed by the moment (and perhaps overheated by the large crush of bodies) that they faint straight away – and are quickly carted off by members of the White House medical team, who are always standing nearby in case of emergencies. This is also the party that launches a season of entertaining that continues unabated with back-to-back festivities that enliven the White House for over two weeks, with over 13,000 lucky guests enjoying an unforgettable experience.

My planning for the intense schedule of White House parties required its own separate timelines, project and staffing plans. Several months in advance, I mapped out décor schemes that matched the Christmas decorations in theme, colors and design. This included selecting linens for the buffets and cocktail tables that were set up for entertaining throughout the State and Ground Floor spaces: the Lower Cross Hall, Palm Room, Diplomatic Room, East Room, Blue Room, State Dining Room and Grand Foyer and Cross Hall. Each space required a different holiday look with coordinating flowers, candelabras,

votives and additional accents, including topiary displays. Color schemes ranged from neutral metallic shades of gold, silver and copper to rich holiday hues in shades of red and green. Once we had the linen template and room-by-room décor in place, I developed plans for floral decorations that became the concepts we would use throughout the holiday season. This involved creating coordinated displays for the parties – six to eight large arrangements for the two giant buffet tables and a few dozen cocktail tables – as well as the floral touches that were part of each room's décor. For example, the Green Room always included arrangements of fresh flowers in a range of natural containers placed throughout the room, while the Red Room featured a large focal point piece with a traditional cranberry element. The Library and Vermeil Room both displayed large centerpiece designs in hand-made decorative containers. Other flower displays were placed in in the East Entrance, Diplomatic Reception and Palm Rooms. In addition to the small bouquets of cocktail table flowers that went in the Grand Foyer, we also filled large vermeil urns with masses of winter flowers – roses, amaryllis, ilex berries and mixed evergreens. All of these flower arrangements were created, maintained and refreshed on a daily basis in order to have a seamless presentation throughout the entire season. To keep up with the schedule and time demands, I invited teams of florist volunteers from across the country to help me create these floral embellishments that were such an essential part of the overall White House holiday décor.

In addition to the non-stop receptions that went on day and night at the White House, we also organized a few special dinners, including the annual dinner for the President's senior staff. Usually held in the East Room, it is a beautiful yet relaxed affair, an opportunity for the President and First Lady to take time out during the busy season to thank dedicated staff for their contributions and hard work. The tables are set as they would be for any formal White House event with linens, flowers and presidential china. Both the red Reagan china and the green Truman or Bush sets were good choices during the holiday season), silver flatware, Kennedy glassware, and the gold Charleston candlesticks were decorated with boxwood or ivy. Our centerpiece designs of roses, amaryllis and winter berries

p. 142 Each day throughout the Christmas season, the White House was filled with a crush of excited holiday revelers. At the beginning of each party, the President and First Lady descended the Grand Staircase to the Grand Foyer where they personally welcomed guests and extended warm holiday wishes

Holiday partygoers usually received advance notice when the President and First Lady were about to appear at White House receptions, giving them time to assemble in the Grand Foyer. A lucky few partygoers ended up in front along the rope line where they had a chance to meet the President and First Lady. Everyone had their cell phones ready to document the occasion.

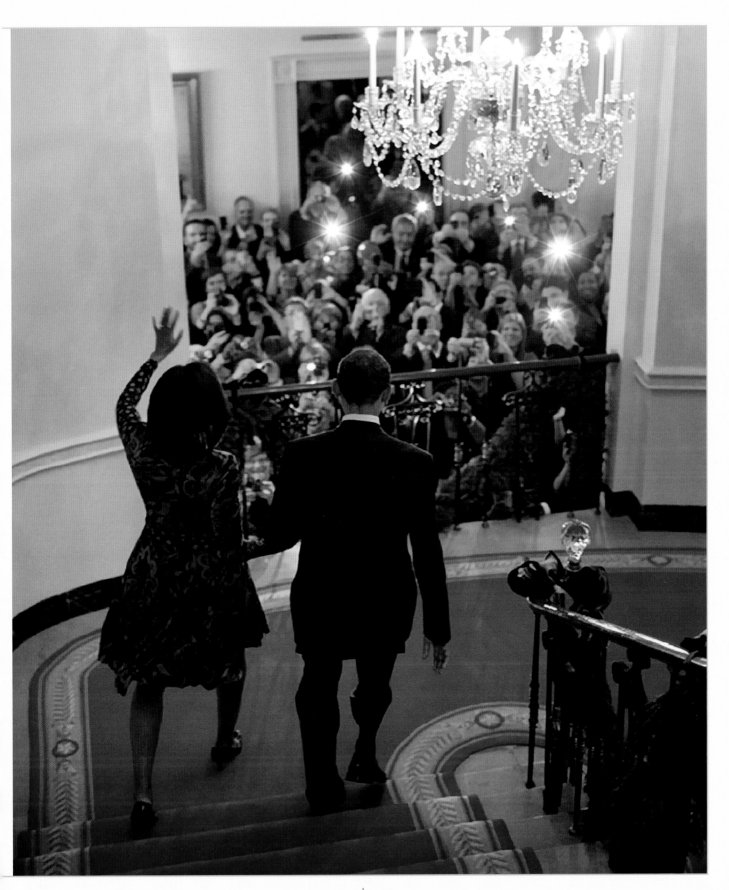

were often presented in the classic Tiffany vermeil bamboo bowls that Jackie Kennedy selected for the White House. The size and proportion of the gilded vessels made them a perfect choice for a round table of ten. One year as we were setting up and putting the final finishing touches on the place settings, a volunteer helped me load and install the chase candles. These spring-loaded metal shells with narrow wax candle inserts that resemble real taper candles and are deemed a safer choice than regular candles in the historic White House setting. We moved from table to table throughout the East Room placing the locked and loaded chase candles in the 60 Charleston candlesticks, finishing up at the head table in the center of the room. Just as the volunteer attempted to put one of the final candles in place, I saw it dislodge and launch forcefully from her hand like a projectile missile as it arced across the table, the force of the blast propelling it onto the stage behind and leaving a trail of shattered glassware in its wake. Everyone stopped to stare, as the room grew silent, the volunteer's face turning a beet shade of red. Protocol requires that if there is broken glass the entire table setting has to be re-done, so the butlers quickly moved into to replace everything. Within a matter of minutes, we were back finishing up the table settings for what turned out to be a beautiful (and thankfully uneventful) holiday dinner devoid of unauthorized missile launches.

BEHIND THE SCENES. Behind the scenes, the chefs work overtime during the holiday season to ensure that the buffets are stocked with an amazing array of Christmas classics, White House favorites, and new recipes that represent the President and First Lady's preferences. The west corridor entrance becomes an auxiliary kitchen where dozens of turkeys are roasted, thousands of pounds of potatoes and other side dishes are cooked at all hours of the day and night. Preparations are intense for weeks leading up to and throughout the holiday season. The food includes a full spread of roast turkey, Virginia ham, beef tenderloin, lamb chops, salads and side dishes, a raw bar of Gulf shrimp and oysters and artisanal cheese displays. Everything is presented on platters and silver serving bowls to create an amazingly impressive and elegant feast. In addition, an entire table is devoted to desserts, including cakes, pies, cookies, trifles and puddings. But it is the Christmas cookies decorated with images of Bo and Sunny that are always the most popular souvenirs, tucked into pockets and purses along with napkins that feature the presidential seal.

Throughout the holiday season, singers and choirs from around the country entertained guests at the White House, serenading them with classic Christmas tunes.

One of the most iconic items served during the holidays is the famous White House eggnog – a potent concoction of sugar, egg yolks and half and half cream mixed with copious amounts of bourbon, brandy and rum topped with a generous helping of whipped cream. The concoction is made months in advance and stored in giant white vats that line the lower White House corridors. Recipes have changed over the years, with different White House chefs weighing in with various techniques and approaches, perhaps with presidential preferences in mind. One element always stays constant in the mix: the generous and boozy mix of three types of alcohol in equivalent (strong) proportions. Many White House regulars look forward to sampling the eggnog every year. But they always give the same advice – to enjoy the eggnog in sublime moderation rather than decadent indulgence – with a knowing nod of experience to back up the recommendation.

For an intense two or three-week period in December, the White House is the venue for a non-stop series of holiday parties that celebrate the joys, traditions and beauty of the Christmas season. For those special guests who are lucky enough to attend a White House party, it is always a fabulous and unforgettable experience that they will one day share with children and grandchildren. And for a fortunate few, the experience is commemorated with an official photo with the President and First Lady. Set against the backdrop of the historic White House setting with exquisite food and drink and beautiful decorations on display, the annual holiday parties are a cherished and time-honored tradition that bring people together in the spirit of the season.

The annual holiday spread at the White House is famous for both the amount of food that fills the expansive buffet tables in the East Room and State Dining Room and the incredible variety of delicious holiday favorites. This dessert table displayed cakes, pies, chocolates, fruit and sugar cookies – including the coveted Bo and Sunny shapes.

FLORAL CANDELABRA

The soft incandescent light of candles at Christmas time is an integral part of holiday décor. Whether used on tables, the mantel, in windows or on Christmas trees, candlelight adds warmth and atmosphere to everything. I believe it is an essential accessory for creating beauty and adding atmosphere to holiday designs and entertaining. Several years ago in Paris, I took a flower class during which we created shimmering flower and candle displays submerged in water and surrounded by mirrored and mercury glass vases. The combination of light, color and nature reflected via water and mirrors was magical and inspiring. The light sparkeld and refracted, multiplying the colors, shapes and romantic ambiance throughout the room to spectacular effect. At the White House, I tried to recreate this magical feeling by incorporating candles in my holiday floral displays and tablescapes, adding mirrored vases and mercury glass touches as embellishments. Here is an idea for blending flowers and candles in a large holiday centerpiece design:

WHAT YOU'LL NEED

- ✍ Large plastic flared bucket (with a 10-12 inch opening)
- ✍ Masking tape
- ✍ 2 bunches magnolia leaves
- ✍ Hot glue gun (and hot glue sticks)
- ✍ 2 – 3 oasis foam bricks
- ✍ 5 18 inch cream taper candles
- ✍ Wired wood picks
- ✍ Floral tape
- ✍ 1 bunch cream or white roses
- ✍ 1 bunch cream spray roses
- ✍ 2 bunches star of Bethlehem
- ✍ 4 bunches paper white narcissus
- ✍ 1 bunch seeded eucalyptus
- ✍ 2 bunches lemon leaf salal tips
- ✍ 1 bunch plumosa vine

STEP-BY-STEP TECHNIQUES

1 Wrap the plastic bucket with masking tape to create a surface for gluing the leaves.

2 Take individual magnolia leaves, fold the green side in, and glue the spine of the leaf onto the tape-covered bucket working in lines from bottom to top around the vase.

3 Continue adding and stacking leaves, taking care to glue the spines very close together, covering the entire bucket .

4 Cut the floral foam bricks to cover the entire bottom surface inside the bucket, wedging the pieces in securely.

5 Fill the bucket with water.

6 Build the foundation and general form of the bouquet by inserting lemon leaves into the foam, creating a loose and roundish shape.

7 Create a garden style bouquet starting with the roses, working from the outside edges and working towards the middle, adding stems to follow the shape of the magnolia leaf vase.

8 Alternate adding roses and then spray roses with foliage, incorporating lemon leaves and eucalyptus stems.

9 Add the star of Bethlehem at various levels around the bouquet, creating depth and dimension.

10 Insert the paper white narcissus, using 2 or 3 stems together to fill in the gaps in the arrangement, following the shape, turning the bouquet after each grouping is placed.

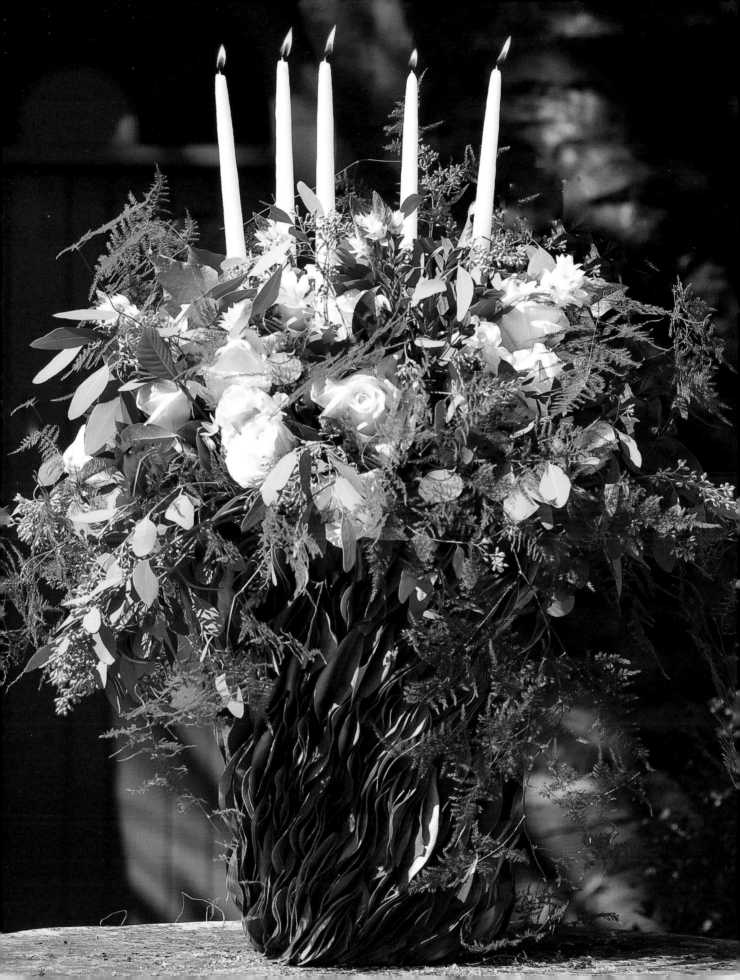

MY HOLIDAY HOME

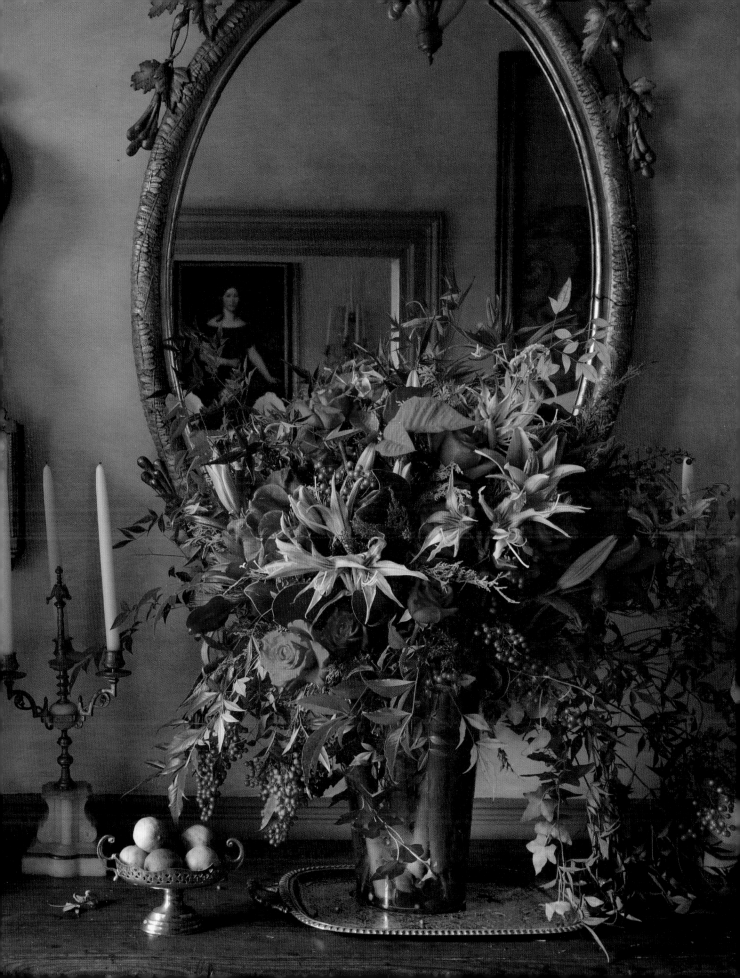

The 18th century houses and cobblestone streets of the old seaport village of Old Town Alexandria, Virginia provide a charming ambiance and perfecting setting for traditional holiday displays. Inspired by early American traditions, including the natural fruit and evergreen wreaths that are iconic elements of Colonial Williamsburg style, many residents decorate their doors and houses with a colorful display of natural materials. Here, over the years, I've enjoyed developing my own traditions for our old, Federal style house, planning holiday events for friends and family, crafting decorations and embellishing my home with festive flowers, wreaths and Christmas décor.

For inspiration, I often look to nature and American historical traditions. One year, I was inspired by founding father Thomas Jefferson's fascination with France and French decorative arts, especially his love of formal gardens in the French style. For a French-themed holiday display, I made giant three-tiered holly topiaries in the Versailles tradition that were crafted by pinning individual holly leaves to a chicken wire and newspaper frame in a striped beach ball pattern motif. These flanked my front door. For the door itself, I made a diamond-shaped wreath out of lemons, holly and red berries. Another year, inspired by the bird and fruit garland motif of the vintage French toile fabric I collect, I crafted pistachio doves that hung above a wreath made of sugared fruit. It involved using a technique of spraying floral adhesive and adding rock salt to give the impression of sugared fruit. On the inside, I decorated my tree and garlands with a coordinating bird and fruit motif. That installation taught me about the importance of mechanics and engineering. When the rigging I used to string up the birds came down in a windstorm, leaving the pistachio birds dangling (as if strangled) by a thread above the door, I realized that the underlying structure was as important as the artistic finish. The infrastructure, including the construction and installation – all of the elements behind the scenes – is key to success.

It's always an inspiring creative challenge to experiment with unusual materials and try out new designs during the holidays. My starting point is usually a fruit or vegetable wreath made of potatoes, peppers, bananas, and other combinations of fruits, flowers and vegetables. Years ago when we first moved into our 200-year old house on Cameron Street, I put a large red apple wreath on the front door. As I was hanging the wreath, I noticed a car full of people driving by very slowly. They stopped right in front of my house. A woman jumped out and asked me if I was the homeowner and if I had made the wreath myself. Why, yes, I said, in answer to both questions. The woman jumped back in the car and the mysterious group sped away. Later that evening, I found a hand-written note that had been pushed through my mail slot notifying me that I had won 3rd place in the 'Old Town Walled Garden Society's' annual wreath contest. I didn't even know that such a contest existed (and was not sure how they knew to drive by our house), but by simply putting up a wreath made of natural materials, I apparently entered the competition. Just recently, I learned that the mythical society does in fact exist and that they have sponsored this quaint and beloved tradition in Old Town for over 75 years.

A key to working with natural materials is understanding their limitations and risks. One time I created a large wreath out of bananas for my front door. I envisioned that individual bunches of bananas would fan out around the wreath creating interesting color and pattern. I bought several pounds of green bananas and wired them to the wreath frame. The banana wreath was good for just a few days – until it started to turn black, as the bananas aged and were subjected to the cold weather. Our house is located on the same block as George Washington's tavern and so passersby commented on my authentic 18th century style 'mourning wreath' that they assumed was part of the historical display – not exactly the festive holiday style I was going for. That year of the apple wreath, I opened the door one day to find a neighborhood squirrel perched on the wreath, happily munching on an apple and looking me directly in the eye. Another year, I made a large wreath out of limes, holly and crabapples that was colorful and festive for the first few days until the unseasonably warm sun beating down on the front door turned the limes into slime and started attracting flies. Because most fruit designs will last only a week or two outside, I've learned to view these decorations as ephemeral 'of the moment' décor and to always have a replacement plan in mind.

My focus on using natural materials extends to the interior décor. One year, for the two mantels in our double parlors, I created swags and garlands made entirely of red pistachios, using patterns made from craft paper that spanned the lengths of the two mantels. I sewed swag forms made of green tulle and

During the holidays, my entry way is always filled with flowers and evergreen boughs that welcome guests with seasonal colors and scents. This bouquet of red roses, spider amaryllises, poinsettias and nandina foliage is festive yet long-lasting with its underlying structure of evergreens. The large wreath on my front door, made of gilded fingerling potatoes, crab apples and berries, is designed to strike a celebratory tone.

stuffed them with newspaper to create a three dimensional effect. Then I hot-glued the pistachios on the forms, adding a border of green moss. The textured pistachio garlands were a perfect accent to the yellow ocher parlors and vintage red French toile slipcovers in the parlors and carried out a traditional fruit and nut motif. After the holidays, I made plans to keep these special decorations, carefully placing them in plastic and putting them in our attic storeroom for safekeeping for use the following year. That turned out to be an egregious mistake. The next spring, when I opened the door to the attic, I was shocked by my discovery. The beautiful red pistachio swags had morphed into eerie props for a horror film, spawning worms that dripped from the ceiling and moths that fluttered listlessly everywhere around the room. It was an important, if not pleasant, teachable moment. When using natural materials that are temporary and fleeting, I learned that it's important to heed that important reality. No matter how much effort goes into a natural decoration (especially involving dried flowers and nuts), it is generally a good idea to let them go soon after the season. And yet despite all of these weather and pestilence hazards, I believe that natural fruit and vegetable designs are always worth the effort – with a few caveats and precautions in mind.

There are many materials that can span the entire season and so I often incorporate these long-lasting designs as a practical choice for my holiday decor. Last year, for example, I made a lemon leaf and magnolia garland inspired by the hand-carved motifs that are featured in the period mantels in our old home. The lemon leaves and magnolia leaves dried in place, providing a effective focal point display. Another long-lasting element was a wreath crafted out of gilded fingerling potatoes with red crabapple and berry accents. Even floral displays can have an extended lifespan when plants such as poinsettias or paper white narcissus are added into an evergreen base. At home, my decorating strategy is to focus on a few key areas – the front door, the entry hall, the dining room, mantelpiece and windows – the main focal point areas that help to define a festive holiday home.

For a six-year period there was admittedly a dearth of obvious holiday cheer at my Old Town home. Once I started my White House job, my own holiday decorating necessarily went on hold. There simply wasn't time to decorate my house after the extraordinary effort and demanding schedule that went into planning, designing and coordinating the White

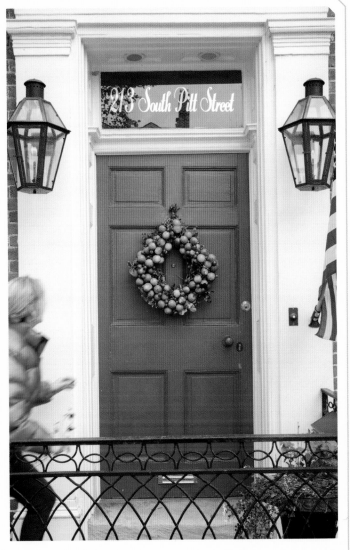

House Christmas. If I managed to hang a simple wreath on the front door, that was a major accomplishment. All of my energy was directed on implementing a spectacular White House Christmas. So, over the last couple of years, it has been a great pleasure to re-connect with my Old Town Alexandria community and celebrate the joys of the season with natural decorations, holiday entertaining with friends and family, decorating my own house and helping friends with flowers, wreaths and décor – bringing inspiration gleaned from the White House for Christmas to my own holiday home.

My holiday routine always includes surprising friends and family members with hand-made wreath designs that are designed especially for their front doors. Here I am tweaking a diamond-shaped lime wreath on a red Old Town door.

LEMON KISSING BALL

I fondly remember the evergreen and mistletoe kissing ball that always hung in the Library of my grandparents' home at Christmas time, a nostalgic symbol of the season, a timeless sign of welcome and goodwill. Years later, when I studied floristry in Paris, I learned how to create small orbs of flowers and greenery as a charming decorative element for front doors. Part of my French instructor's heritage, this tradition was passed down from generation to generation in her family over many years. At the White House, I used this classic form in the Red Room, State Dining Room and as decoration for the North Portico lantern and on the exterior gates. In my own home, I enjoy hanging kissing balls in the windows, where they are visible and can catch the light. Whether crafted from fruit, flowers or simple greens – and placed in passageways, over the door or in windows – kissing balls create a wonderful sense of tradition and are a perfect addition to Christmas decor. Here are tips for making a lemon kissing ball out of simple materials, accented with crabapples and holiday greenery.

WHAT YOU'LL NEED

- One 4 inch oasis sphere (with netting)
- Bind wire (for hanging)
- 6 inch wired wood pics (for attaching the lemons)
- Green paddle wire
- 15 small lemons
- A bunch of mixed evergreens (e.g., pine, holly, etc.)
- 25 small crab apples (or similar size red fruit)
- 3 – 4 strands of green trailing ivy

STEP-BY-STEP TECHNIQUES

1 Tie a length of sturdy bind wire through the netting at the top of the oasis sphere, leaving approximately 12 – 15 inches.

2 Soak the oasis sphere in water until it is completely saturated.

3 Cut 4-inch pieces of seasonal evergreens, removing the bottom leaves from each sprig.

4 Cover the entire oasis sphere with sprigs of greenery.

5 Add lemons to the sphere by inserting one end of the wired wood pick into the lemon and the other into the oasis sphere, covering the entire surface.

6 Using the paddle wire, create a garland of crab apples by piercing and stringing the apples, leaving 5 – 6 inches in between each apple and a 6 inch length at each end. Make 5 mini-garlands.

7 Tie the end of the crab apple garlands to a wired wood pick and insert them into the sphere.

8 Weave the apples in and around the lemons so that they appear to 'float' above the design.

9 Add strands of trailing green ivy for a natural effect and to cover the bind wire at the top.

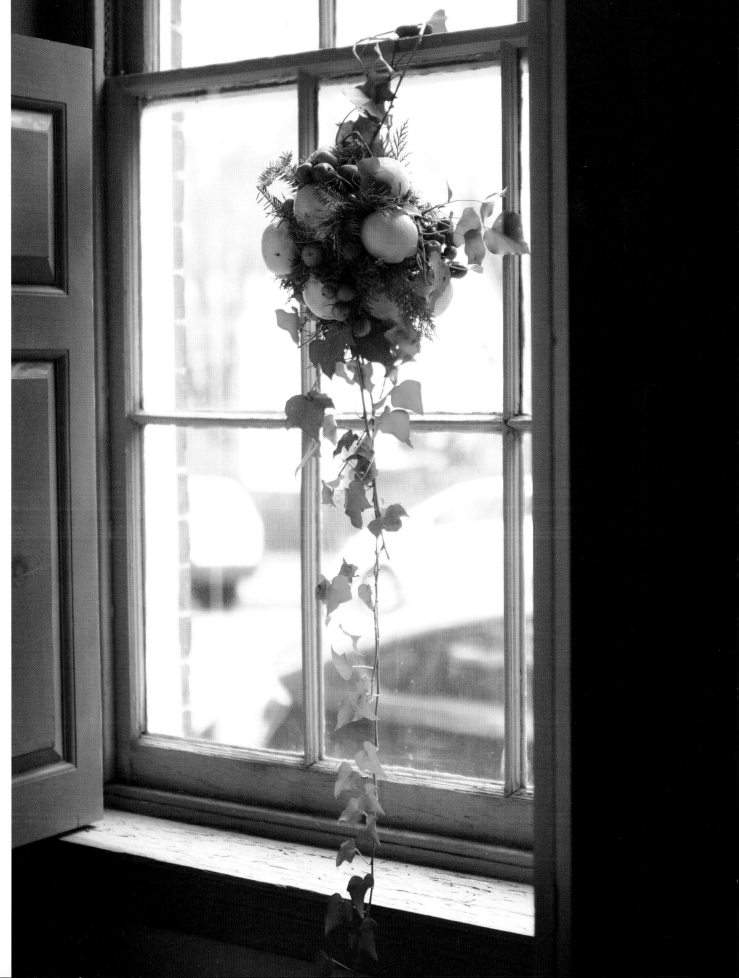

LEMON LEAF AND MAGNOLIA GARLAND

Gathering around a blazing fire is a wintertime tradition that is especially meaningful during the holiday season. It celebrates the heart of the home, warmth and light – and is often the setting for cherished family traditions. By decorating the mantel with fragrant winter greenery and festive ribbon trim, it's possible to capture the spirit of the season and provide a warm and welcoming backdrop for gathering with friends and family throughout the holiday. The design for the leaf and paper garland was inspired by the hand-carved patterns and motifs that are featured in the period mantels in my Old Town home. The Greek key pattern is a classically beautiful motif that is timeless and elegant; my idea was to create a de-constructed version that references these period architectural details. I used 14 panels (that each measure 12 inches by 8 inches) to create the garland. The panels are made from brown paper grocery bags that I cut and measured and stapled together for double thickness. To create a strong graphic presentation, I alternated the design of scalloped magnolia leaves with a checkerboard motif made from folded green aspidistra leaves and gold paper. I applied the leaves and paper with hot glue to the paper and added a preserved green reindeer moss border to complete the design. Then I stapled the panels to a red satin ribbon for hanging. For depth and movement, I added simple garlands of lemon leaves and magnolia leaves stapled end to end. My goal was to use simple, natural materials that are easily available to create an original and festive design that complements the interior decor.

WHAT YOU'LL NEED

- 3 bunches of magnolia leaves
- 3 bunches of green aspidistra leaves
- 3 bunches lemon leaf salal tips
- 1 roll of gold wrapping paper
- 1 bag of preserved reindeer moss (lime green)
- Brown craft paper (or grocery bags)
- Pencil
- Ruler
- Scissors
- Stapler
- Hot glue gun (and hot glue sticks)
- Floral bind wire (paper-covered wire)
- Thin gauge spool wire
- Satin ribbon for hanging

STEP-BY-STEP TECHNIQUES

1. Measure the length of the mantel and the length of the drop on each side – this is the total length of the garland.

2. Cut 28 rectangular panels measuring 12 inches by 8 inches from the brown craft paper, stapling them together for double thickness, resulting in 14 panels.

3. Create 7 panels of magnolia leaves, folded in half, brown side out, by gluing them in rows starting at the top of the panel, adding leaves in a scalloped motif.

4. Create 7 additional panels of aspidistra leaves and gilded paper, cutting each element into 4 inch by 2 inch strips (and folded into 2 inch loops), stapling them to the panel in an alternating pattern.

5. Glue a border of reindeer moss to the panels to create a finished effect.

6. Cut a length of satin ribbon that spans the width of the mantel and is long enough to drop on either side.

7. Staple 7 panels to the satin ribbon, leaving 8 inches between each panel, alternating the two designs.

8. Create a second layer of the garland by stapling the remaining 7 panels to the corners of the first seven panels.

9. Finish the presentation with a narrow lemon leaf garland made with bundles of lemon leaves wired with paddle wire to a bind wire base.

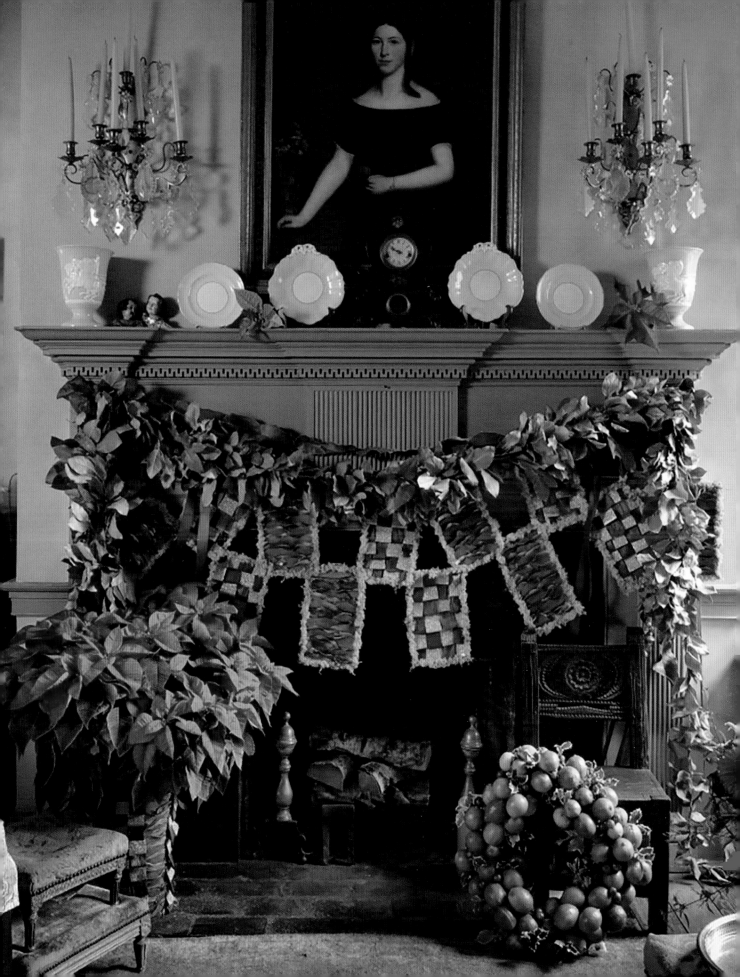

CONCLUSION. A common theme in Christmas songs and stories is that the spirit of Christmas comes alive in dreams. In the children's book 'The Polar Express', a small child travels to the North Pole in a dream, returning with a jingle bell that only he can hear, symbolizing the magic and hope of Christmas. The poem 'The Night Before Christmas' captures the excitement and delight of children as they anticipate Santa's arrival, while the timeless and enchanting 'Nutcracker' ballet celebrates the transformational power of love. In Charles Dickens' classic tale 'A Christmas Carol', the ghosts of Christmas past, present and future appear in Scrooge's dreams. The iconic Christmas films 'Christmas on 42nd Street' and 'It's a Wonderful Life' reference the healing power of faith and dreams. The songs 'I'm Dreaming of a White Christmas' and 'I'll be Home for Christmas' express an idyllic vision of the holiday season, even if it is experienced only in one's dreams. At one time or another, all of these symbolic themes were incorporated in White House holiday décor.

Indeed, Christmas is a magical time of year when all dreams seem possible and all Americans have dreams no matter their ages, backgrounds or economic circumstances – the universal hopes and aspirations parents have for their children, the collective dreams we share regarding freedom and world peace, and personal dreams we hold close for reaching our full potential and sharing blessings with others. During the holiday season, we celebrate cherished traditions, embrace a sense of wonder and possibility and dare to believe that all dreams can come true. Remembrances of the past and a sense of hope for the future – these are the special blessings and sweet dreams of Christmas.

The White House Christmas exemplifies this spirit of optimism, hopefulness and imagination of the Christmas season with spectacular displays of holiday splendor that pay tribute to our American heritage and celebrate an enduring promise of hope and possibility. In the spirit of the season, the sweet dreams of the White House Christmas merge into the quintessential American Dream and become a source of pride and inspiration for all.

In 2012, I was delighted to invite my family, including my husband, sister and niece, to join me at the annual White House Christmas party where they had a chance to meet the President and First Lady and take a photograph with them. My sister designed the clever 'houndstooth' wrapping paper with a Bo and Sunny motif, while my niece created the iconic 'Bo-flake' collection of Bo-themed snowflakes – projects that made everyone, including the President and First Lady, smile.

Happy H

ays,

Michelle Obama

A SIMPLE GIFT OF GRATITUDE

The idea for this book arose out of my own experience working on the White House holiday extravaganza year after year. No matter what other events and obligations I had day in and day out (of which there were many in my 100 hour work weeks), Christmas was always on my mind. While my first book, 'Floral Diplomacy at the White House' focuses on the specific role of flowers and décor in creating nuanced strategic, diplomatic and policy-themed messages that conveyed special meaning, this book takes a broader approach. I realized that the symbolism of the White House encompasses much more than flowers – it is the iconic venue where events, traditions and history unfold each and every day. Perhaps no other White House event carries as much symbolism as the annual White House Christmas, a magical celebration that represents our highest hopes, loftiest ideals and most dearly held American traditions.

'A White House Christmas' is a tribute to the volunteers who lifted the White House Christmas to new levels of creative ambition and technical execution: the florists, graphic designers, architects, political staff, and Presidential Innovation Fellows who worked together to achieve a common goal, always creating something much bigger than the sum of the parts. These volunteers became part of a new work model that we used to great effect, increasing efficiency and capacity and eliminating the need for expensive overtime and consultants' fees. By opening up the White House to enthusiastic and dedicated volunteers from all walks of life, we expanded exponentially the scope and quantity of projects we could tackle in any given year.

I am especially grateful to my friends and family for their support of my White House work and the talented volunteers who worked with me on special projects over the years, including Diana Kuo, Margaret Ludwig, Cameron Hardesty, Rosie Hunter, Maggie Austin and Jess LaBaugh, Lisa Riordan, Liz Bushong, Holly Chapple, Gina Salter, Jen Brant, Ginny Wydler, Desiree Linson, Jane Garrison, Laura Yocom, Gretchen Callison, Bonnie Pollard, Erica Pollard, Ashley Greer, Carol Woodbury, Andrea Gagnon and so many others, including the Red Hill Garden Club, Office of Science and Technology Policy, Office of Legislative Counsel, Grit and Grace, Haute Papier, Ritzy Bee, PIFs, AIFD, and long-time volunteers Bill Hixson and Jim Marvin. There are so many talented and inspirational designers who joined with me to create beautiful decorations and I appreciate each and every one of their contributions.

Once again I am thankful for my Belgian publishing team at Stichting Kunstboek, led by publisher Karel Puype, editor Katrien Van Moerbeke and designer Jan de Coster. They make the process of writing a book pure delight with their talent, dedication, efficiency and professionalism, and approached this holiday project with great enthusiasm, a collaborative spirit and attention to detail. They are experts at coordinating the presentation of visual elements and text to achieve creative and inviting formats, creating the personal tone that I always want to convey.

My photographer Kevin Allen has been a key partner for many years, capturing images of flowers, interiors and wreaths that are represented in this book. Additional photographs by John McDonnell and Erik Kvalsik depict our holiday house so beautifully. Many thanks to Margot Shaw, editor-in-chief of Flower Magazine, who graciously provided photos from a holiday magazine photo shoot to use in this project, and Marty Katz (DC Photographer), Edward Gehman Kohan of Obamafoodorama, Georgianna Lane, Christine Chung, White House Historical Association and the White House Photo Office for their images of White House holiday décor. Our Alexandria friends, Dr. Morgan D. Delaney and Osborne Phinizy Mackie provided the beautiful backdrop of Ghequiere House for an inspiring holiday photo shoot.

I am extremely grateful for my dear husband Bob who continues to bring inspiration and joy not just during the holiday season but each and every day throughout the year. Of course, I appreciate the incredible honor bestowed on me by former First Lady Michelle Obama who selected me to serve as her Chief Floral Designer. She gave me the incredible opportunity to conceptualize and carry out her vision of an inspiring White House Christmas year after year. And, finally, I appreciate you, the reader, and hope that your own holiday season is filled with boundless joy and special magic – the simple gifts and sweet dreams of Christmas.

Author
Laura Dowling
www.lauradowling.com

Layout
www.groupvandamme.eu

Published by
Stichting Kunstboek bvba
Legeweg 165
B-8020 Oostkamp
info@stichtingkunstboek.com
www.stichtingkunstboek.com

ISBN 978-90-5856-575-4
D/2017/6407/13
NUR 421

Printed in the EU

Previously published

Laura Dowling
FLORAL DIPLOMACY
at the White House

ISBN 978-90-5856-558-7